Contents

Credits: Page 1 – Meta Design; Previous Spread – Pullin + Morris, Inc.; Opposite Page – Webster Design Associates; Following Page – Grady, Campbell Inc.

Remarks: We extend our heartfelt thanks to contributors throughout the world who have made it possible to publish a wide and international spectrum of the best work in this field. Entry instructions for all Graphis Books may be requested from: Graphis Inc., 307 Fifth Avenue, Tenth Floor, New York, New York 10016, or visit our web site at www.graphis.com.

Anmerkungen: Unser Dank gilt den Einsendern aus aller Welt, die es uns ermöglicht haben, ein breites, internationales Spektrum der besten Arbeiten zu veröffentlichen. Teilnahmebedingungen für die Graphis-Bücher sind erhältlich bei: Graphis, Inc., 307 Fifth Avenue, Tenth Floor, New York, New York 10016. Besuchen Sie uns im World Wide Web, www.graphis.com.

Remerciements: Nous remercions les participants du monde entier qui ont rendu possible la publication de cet ouvrage offrant un panorama complet des meilleurs travaux. Les modalités d'inscription peuvent être obtenues auprès de: Graphis, Inc., 307 Fifth Avenue, Tenth Floor, New York, New York 10016. Rendez-nous visite sur notre site web: www.graphis.com.

In today's marketplace, graphic design firms see themselves as branding and identity firms. The clientele they serve share this way of thinking. This has come about because of the technology explosion that has occurred in the past few decades. A world economy has led to products, brands and other visual representations of leading businesses and institutions to garner recognition around the globe.

The American graphic design industry deserves much of the credit for this phenomenon. This fact is emphasized time and again in DesignersUSA No. 2, as some of the leading graphic design firms from across the nation showcase their creativity on these pages.

The spread of international commerce has increased the importance of graphic design as a result of its dependency upon visual images that are easily understood regardless of the native tongue of the viewer. Graphic design, therefore, has evolved into a highly concentrated form of visual communication, instantaneously delivering the client's message worldwide. To fulfill this need to communicate visually, graphic designers create powerful visual tools to establish and build unique identities that attract and retain customers.

Businesses and organizations rely upon the graphic design industry when they wish to position or reposition themselves in the marketplace, highlight differences between their competition and themselves, announce internal changes to the outside world, trigger specific intellectual or emotional responses, or attract attention for whatever reason.

Because graphic design is being utilized more than any time in the past, it can serve all of these functions by using a visual language, understood internationally, and do so with amazing ease. Consumers are exposed to this visual communication at every turn, see it, understand it, and ultimately use it to better their lives or expand their knowledge.

The reliance on a visual language has given graphic designers an unprecedented opportunity to dispense information and influence the viewer. With the dominant media (books, magazines, newspapers, television, movies and the Internet), it has become imperative to deliver the preponderance of the information in a visual rather than verbal form.

Showcased in DesignersUSA No. 2 are some of the best design efforts from the most talented design studios in the U.S. The projects include everything from something as singular as a calling card, to as grandiose as a building facade. What ties these projects together is the peerless excellence of the end result, the best examples of graphic design that is changing the world in a broad spectrum of media.

alchemycs.com 617 451 7711

Design affects the way something
is perceived: it makes the experience
deeper, and more personal.

Applied to a brand, design builds value.
It creates individuality and loyalty.
It communicates across all mediums.

Design changes everything.

Founders
Jeff Monahan and Howard Rhee

alchemy™

MITT ROMNEY

MITT ROMNEY

TRUE STRENGTH.

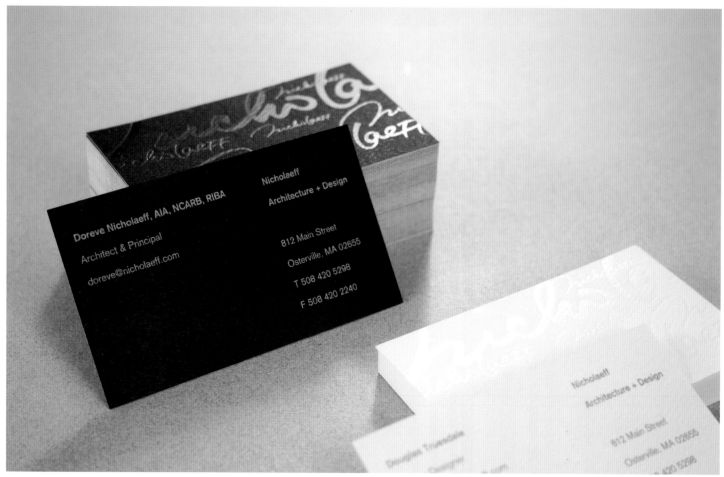

Alexander Isley Inc.
9 Brookside Place
Redding, CT 06896
203.544.9692
www.alexanderisley.com

We are experts in brand development and communication design for organizations involved with culture, education, and the youth market. We work with companies and institutions to help craft their brand personalities and introduce them to the public. Our teams of designers, writers, and strategists work among all disciplines to establish a consistent voice, attitude, and point of view to position our clients in the minds of their audience. This is important because, as with people, organizations are judged by what they say, how they look, and the way they behave. (We can do a lot to help with the first two.)

Our nine-person firm, founded in 1988, has received recognition and numerous awards in the fields of corporate identity, marketing communications, publication design, architectural signage, retail merchandising, packaging, and exhibit design.

As an important part of our practice, we utilize our expertise in sustainable, environmentally friendly, and socially responsible design when it's suitable for an assignment. In so doing, we work in collaboration with our clients to create work that reflects and advances their mission and values.

Our team has created effective and memorable work for a diverse range of clients including *Weekly Reader*, Peddie School, The Spence School, The Maritime Aquarium, Brooklyn Academy of Music, the Robin Hood Foundation, Scholastic, Nickelodeon, Lollytogs Apparel Group, and the National Endowment for the Arts, to name a few.

While the work our firm undertakes is quite varied, our approach to solving problems is consistent: Do the research, establish an appropriate plan of action, and, above all, always determine what something should do before thinking about what it should look like. We then produce a solution that is direct, appropriate, and memorable.

This approach has worked well, as we at Alexander Isley Inc. have earned the trust of our clients while gaining an international reputation for innovative, influential, and effective work.

ALEXANDER ISLEY INC.

MISS BENYEI'S CLASS

DESIGN FOR KIDS

We know kids.

1 VH1 Save the Music Foundation (logo redesign)
2 The Children's General Store (retail packaging)
3 Animal Planet (retail packaging for Toys "R" Us)
4 The Robin Hood Foundation (logo design for
 philanthropic program)
5 Starbucks (copy and design for the packaging and
 poster for Starbucks Express limited-edition train)

1

Before

After

2

3

4

5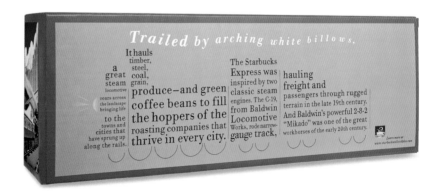

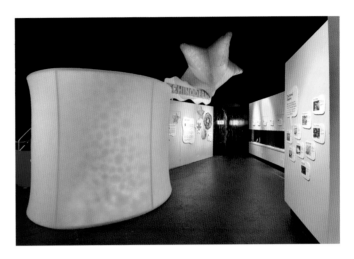

The Maritime Aquarium at Norwalk (exhibit design for Adventure Under the Sea with SpongeBob SquarePants)

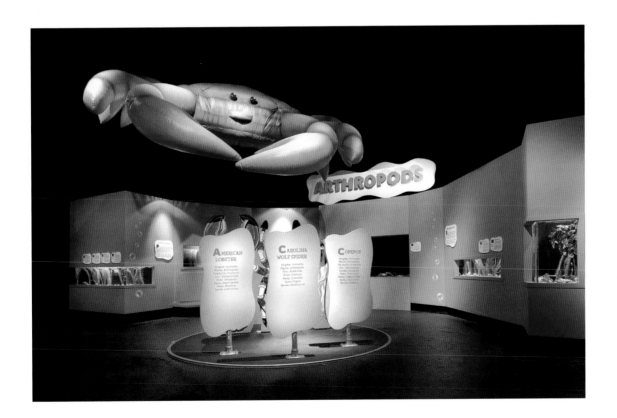

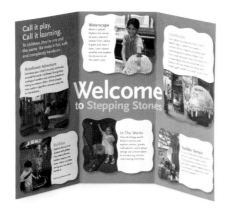

1

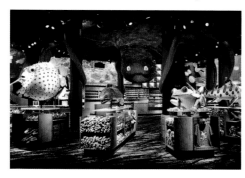

2

3

4a

■SCHOLASTIC

1 Stepping Stones Museum for Children *(promotional materials)*
2 John G. Shedd Aquarium *(gift shop retail design)*
3 Equity Marketing, Inc. *(identity for licensed toys manufacturer and distributor)*
4 Scholastic Toys *(copy and design for [a] promotional video and [b] instruction manuals)*
5 Nickelodeon Magazine *(initial design and redesign upon the publication's 10th anniversary)*

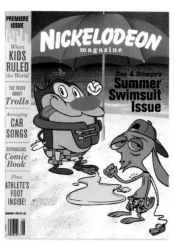

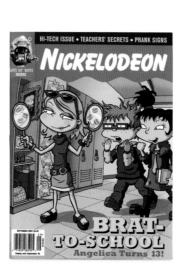

5

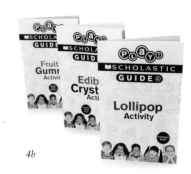

4b

Weekly Reader

We were responsible for the redesign and ongoing design consultation for the Weekly Reader's 125-year-old classroom magazines. We created a format for each of six reading levels.

Before

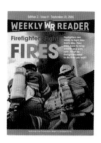

After

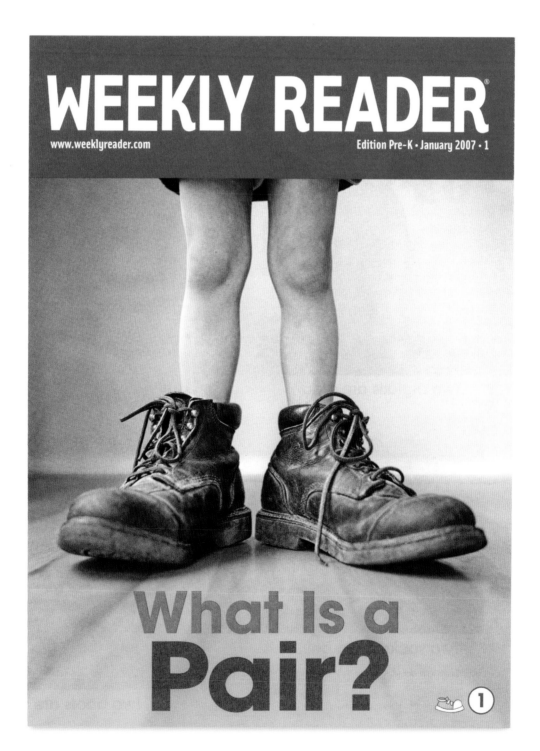

The Spence School

As part of our process in refining the identity and developing communication materials for this noted independent educational institution, we prepared a strategic plan and then developed designs to reflect the culture, standards, diversity, and excitement of the school. Our involvement included the creation of a viewbook, curriculum and applications booklets, and note cards.

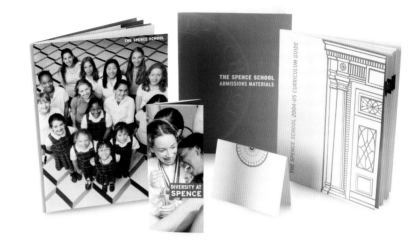

Peddie School

We created application guidelines and a program of overall communication, outreach, and informative materials in order to reaffirm this highly regarded institution's position as a leading independent boarding school. We produced an annual report, alumni publications, a viewbook, guidelines for the development of promotional material, and design standards for athletic uniforms.

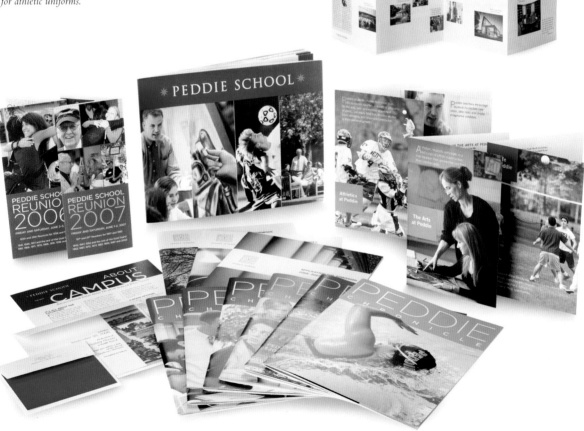

Busy lives. Simple clothes.

School dress codes provide a sense of confidence and community. Choosing the right uniform gives kids a chance to focus on the things that are important: classwork, creativity, and play. We know a kid's busy life can be complicated, and we're here to help make things a little simpler—for kids and parents too. **We're French Toast. We know schools, we know uniforms, and we know kids.**

FRENCH TOAST CORPORATE HEADQUARTERS: 100 W. 33RD STREET, SUITE 1012, NEW YORK, NY 10001 TEL 800.262.5437 FAX 212.268.5160 • REGIONAL OFFICES: NEW ENGLAND 603.890.3355 • FLORIDA/PUERTO RICO 305.266.5437 SOUTHEAST 803.283.0525 • MIDWEST 847.412.0005 • SOUTHWEST 214.631.2802 • WEST COAST 310.832.7519

Schools suggest it. Moms request it.™
www.frenchtoast.com

Lollytogs Apparel Group/French Toast

We were chosen by Lollytogs Apparel Group to develop an overall advertising and marketing communications program for French Toast School Uniforms, a line of uniforms created for urban and inner-city public schools. The program included a print ad campaign, city bus ads, radio advertising, and merchandising and promotional materials. Our involvement also included copywriting and the development of a brand tagline.

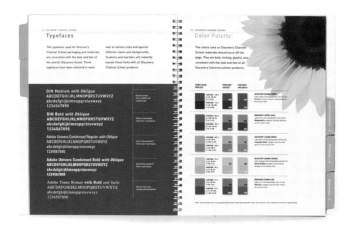

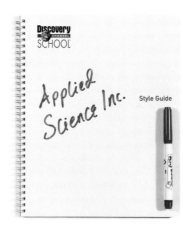

Discovery Communications Inc.

We created a branding and style guide for Discovery Channel Schools. We developed a graphic and editorial system to be used on all Discovery-branded classroom and educational materials and provided guidelines for use of imagery, colors, and typography. We then wrote and produced an informative style guide with a cover made from marker board material that can be customized for each recipient.

Aéropostale

We created a series of custom friezes, wallpaper patterns, and changing room designs for the prototype and 700-store rollout of this chain, which targets 11- to 18-year-olds. The program incorporates a unique two-layered window scrim system that provides continually changing looks. (Created in collaboration with Schwartz Architects.)

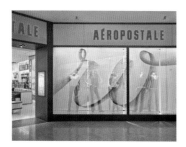

Selected Clients

92nd Street Y
The Actors Fund
Aéropostale
Aldrich Contemporary Art Museum
All Stars Project, Inc.
AOL
Animal Planet
Brooklyn Academy of Music
Champion International
Chevron
Chronicle Books
City of New York
Cooper-Hewitt, National Design Museum
Custom Foot
Discovery Communications Inc.
Equity Marketing, Inc.
Giorgio Armani
Harper Design International
The Hearst Corporation
John G. Shedd Aquarium
Liberty Science Center
Lifetime Learning Systems
Little, Brown & Company
Lollytogs Apparel Group / French Toast
The Magazine Works
Maritime Aquarium at Norwalk
McDonald's
Memorial Sloan-Kettering Cancer Center
MTV Networks
Museum of the Moving Image
National Dance Institute
Nickelodeon
Oaktree Milk
Peddie School
Pei Cobb Freed & Partners
The Penguin Group
PepsiCo
Reebok International Ltd.
Rizzoli Publications
The Robin Hood Foundation
Roundabout Theatre Company
Scholastic
Sony
The Spence School
Stamford Center for the Arts
Stamford Museum & Nature Center
Starbucks
Sterling Publishing
Stone Barns Center for Food and Agriculture
Stora Enso
The Taunton Press
Texaco
Time Warner
Toys "R" Us
Turnstone
USA Networks
U.S. Green Building Council
Warner Bros. Records
Weekly Reader
Weight Watchers Publishing Group
WH Smith Ltd.
Worldstudio Foundation

Allemann Almquist & Jones

124 North Third Street, 2fl.
Philadelphia, PA 19106
215 829 9442
www.aajdesign.com

We have a simple philosophy: Connect with clarity. And we have been adhering to its principles as one of the East Coast's leading design firms for more than 23 years.

We work both in print and on the Web; marketing and corporate communications; corporate identity and branding.

Our clients include a broad range of large companies, start-ups and prominent not-for-profit organizations.

What unites them all is the desire to connect with their audiences through communications design that accurately reflects the personality and culture of their organizations.

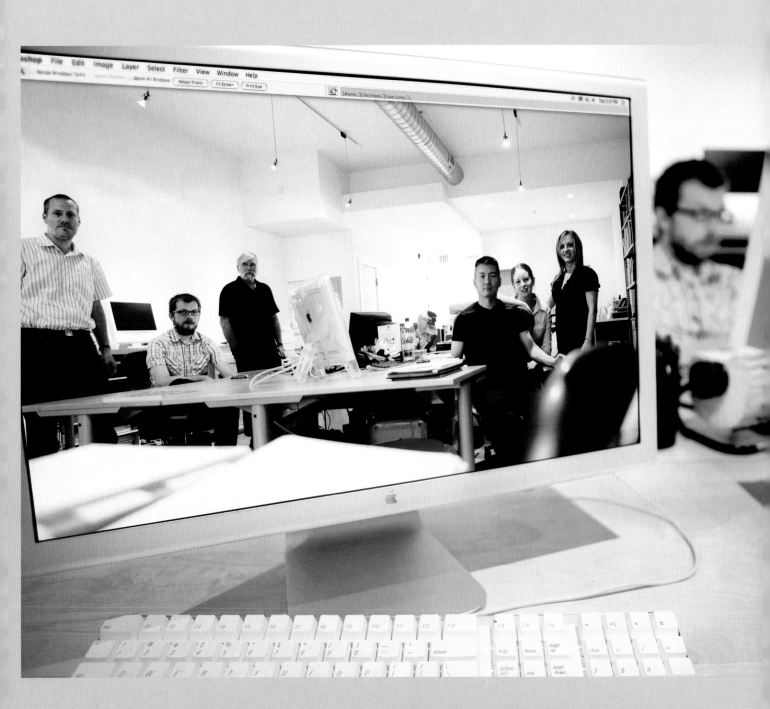

The
Franklin Institute

2006 Annual Report

TRANSFORMING

Executive Message
Science Museum
Center for Innovation in Science Learning
The Franklin Center
Financial Report
Leadership and Support
Board of Trustees

JUSTIFICATION	MISSION	IDENTITY	EXHIBITS	EVENTS	INTERACTION
PLUS	PERCEPTIONS	EXPECTATIONS	INTERESTS	THOUGHTS	LIFESTYLES
AUDIENCES	DEMOGRAPHICS	CHILDREN	TEENS	ADULTS	SENIORS
GROUPS	FAMILIES	TOURISTS	SCHOOLS	STUDENTS	TEACHERS
EVENTS	CURRICULA	ACTIVITIES	KNOWLEDGE	MINDS	LEADERSHIP

TRANSFORMING THE FUTURE

Today's Franklin Institute emerges renewed as the result of sustained planning, innovative programming, forward-looking, dedicated staff, and a committed Board of Trustees, all working in a disciplined approach toward the common goal of inspiring a passion for learning and discovery about science and technology.

What the Institute had accomplished in the past several years—in exhibits, school partnerships, museum programs, community outreach, and liaisons with the scientific community—prepared it for the new ventures upon which it embarked in 2006 and foreshadows horizons for the future.

EVOLVING

THE SCIENCE MUSEUM

To the outside world, 2006 may have been the year of *Body Worlds*, but inside The Franklin Institute Science Museum, it was a year of strengthening ties to its existing community and expanding connections to heretofore under-served audiences—all driven by significant innovation in programming.

IMS
Intelligence.360:
Global Pharmaceutical Perspectives
Brochure

HARBINGERS *of* CHANGE

As generics manufacturers grow more aggressive, will branded companies follow suit by deploying thorough patent strategies—and crack legal teams? Will government efforts in Japan finally bring cancer out of the shadows, boost early detection and treatment, and spur oncology sales? Will the adoption of intellectual property rights drive pharma growth in India and help push the country to the top tier of global economic powers? In the following pages, we cover developments—some of them flying beneath the radar—that could have major implications for pharmaceutical companies down the road. We'll also explore how last year's harbingers indeed presaged significant trends, from the rise of patient activism to the fall of innovation in primary care.

the NUMBERS

Where did the industry see the most growth (or lack of it) in 2006? Which therapy classes are now on top—and what, for the moment, are the world's leading brands? Which products achieved blockbuster status, and which began to lose their lustre? And what new chemical entities gained approval and made their market debut? In a fast-changing business, the numbers this year reveal transition on every front, from the growing importance of emerging markets to the rise of specialist driven drugs. On the following pages, we offer a snapshot of global pharma from different perspectives, covering regions, classes, companies, brands and levels of patent protection by market.

There's no proven formula for a smart business decision.

But the right mix of information, analytics and consulting will give you the insight to make the right move.

IMS. Intelligence. Applied.

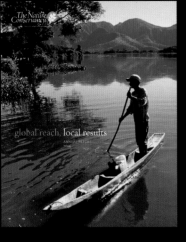

global reach, local results
ANNUAL REPORT

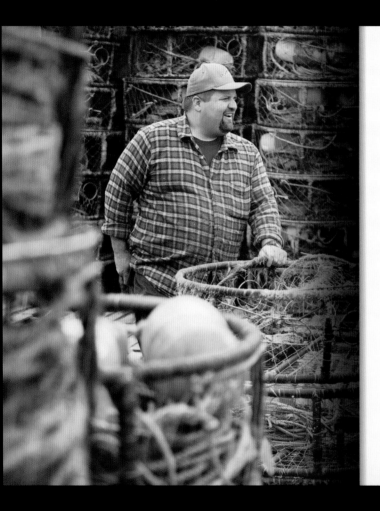

pioneer
fisherman

Geoff Bettencourt is the fourth generation in his family to fish the waters off California's central coast. He's fished any number of ways, including trawl fishing. With trawl fishing, fishermen drag weighted nets along the ocean's bottom, capturing desirable commercial species—and everything else in the net's path. Bettencourt, however, has agreed to abandon trawl fishing and sell his permit to The Nature Conservancy as part of a new conservation approach. He will instead fish in more sustainable ways that he hopes will be equally profitable. By making this change, he's risking both his financial future and his reputation. Bettencourt is a pioneer among his fellow fisherman and his next move is being watched with great interest in this tight-knit community.

● MARINE **Central Coast of California**

California's offshore banks, kelp beds and underwater canyons sustain a dazzling array of species, including seabirds, seals, dolphins, whales and tuna.

In a recent fishing season, West Coast trawlers landed 50 million pounds of target groundfish and discarded 46.6 million pounds of "by-catch."

The trawler-buyout program is one innovative strategy among many that the Conservancy's Global Marine Initiative uses to benefit marine life and local economies.

Geoff Bettencourt

27

The Nature Conservancy
Global Reach, Local Results
Annual Report

protecting the world's oceans

*Saint Joseph's University
Comprehensive Institutional
Identity System*

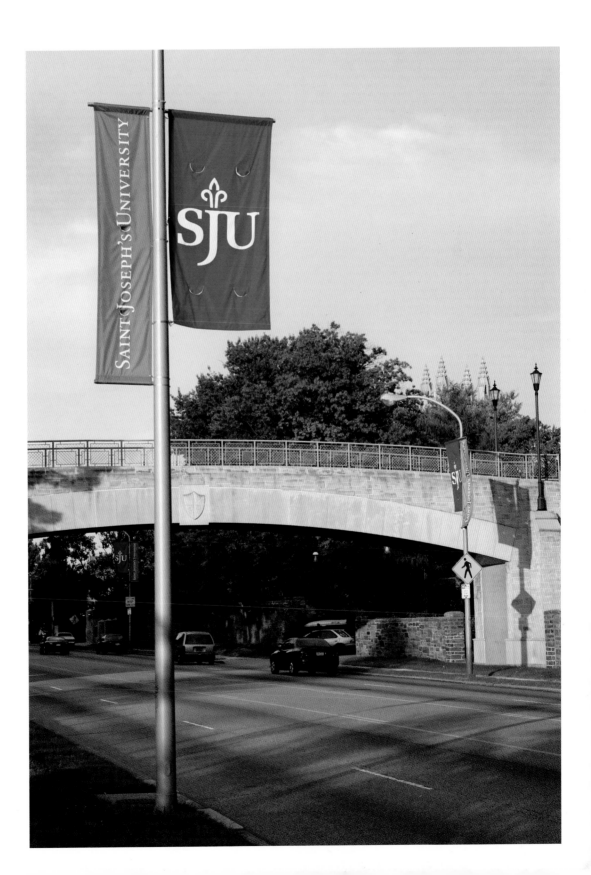

Verizon Communications
Annual Report
Print and Online Versions

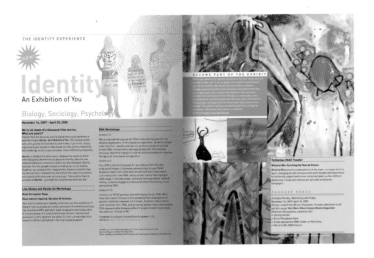

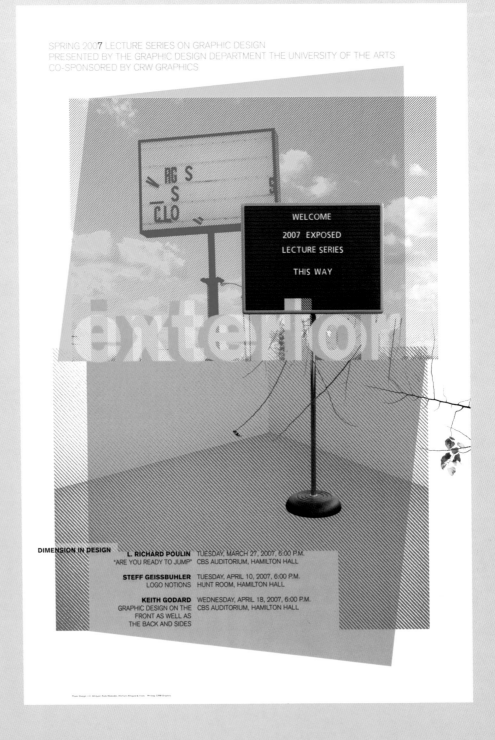

SPRING 2007 LECTURE SERIES ON GRAPHIC DESIGN
PRESENTED BY THE GRAPHIC DESIGN DEPARTMENT THE UNIVERSITY OF THE ARTS
CO-SPONSORED BY CRW GRAPHICS

WELCOME

2007 EXPOSED

LECTURE SERIES

THIS WAY

exterior

DIMENSION IN DESIGN

L. RICHARD POULIN　TUESDAY, MARCH 27, 2007, 6:00 P.M.
"ARE YOU READY TO JUMP"　CBS AUDITORIUM, HAMILTON HALL

STEFF GEISSBUHLER　TUESDAY, APRIL 10, 2007, 6:00 P.M.
LOGO NOTIONS　HUNT ROOM, HAMILTON HALL

KEITH GODARD　WEDNESDAY, APRIL 18, 2007, 6:00 P.M.
GRAPHIC DESIGN ON THE　CBS AUDITORIUM, HAMILTON HALL
FRONT AS WELL AS
THE BACK AND SIDES

BND

14152 Jardin Avenue North
Minneapolis, Minnesota 55038
(612) 298-7599
www.bradnorrdesign.com
brad@bradnorrdesign.com

Brad Norr Design was founded in 1992 in Minneapolis, Minnesota. Great design town; great ad town; great music town; great arts town. Weather, not so much… you know the drill.

BND provides design solutions for a wide range of applications, including identity, brand-building, logos and marks, collateral, packaging, posters, book covers, environments, and interactive design. We work with clients large and small, in retail and b-to-b situations. We have no account people; clients work face-to-face with designers.

BND adheres to the principle that great design will stand out from the morass of images one encounters on a daily basis, and therefore, the client or product we represent will stand out. We believe in innovation and craftsmanship, in an honest working relationship with our clients, in nurturing the creative process through respect, honesty, and a sense of humor. We believe in positively impacting our world with our work. We believe design can solve problems; we believe design can be fun; we believe design can be art.

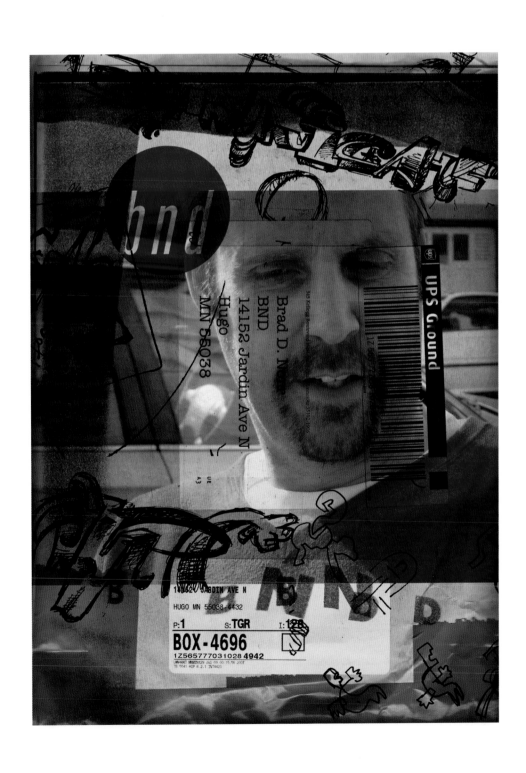

Book covers for University of Minnesota Press
(Opposite page) Logos for: 1 Big Ink Display Graphics; 2 Creative Metrics Consulting; 3 Good Egg Books;
4 LIFE-FM; 5 Private label for Twill by Scott Dayton, fine menswear; 6 Minnesota Vein Center; 7 FirstPerson
Interior Design; 8 Quadriga Builders Insurance; 9 "Transforming the Powers" Book Promotion; 10 O$_2$ Rainwear;
11 SpringBoard Software; 12 Trio Bookworks

1

CREATIVE METRICS

2

g

3

Life
97.3 fm | KDNW

4

5

MINNESOTA
VEIN CENTER

6

first person
design

7

QUADRIGA®

8

9

10

SpringBoard

11

TRIO
BOOK WORKS

12

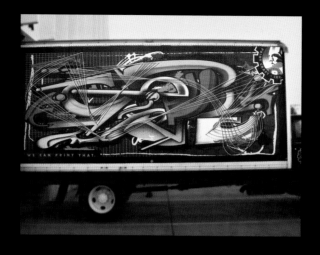

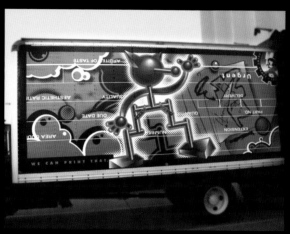

Original art for Print Craft trucks
(Opposite page) Poster series for
Print Craft

Limited edition posters
(Top) "Regarding the Future"
(Above) "Reclining Nude"

BND environmental poster

*(Top and bottom) Posters for JobDig, an employment media company
(Center) BND promotional book*

BRADY COMMUNICATIONS

Sixteenth Floor
Four Gateway Center
Pittsburgh, Pennsylvania
15222-1207 USA

Office: 412.288.9300
Facsimile: 412.281.8794
Web: bradycommunications.com

 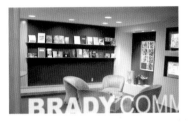

The difference between good communication and great communication is the power of discernment: keen insight into your marketing goals and good judgment on the right message and creative to help you meet them.

Helping you go farther…
takes someone who thinks further.

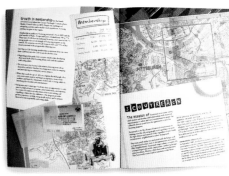

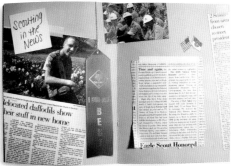

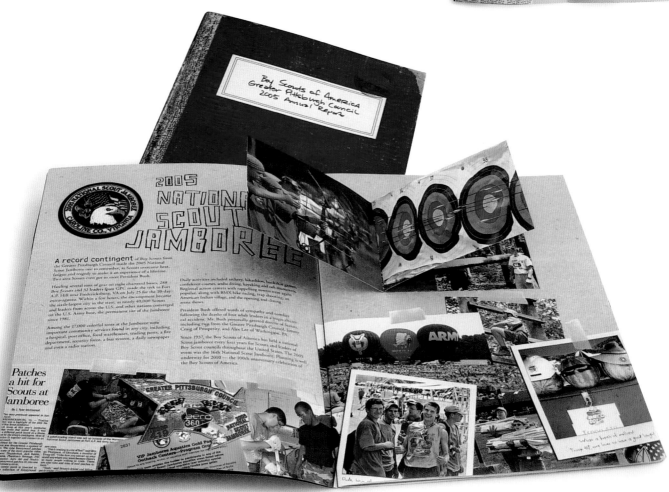

001 Project: Greater Pittsburgh Council Boy Scouts of America Annual Report

To chronicle a year filled with triumphs, the Greater Pittsburgh Council Boy Scouts of America 2005 Annual Report took the form of a scrapbook. Complete with a timeworn look and an interactive layout, the report appeared to have been carried in a scout's backpack for the report year.

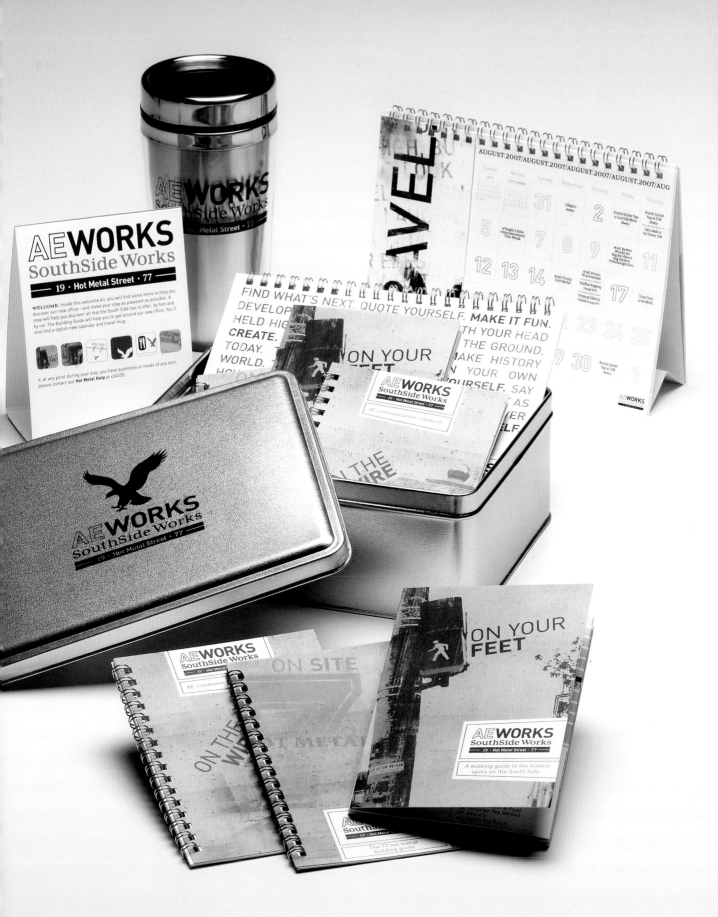

002 Project: American Eagle Outfitters, Inc. Welcome Kit

When American Eagle Outfitters, Inc. (AE) moved its headquarters, the company wanted to do something out of the ordinary to ease the transition for employees. On the first day in their new offices, AE's employees found welcome kits on their desks that included custom-designed area maps showcasing points of interest; guides to the new building; theater, movie and dinner coupons from neighboring businesses; calendars depicting relevant company and community events; and more.

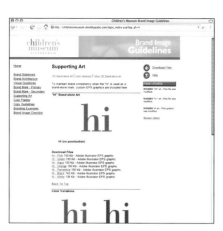

003 Project: Children's Museum of Pittsburgh Identity Development

After updating its exhibits and facilities through a major expansion project, the Children's Museum of Pittsburgh decided to revamp its brand identity to match the new digs. A simple and friendly new logo called out the hidden "hi" within "children's" and served as a basis for applying the brand to marketing and promotional materials.

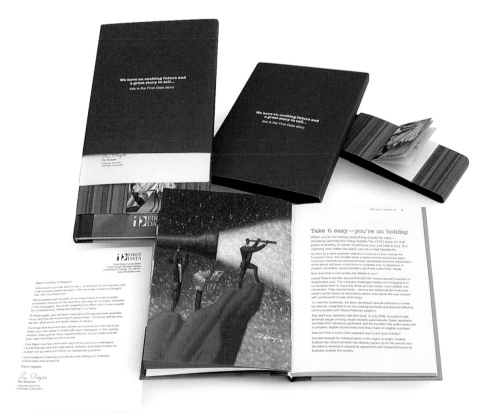

004 Project: Mylan Laboratories Annual Report

Using "MY" as the central design and copy element for their 2006 annual report, Mylan Laboratories provided insight to shareholders through a guided tour of Mylan's vision, consumers, healthcare customers and employees.

005 Project: The First Data Story

After a major reorganization, First Data wanted to tell the company's unique story to its employees. A hardbound book titled *Straight Talk* engaged readers immediately with a compelling headline: "We have an exciting future ahead and a great story to tell...this is the First Data story." Delivered to 29,000 employees worldwide in six different languages—all on the same day—the book communicated the values and mission of the global company and reaffirmed the bright future ahead.

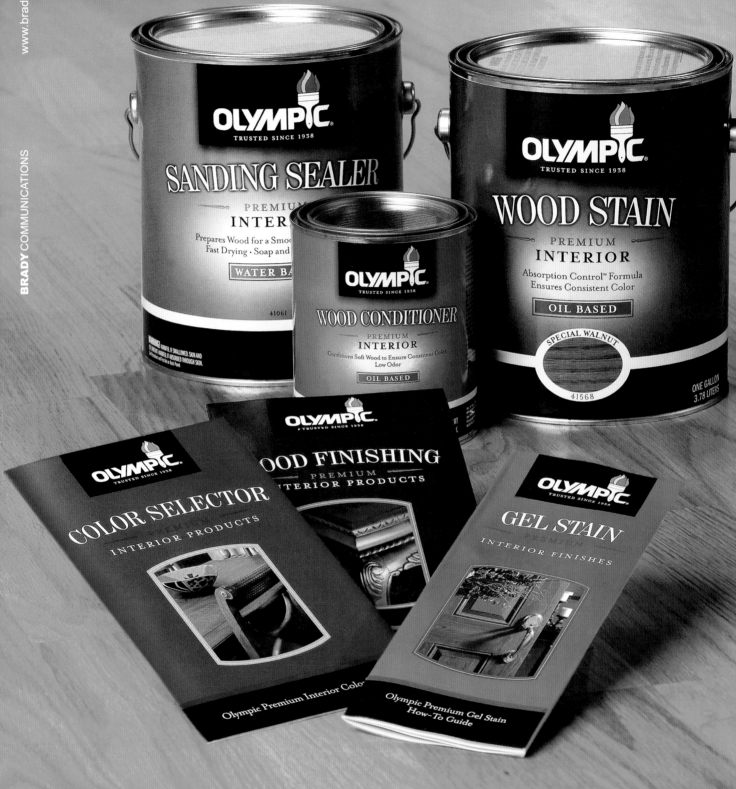

006 **Project:** Olympic Stains Packaging and POS Campaign

To create in-store excitement and to communicate superior quality to customers, Olympic by PPG enlisted the help of consumer focus groups. The resulting customer input provided a basis for the creation of a new packaging line and coordinating POS materials that employed rich metallic colors and a craftsman-like touch. The materials made a definitive statement on-shelf and in-store, conveying Olympic as the premium, trusted interior stain.

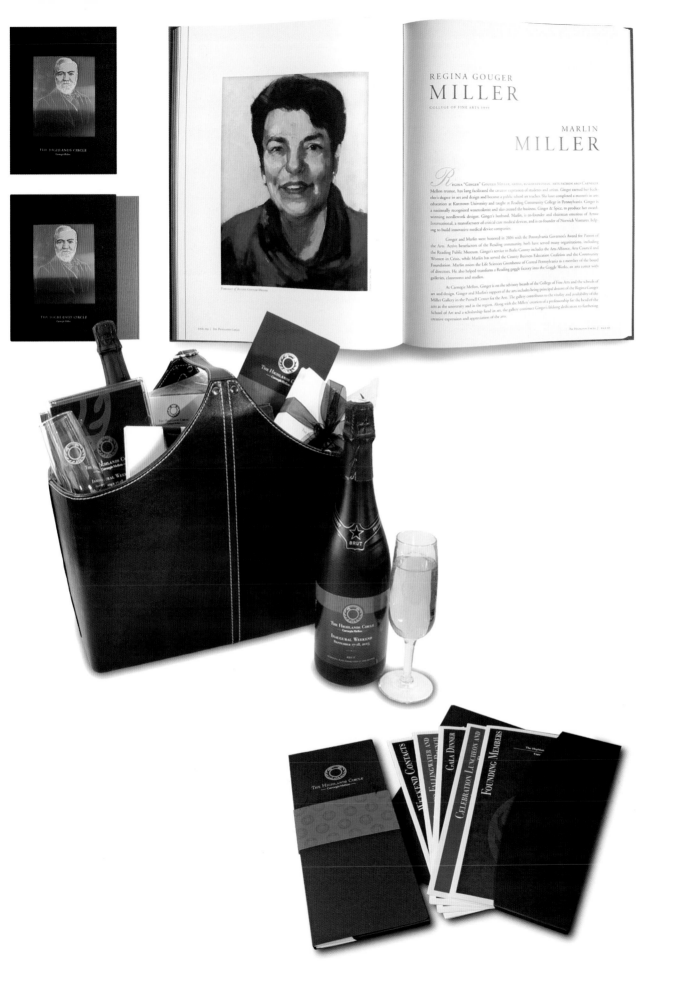

007 Project: Carnegie Mellon University Highlands Circle Promotional Materials

To thank high-level benefactors, Carnegie Mellon University (CMU) created The Highlands Circle, an exclusive membership society. The new program required a complete identity solution. Reflecting the heritage of the university's founders, the logo combined the Scottish thistle with the CMU mark. Deluxe leather gift totes contained a champagne bottle with custom labels, champagne flutes with engraved logos, an informational DVD, society stationery, a branded chocolate bar and much more. Additionally, CMU spotlighted Highlands Circle members in a hardbound book complete with artists' renderings of each benefactor.

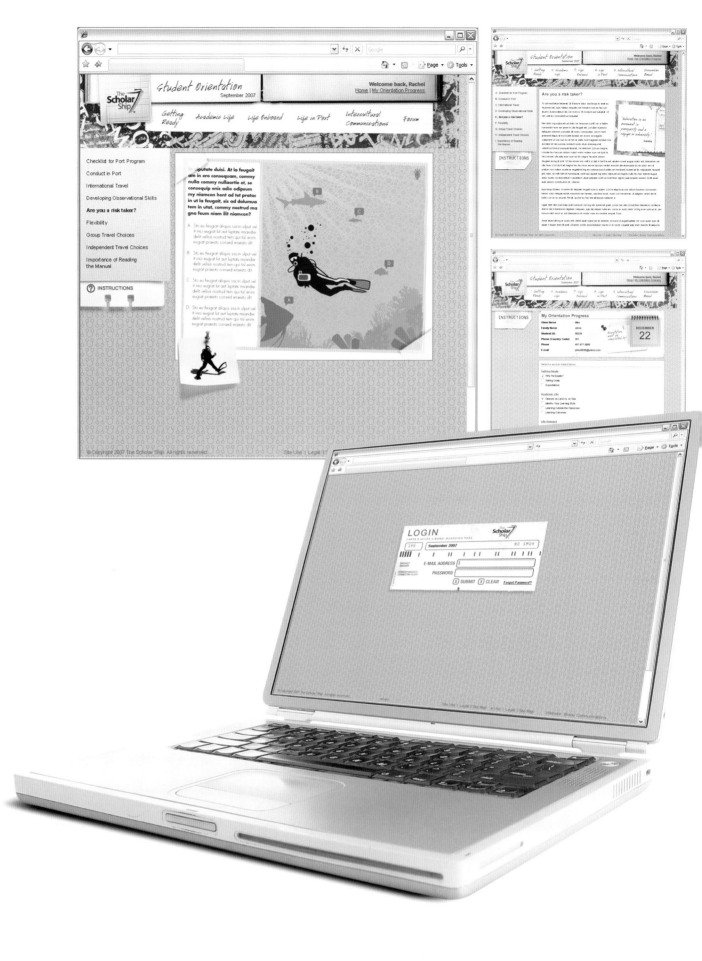

008 Project: The Scholar Ship Student Orientation Web Site

The Scholar Ship needed an interactive online hub where student participants could prepare for the organization's innovative, semester-long academic program aboard a dedicated passenger ship that roams the globe as an oceangoing campus. The online orientation program—designed to mimic a travel journal with imagery of postcards, boarding tickets and souvenirs—provided information and Flash-based learning games to help students develop the necessary skills, attitudes and behaviors for effective interaction onboard and in-port.

BROWN463
303 east pine street seattle, washington 98122
206.587.0050
www.brown463.com

We are an award-winning, multidisciplinary design firm that helps companies connect
with their customers by communicating a clear, compelling message through innovative design.
Our portfolio includes branding, corporate identity, annual reports, marketing collateral, web sites,
packaging, advertising, and promotional pieces for clients ranging from well-established brands,
to start-ups and non-profits.

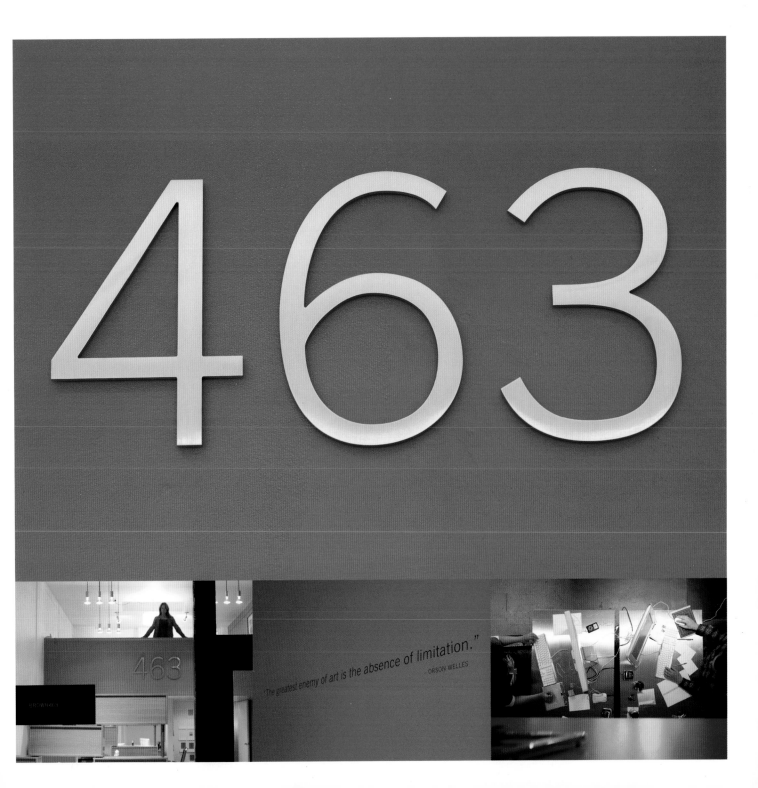

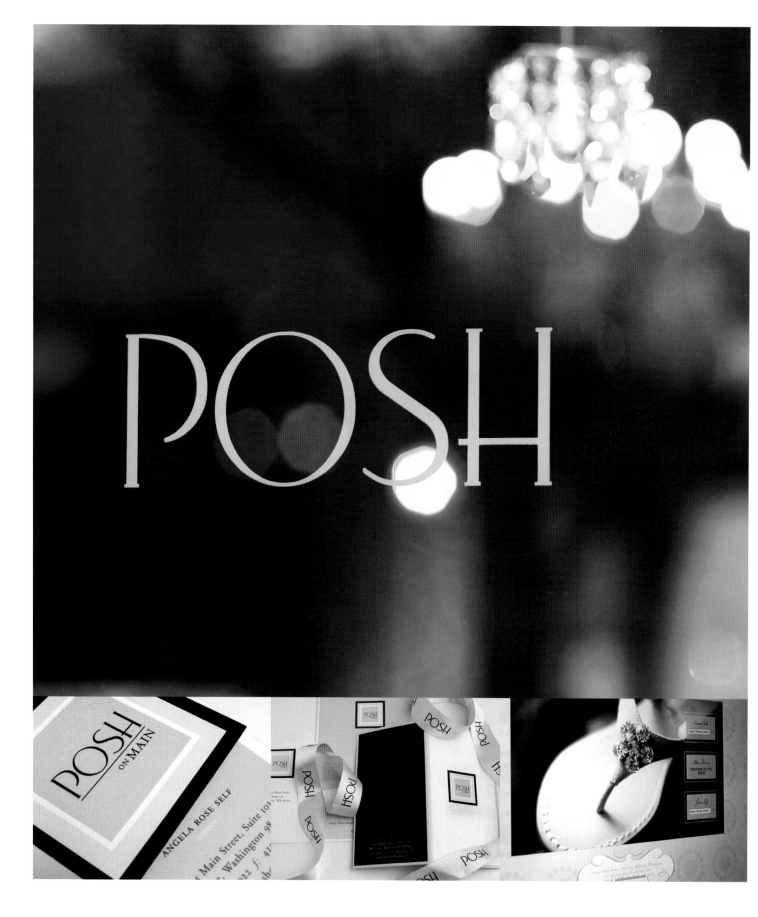

POSH ON MAIN

With rare varieties of designer shoes (usually only found in NY or Paris)
this instantly successful destination is located in Bellevue, Washington. Logo extension
included stationery package, signage, advertising, retail packaging and web site.
Winner of Seattle Magazine's Best New Shoe Store, 2006.

LA REE BOUTIQUE
Located in Bellevue, Washington, La Ree is an upscale women's designer
clothing and accessories boutique. We are responsible for the logo,
stationery package, custom shopping bags, ribbon, signage,
advertising, as well as general marketing.
Winner of Seattle Magazine's Best New Clothing Store, 2007.

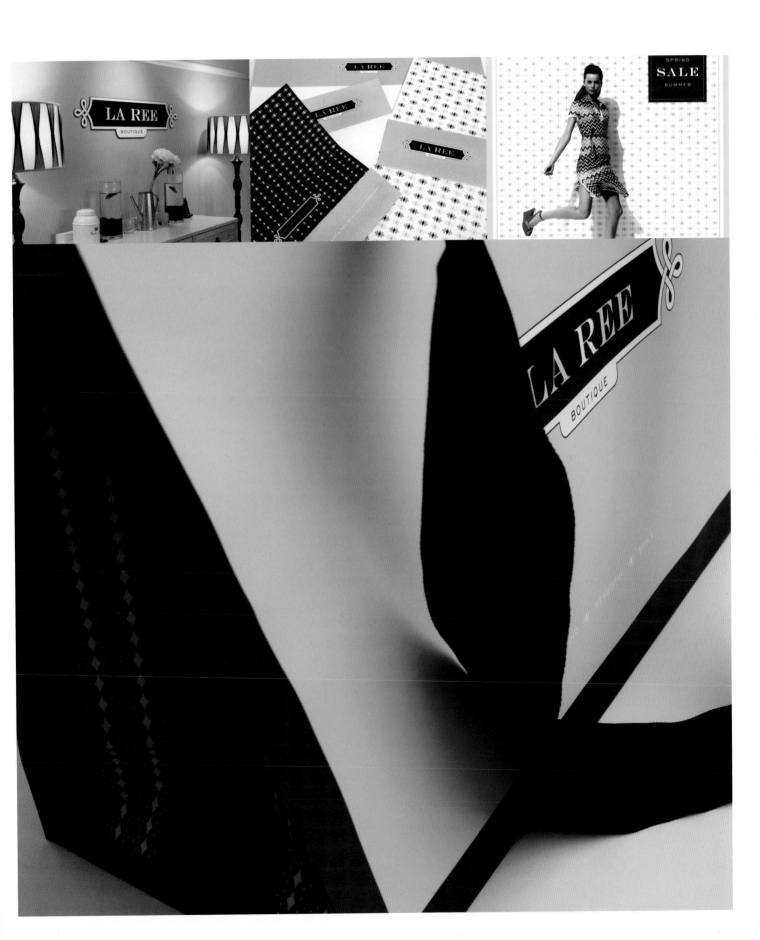

JEFF CORWIN PHOTOGRAPHY
Designed to stand out from the crowd, this 36" x 23" promotional piece
showcased Jeff's little-known personal work (landscapes),
interlaced with his well-known corporate work. Sent out in a custom stay-flat,
this promo resulted in various new (including landscape) projects for Jeff.
Winner of HOW Magazine's Self Promotion Annual, Outstanding Photographer's Promotion.

OUR BUSINESS PRINCIPLES.

• Our client's interests come first in everything we do.

• We take great pride in the professional quality of our ... to be the best.

• We respect the confide...

BEL AIR INVESTMENT ADVISORS

Bel Air is known for their leadership in providing money management
exclusively for wealthy individuals, families and foundations.
A client for over 10 years, we are responsible for naming, logo generation,
advertising, multiple capability packages, as well as their web site.

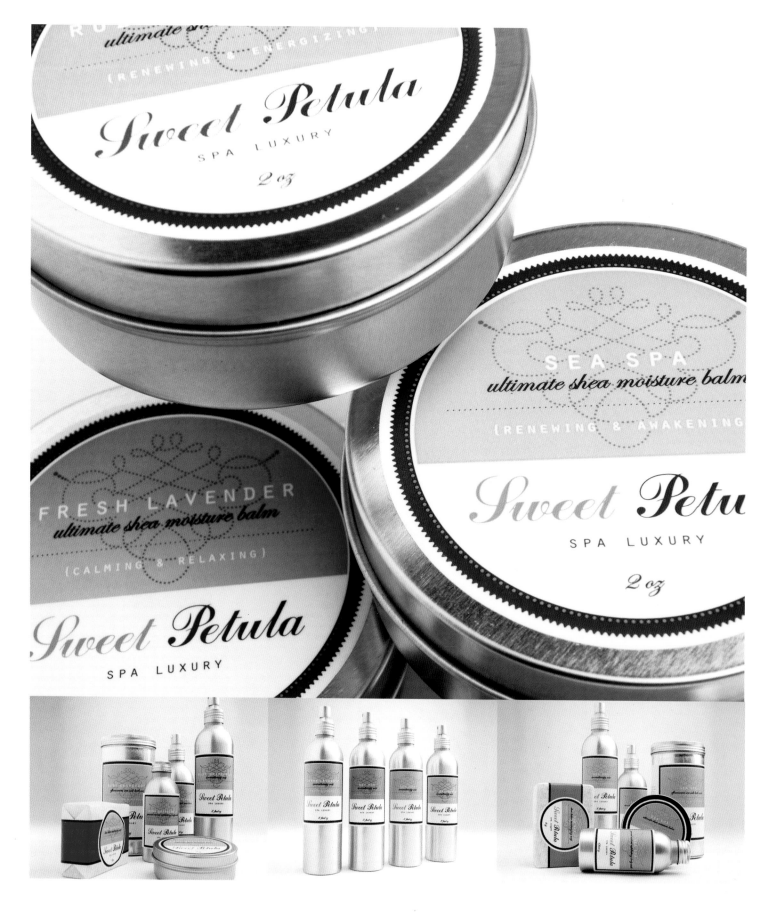

SWEET PETULA

Sweet Petula needed packaging for their high-end line of beauty products
we named, "Spa Luxury." With four unique flavors and nine products of each,
the new, ornately designed metal containers are now the driving graphics
for the store and it's overall branding.

GOOD CLEAN DOG
Sweet Petula created a beauty product line specifically for dogs
and the packaging was based on the owner's pet, Arlo. Gift boxes were designed
when Anthropology decided to sell select products for their holiday season,
as well as in-store signage, sales brochures and web site.

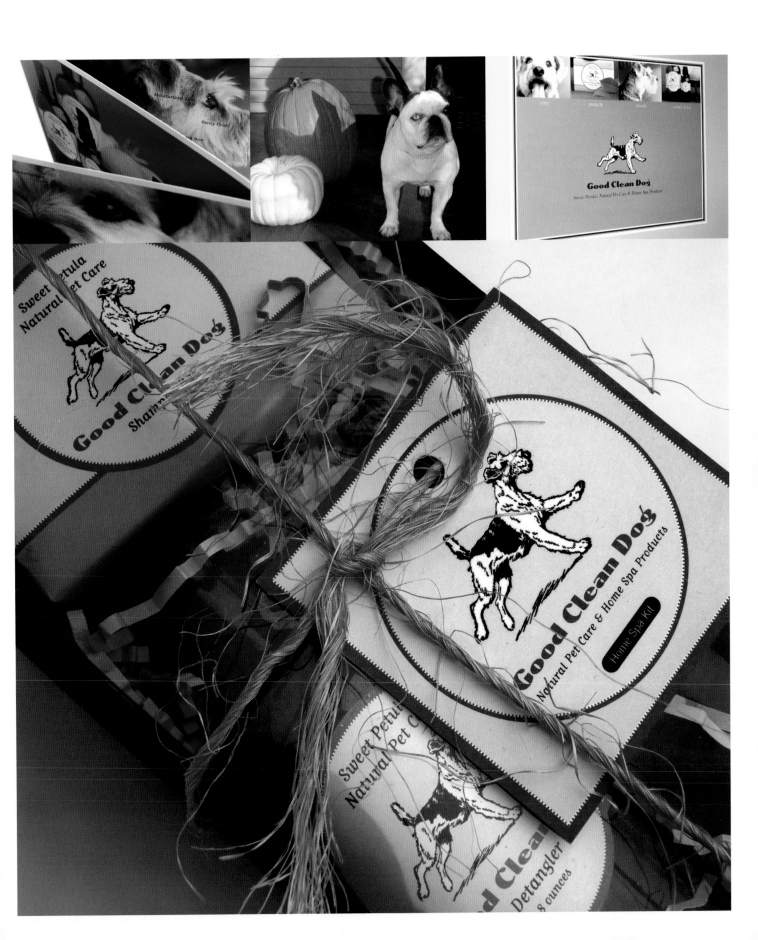

Digital Realty focuses on properties designed to meet the demanding
technology requirements of today's corporate enterprises; including power capabilities,
data security, and disaster recovery. We have worked with DLR since
it's IPO and have designed their annual reports as full-spectrum branding pieces.
The concept for the annual below is "Real Estate for the Virtual World" which utilizes a variety
of papers (including transparent), uses foil stamping and conventional printing.

116 East 16 Street
New York, NY 10003
212.532.4460
www.cgpartnersllc.com

Partners
Steff Geissbuhler
Keith Helmetag
Emanuela Frigerio
Jonathan Alger

Associate Partners
Maya Kopytman
Scott Plunkett
T. Kevin Sayama
Amy Siegel

C&G Partners focuses on work in media, the arts and public spaces.

The firm's wide-ranging portfolio includes print graphics and identities, exhibitions and environments, signage and wayfinding systems, and interactive and web projects.

C&G Partners was founded by Steff Geissbuhler, Keith Helmetag, Emanuela Frigerio and Jonathan Alger. The partners' cumulative history includes the creation of some of the world's most recognizable experiences, images, spaces and icons.

C&G Partners take its name from the abbreviation of Chermayeff & Geismar Inc., the pioneering design firm where the four founders met and collaborated for decades before launching the current firm in 2005. Widely recognized as leaders within the design industry, the people of C&G Partners are the recipients of nearly every award bestowed by the profession.

In 2005, Steff Geissbuhler was awarded the Gold Medal of the American Institute of Graphic Arts. In 2006 Jonathan Alger was named President of the Society for Environmental Graphic Design. In 2007, the firm was a Finalist for the National Design Award, given by the Smithsonian.

C&G from A to Z

This list, A to Z, is a salute to all the clients who have put their faith in us. Without their support and collaboration, we would be nothing. The images on these pages are just from projects completed since 2005. The clients listed derive from that time and earlier.

Abrams Books
Academy for Educational Development
Active Aging Association
ADVO

- AIGA
Alvin Ailey American Dance Theater
American Chemical Society
American Cinema Editors

- American Council of Learned Societies
American Express

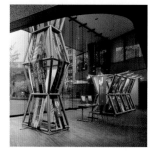

- American Institute of Architects
Andrews McMeel Universal
Andrus Children's Center

- Art Directors Club
Artear Argentina
Autry National Center
Bank of America
Barneys New York

- Baruch College
Battery Park Conservancy
Beyer Blinder Belle
Binghamton Visitor Center
Birmingham Museum of Art
Bond Market Association
Boston Computer Society

- Boston Public Library
Brearley School

- Broadcasting Board of Governors
Bronx Zoo
Brooklyn Botanical Gardens

- ByKids
Cablevision

CALAMOS

- Calamos Investments
 CARE
 Castle at Tarrytown

- CBS
 Centro de Convenciones de Cartagena
 Charles Square Hotel

- Chelsea Garden Center
 Children's Museum of Manhattan
 City University of New York
 Columbia Graduate School of Journalism
 ConEdison
 Conrad Hotels
 Cook+Fox
 Cooper, Robertson and Partners
 Corcoran Gallery of Art

- Crane & Co.
 Cummins
 Darien Library
 Davis Brody Bond Aedas

Deafness Research Institute
Don Q
Durst Organization

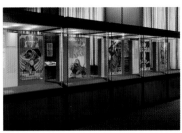

- Elmer Holmes Bobst Library
 Engraved Stationery Manufacturers
 ERA Real Estate

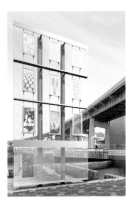

- Erie Canal Harbor District

+Esposito
+Emr

- Esposito+Emr
 Estée Lauder
 FactSet Data Systems
 FDR Visitors Center
 Federal Reserve Bank of Atlanta
 FEED Magazine
 Festival of the Arts
 Filene's
 Financial Times

- Flushing Freedom Mile
 Fort Worth Art Museum
 Foster+Partners

- G.J. Haerer
 Gannett/USA Today
 Genoa Aquarium
 Gensler

- Good Housekeeping*

- Greenwing Honda

- Griffith Observatory
 H3 Hardy Collaboration Architecture

- Hearst Corporation*
 Hecht's
 Heinz National Wildlife Refuge
 Henry Miller's Theater
 Heritage Trails New York
 Heyman Properties
 Hillier Architects

HOK Sport Venue Event
Hotel MIA
Hypertherm
Ibex Wear
IBM
Index Casting

- Index Corporation
 Infineer
 Innerplan
 Insignia
 Integrated Living Communities

- Irwin Financial
 Jack Morton Worldwide

- Japanese American National Museum

- Javits Federal Building and Courthouse
 JCDecaux
 Jean-Paul Viguier S.A. d'Architecture
 JVP
 JFK International Airport
 Joffrey Ballet
 John F. Kennedy Presidential Library
 JP Morgan
 Katonah Museum of Art
 Knoll

- Kyorin

LA Department of Parks and Recreation
LA Public Library
Levin & Associates
Library of Congress
Lincoln Center for the Performing Arts
Lincoln Square BID
Liz Claiborne
Logan International Airport
Marubiru
Maryland State House

- McNay Art Museum
 Mercedes Benz
 Merck
 Mercy Corps
 mercyFirst
 Metropolitan Transit Authority
 Miami International Airport
 Minneapolis Institute of Art
 Mississippi State History Museum
 Morehead Planetarium and Science Center
 Morgan Stanley

- National Center for the Preservation
 of Democracy
 National Geographic
 National Museum of American History
 National Oceanographic
 and Atmospheric Administration
 National Park Service

- mPress
 Multicanal
 Municipal Art Society of New York

- National Parks
 of New York Harbor Conservancy
 National Public Radio
 NBC

MU$EUM
OF AMERICAN
FINANCE

- Museum of American Finance
 Museum of Contemporary Art Los Angeles
 Museum of Modern Art

NASDAQ
TIMES SQUARE

- NASDAQ Times Square
 Nashua Corporation
 National Archives and Records Administration

- Neenah Paper

- Nemours Mansion and Garden
 Visitor Center

New 42nd Street
New Victory Theater
New York Hall of Science
New York Public Library

- New York University
 New York Yankees
 NYC Department of Parks and Recreation
 NYC Economic Development Corporation

- NYC Office of Emergency Management
 Overture
 PaineWebber
 Pearson
 Pei Cobb Freed
 Peter Freed Photography
 Pfeiffer Partners
 Phillip Morris
 Plantation House
 Polshek Partnership
 Prudential Financial
 Queens Museum of Art
 R.M. Kliment & Frances Halsband

- Radio Free Asia
 Radio Free Europe/Radio Liberty

- Rider University

Rio Algom
Robert A.M. Stern Architects

- Rockefeller Foundation

- Rookery Bay Estuarine Reserve
 Royal Bank of Scotland
 Royal Shakespeare Company
 Russell Estates
 Saratoga Associates
 Scholastic

- ShopWise

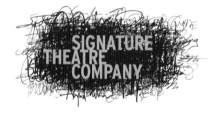

- Signature Theatre Company
 Singapore Discovery Center
 Singapore History Museum
 Singapore National Heritage Board
 Skidmore, Owings & Merrill
 Smithsonian Institution
 Sony Entertainment Television
 Sports Illustrated

- Starr Whitehouse

Telemundo
TIAA/CREF
Time Warner
Toledo Museum of Art
Torneos y Competencias
Towers Perrin
U.S. Environmental Protection Agency
U.S. Fish and Wildlife Service

• U.S. General Services Administration
U.S. Holocaust Memorial Museum

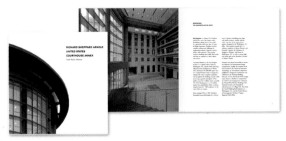

• U.S. Patent and Trademark Office Museum
Union Pacific Corporation

• University Club

• University of California, Los Angeles

University of Connecticut at Stamford
University of Maryland

• University of North Carolina
University of Pennsylvania
Univision
USAID

• Voice of America

VORNADO
CHARLES E. SMITH

• Vornado/Charles E. Smith
Washington Crossing Visitor Center
Washington Dulles International Airport
West Group
Wildlife Conservation Society

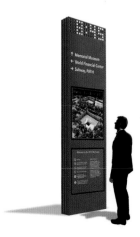

• World Trade Center Memorial Foundation

• Yankee Stadium
YMCA

* Initiated at Chermayeff & Geismar Inc. and
completed at C&G Partners.

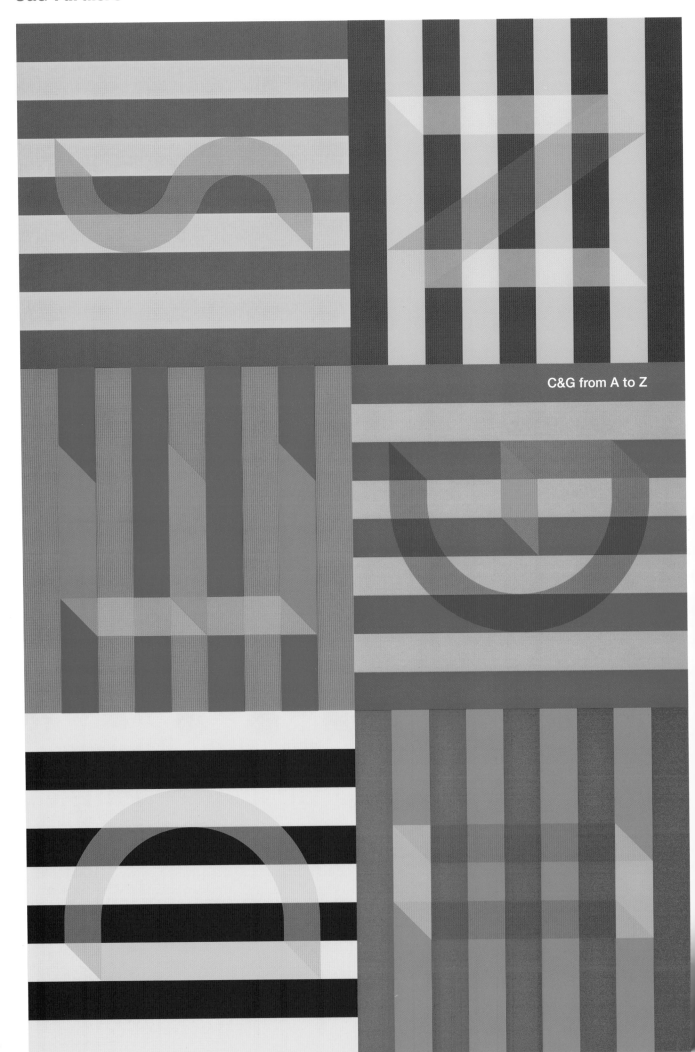

C&G from A to Z

Capstone Studios, Inc.

Capstone Studios, Inc.
One Technology, Suite I-801
Irvine, CA 92618
949.888.9911
www.CapstoneStudios.com
www.CapstoneStudiosInternational.com

Capstone's strategic, brand-savvy approach delivers unique, emotionally driven campaigns that set their clients' products and services apart from the competition. Capstone's greatest strength is their forward-thinking work process, which embraces current design trends and emerging technologies — often using nontraditional materials, methods, and media to achieve their goals.

Clients value Capstone's holistic, collaborative approach to marketing and their ability to leverage brands across multiple touch-points ensuring integrity, continuity, and consistency. Capstone's areas of expertise include print, web, multimedia, and environmental design; brand development and campaign planning.

With its roots in entertainment design and advertising, Capstone's work is infused with Hollywood excitement. Their work has been recognized by many prestigious organizations and publications, winning over 150 awards and honors, including: Belding, Key Art, and American Corporate Identity.

Capstone was founded in 1985 by Jo-Anne Redwood and partner John T. Dismukes and services clients in the entertainment, corporate, consumer, hospitality and real estate industries. Clients include Paramount Pictures, Universal Studios, RJR/Nabisco, Toshiba, Sony, Lennar Homes, Hyatt, Pulte/Del Webb, and AT&T.

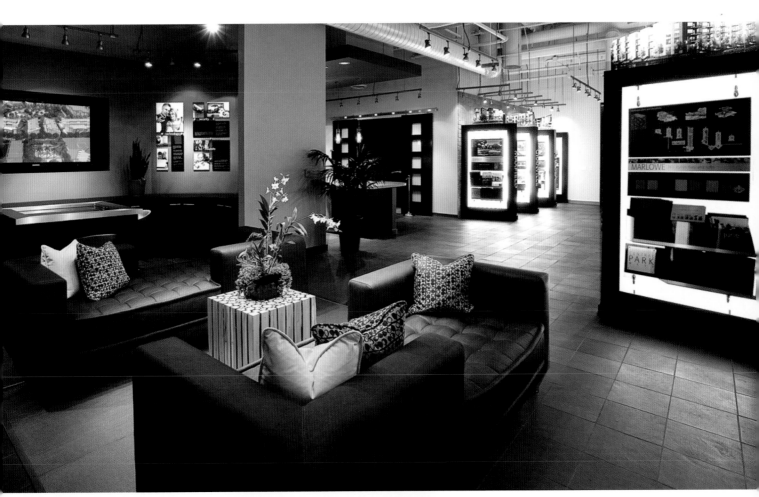

Lennar Homes
Central Park West Sales Center, Irvine, California

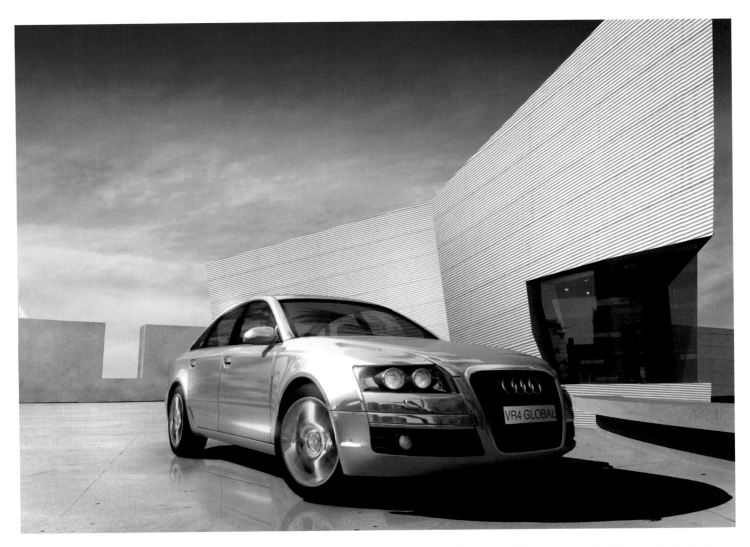

www.VR4GLOBAL.com

VR4 Global
Fast-paced Virtual Reality movie through Los Angeles

From left to right: Jacobs & Gerber · The Integer Group · Time Life · Dieste & Partners · Harley-Davidson

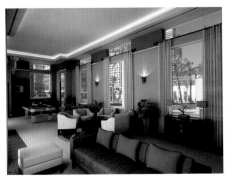

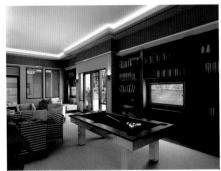

Pacifica, Lennar Homes *Pre-visualization, 3D Renderings*

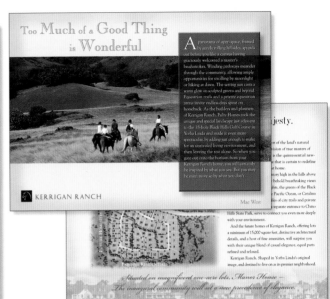

MANOR HOUSE

Too Much of a Good Thing is Wonderful

KERRIGAN RANCH

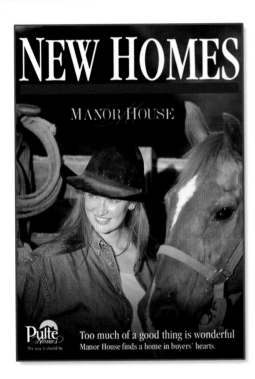

NEW HOMES

MANOR HOUSE

Too much of a good thing is wonderful
Manor House finds a home in buyers' hearts.

Pulte Homes
The way it should be

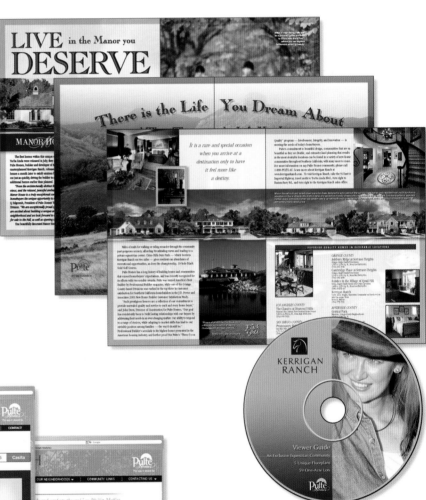

LIVE in the Manor you DESERVE

MANOR HOUSE

There is the Life You Dream About

It is a rare and special occasion when you arrive at a destination only to have it feel more like a destiny.

KERRIGAN RANCH

Viewer Guide
An Exclusive Equestrian Community
5 Unique Floorplans
59 One-Acre Lots

Pulte Homes

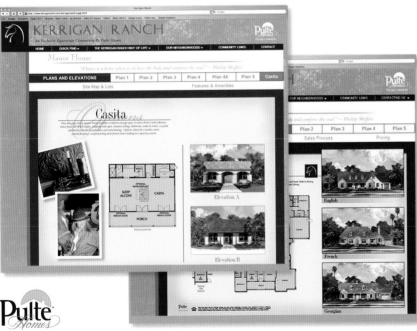

KERRIGAN RANCH
An Exclusive Equestrian Community By Pulte Homes

Manor House

PLANS AND ELEVATIONS | Plan 1 | Plan 2 | Plan 3 | Plan 4 | Plan 4X | Plan 5 | Casita

Casita

Elevation A

Elevation B

Plan 2 | Plan 3 | Plan 4 | Plan 5

English

French

Georgian

Pulte Homes
The way it should be

Kerrigan Ranch, Pulte Homes
*Residential development marketing collateral,
public relations, interactive presentation, website
and architectural renderings*

Toshiba America Business Solutions, Inc. Dealer Product Demonstration Kit · Product Launch Collateral

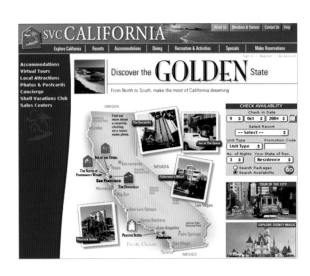

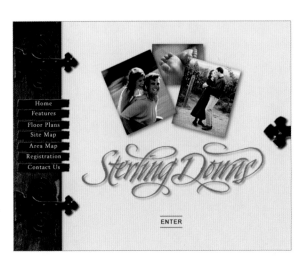

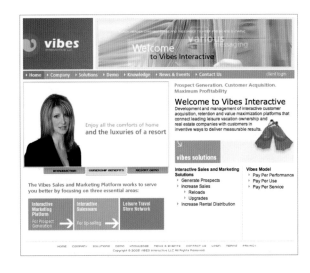

Shell Vacation Club *25 Portal and Resort Destination Sites*

Grimmway Management Company *Sterling Downs Residential Community*

Vibes Interactive *Vacation Ownership Website Design and Development*

The Art Rocks *Traveling Art Exhibition*

Encore Software · Ripcord Games · Atari

Franke+Fiorella
401 North 3rd Street, Suite 380
Minneapolis, MN 55401
612.338.1700
www.frankefiorella.com

Designing brand identities that help our clients succeed is our exclusive focus. Pure and simple. Since 1993 Franke+Fiorella has been creating brand and corporate identities for some of the largest organizations in the world – and some of the smallest as well.

3M COMPANY

3M needed to strengthen and unify its global brand presence. The new visual identity system features a flexible montage design that allows individual business units to express their own unique message while also communicating 3M's foundation of innovation and technology. A comprehensive set of online identity standards helps users apply the new look consistently.

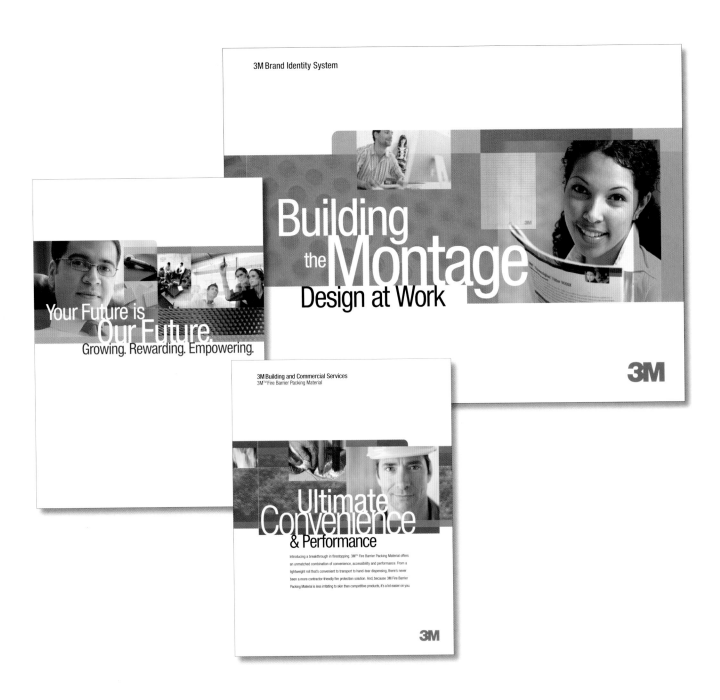

PROJECT SCOPE

IDENTITY SYSTEM DESIGN

ONLINE IDENTITY STANDARDS

A new identity for Cargill signaled change and was immediately embraced as a symbol of the future. The logo redesign preserved the strength of the Cargill name and the legacy of the previous mark. Online identity standards and a desktop reference guide were also designed to create engaging, easy-to-use reference tools.

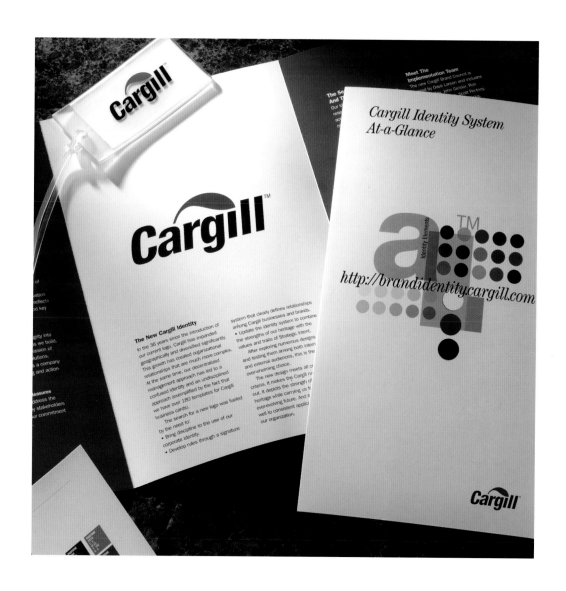

PROJECT SCOPE

CORPORATE IDENTITY

LOGO DESIGN

IDENTITY STANDARDS

INTERNAL COMMUNICATIONS

STATIONERY SYSTEM

SIGNAGE

A newly formed executive recruitment firm needed to carve a niche for itself in an already crowded market. With diversity as their focus, we redesigned their logo and developed a visual identity system to express their unique position. We then extended the system to their print collateral and website.

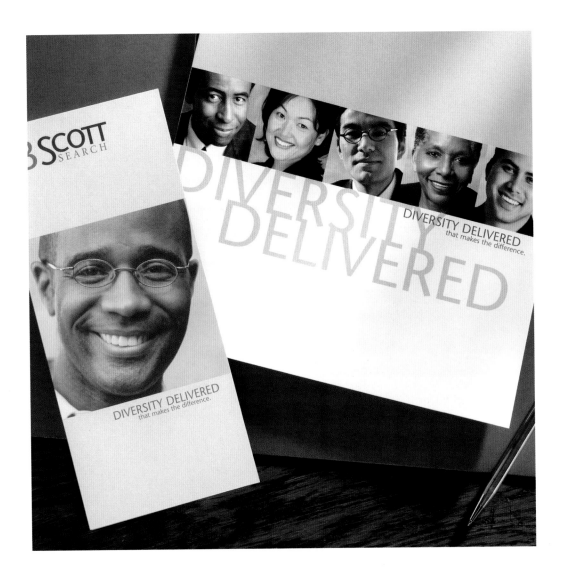

PROJECT SCOPE

CORPORATE IDENTITY

BRAND STRATEGY

LOGO DESIGN

STATIONERY SYSTEM

MARKETING COLLATERAL

WEBSITE

Children's Cancer Research Fund asked us to design the visual identity and promotional materials for the 26th Annual Dawn of a Dream® gala. The invitation set the tone with its playful design emphasizing rich textures, intricate shapes and a butterfly—a symbol of hope. The look of the collateral was integrated into all communications as well as the gala décor.

CHILDREN'S CANCER RESEARCH FUND

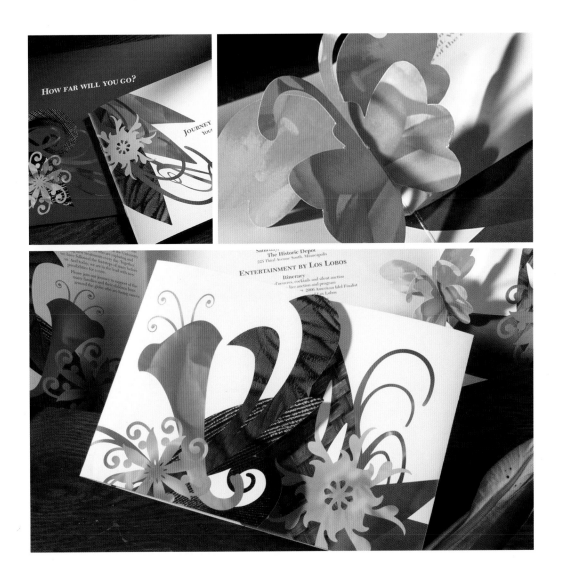

PROJECT SCOPE

VISUAL IDENTITY
PRINT COMMUNICATIONS
PRINT AD

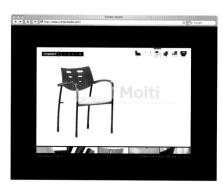

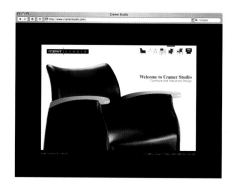

Cramer Studio, an award-winning industrial design firm, turned to Franke+Fiorella for brand identity design, including the design of its logo. We recently redesigned their website to showcase the studio's latest work and position Cramer Studio as a leader in the marketplace. Bold, simple imagery conveys the style and function of the studio's work.

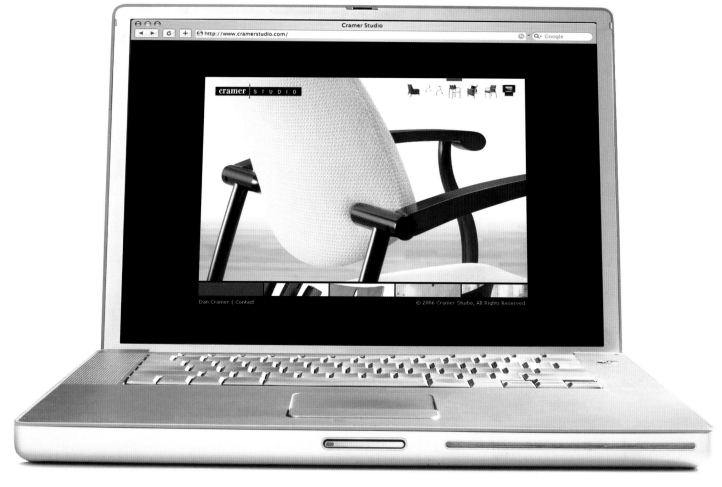

PROJECT SCOPE

CORPORATE IDENTITY

LOGO DESIGN

WEBSITE

DIRECT MAIL CAMPAIGN

When two major organizations merged to form a $5 billion public crop nutrition company, the challenge was to position the company as a global leader. The logo reflects the diversity of the world's farming regions by representing fields in various stages of growth. Launch communications were designed with global appeal and translated into local languages.

PROJECT SCOPE
CORPORATE IDENTITY
LOGO DESIGN
IDENTITY STANDARDS
LAUNCH COMMUNICATIONS
CAPABILITIES BROCHURE
WEBSITE
INTRANET

Franke+Fiorella
401 North 3rd Street, Suite 380
Minneapolis, MN 55401
612.338.1700
www.frankefiorella.com

Below are some of the logos we have designed for our clients and their brands.
For more information, visit us at www.frankefiorella.com.

Gee + Chung Design
38 Bryant Street, Suite 100
San Francisco, CA 94105
415.543.1192
earl@geechungdesign.com
www.geechungdesign.com

Gee + Chung Design is an award-winning multidisciplinary design firm with an international reputation for exceptional design that is instantly recognizable for its innovation, creativity and value for clients. Founded by Partners and Creative Directors Earl Gee and Fani Chung, the firm specializes in discovering what is truly unique about their clients to create strategic brand differentiation that sets them apart from competition. The firm's wide range of concept-driven solutions reflects their clients' unique personalities and individual messages. Having many technology-oriented clients, Gee + Chung Design excels at making complex new ideas understandable, meaningful and memorable to audiences. The firm's uncommon versatility in branding, print, environmental and web design allows them to build powerful, cohesive brands across all media. While Gee + Chung Design has received many prestigious awards for their work, their real reward lies in creating lasting client value and helping companies succeed beyond their expectations.

Capabilities: Branding, Identity, Collateral, Annual Reports, Books, Packaging, Exhibits, Environmental Graphics, Websites

Clients: Adobe Systems, Apple, Applied Materials, Chronicle Books, Federal Reserve Bank, IBM, Lucasfilm, Oracle, Sony, Stanford University, Sun Microsystems, Symantec

Awards: Graphis, Communication Arts, I.D., Print, American Institute of Graphic Arts, Art Directors Club, Type Directors Club, Society of Typographic Arts, Society of Publication Designers, Society for Environmental Graphic Design

Collections: United States Library of Congress, Smithsonian Institution, AIGA Archives, Art Center College of Design Archives, San Francisco Museum of Modern Art

Education: Earl Gee: BFA with Distinction, Art Center College of Design; Fani Chung: MFA, Yale University

Branding

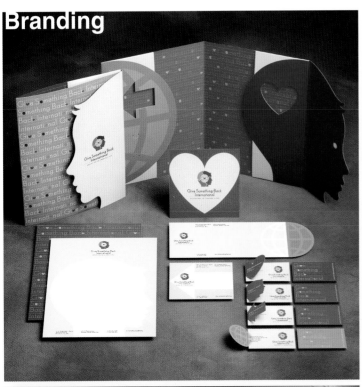

Collateral

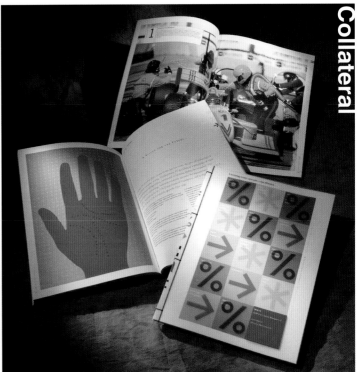

Packaging

Exhibits

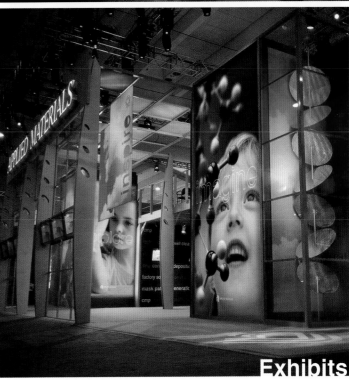

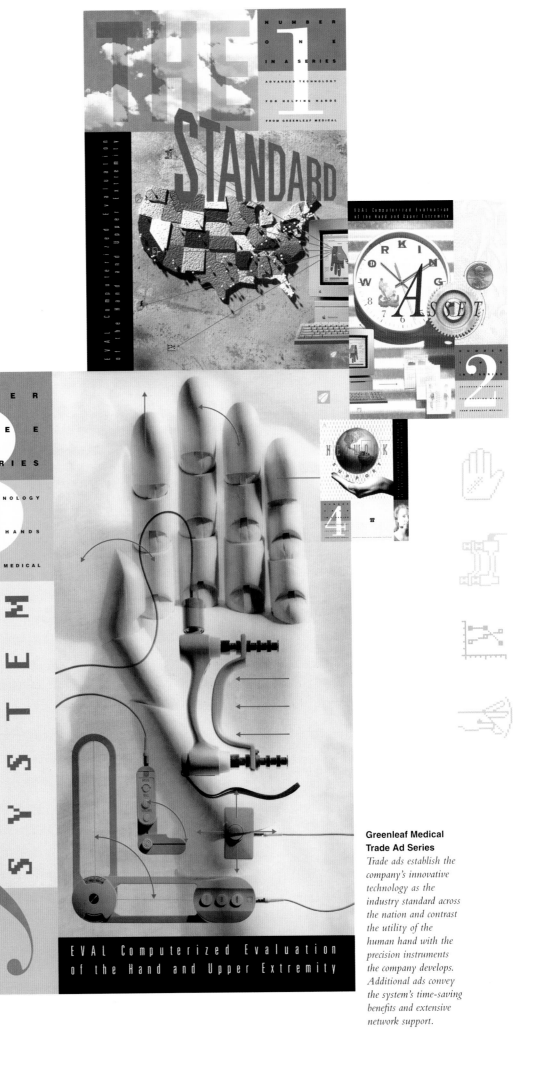

Design for Medical Technology
Greenleaf Medical develops a pioneering computerized hand evaluation system for hand surgeons which provides unparalleled precision and accuracy in medical documentation. Our comprehensive branding and collateral program has enabled the startup company's technology to become the accepted standard in the industry.

Greenleaf Medical Trade Ad Series
Trade ads establish the company's innovative technology as the industry standard across the nation and contrast the utility of the human hand with the precision instruments the company develops. Additional ads convey the system's time-saving benefits and extensive network support.

THE
NUMBER ONE IN A SERIES
ADVANCED TECHNOLOGY
FOR HELPING HANDS
FROM GREENLEAF MEDICAL
1
STANDARD
EVAL Computerized Evaluation of the Hand and Upper Extremity

NUMBER THREE IN A SERIES
3
ADVANCED TECHNOLOGY
FOR HELPING HANDS
FROM GREENLEAF MEDICAL
Precision
SYSTEM
EVAL Computerized Evaluation of the Hand and Upper Extremity

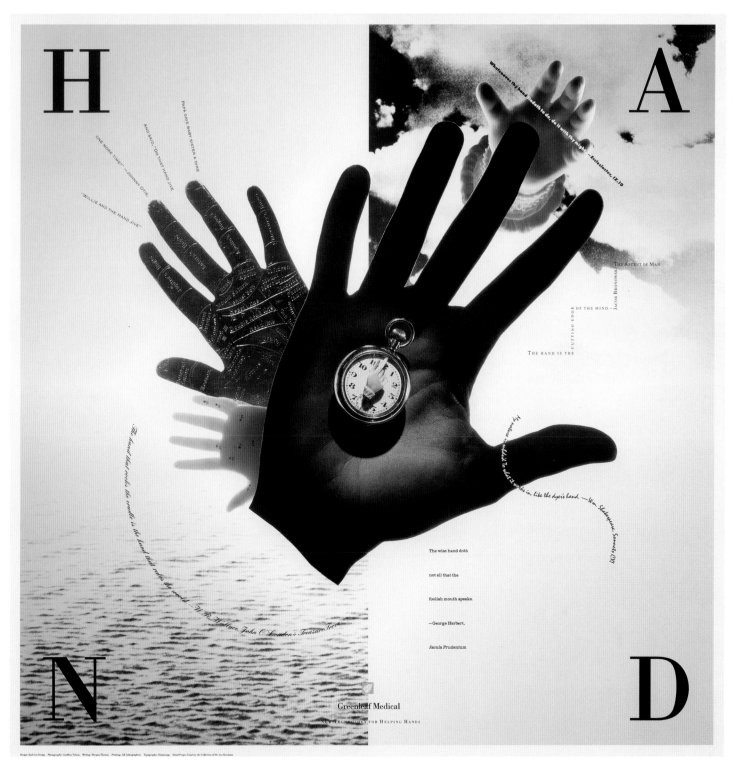

Greenleaf Medical Hand Poster

An art poster for hand clinics and offices of hand surgeons combines an eclectic selection of hand-related quotes with a variety of hand artifacts, portraying the hand as a universal symbol of time and utility. Soft gradated backgrounds create the effect of light emanating from the hand to symbolize healing.

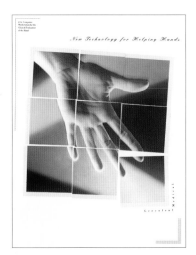

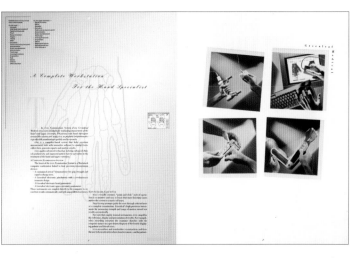

Greenleaf Medical Brochure

The New Technology for Helping Hands theme allows the documentation of medical information to be perceived in a new light, using dramatic theatrical lighting and photographic sections to graphically represent an impaired hand and highlight the system's components.

Design for High Technology
Applied Materials is the world's leading manufacturer of semiconductor equipment. Their Technical Seminars at SEMICON/West, the industry's largest and most important conference, attract silicon wafer engineers and fabrication specialists from around the world. Our unique event promotion programs have generated significant increases in conference attendance each year.

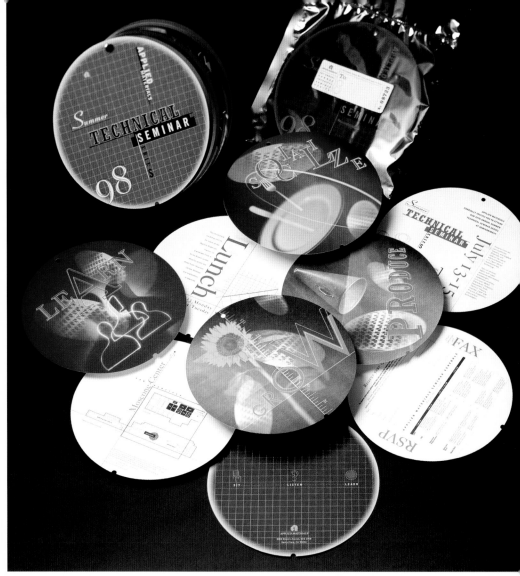

**Applied Materials
Seminar Invitation**
A conference dedicated to silicon wafer technology uses wafer-shaped panels attached by a steel rivet as a metaphor for the layers of information etched onto a wafer.

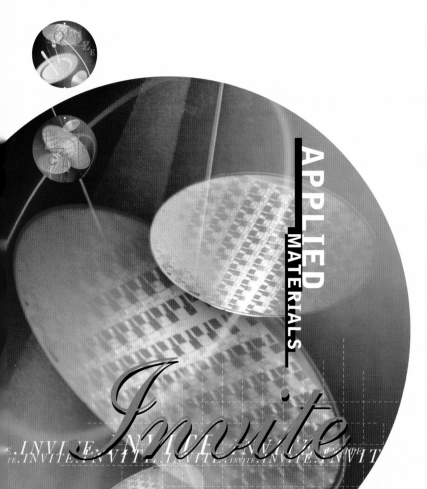

**Applied Materials
Save-the-Date
Postcards**
The card's unusual attention-getting shapes outlined conference content and created a marked increase in early sign-ups and event attendance.

Applied Materials Seminar Invitation

X-rays of familiar everyday objects combine with microscopic images of wafer coatings to convey conference themes in an engaging manner. The invitation's unique shape is inspired by the company's wafer fabrication chambers, with drilled holes to simulate rivets.

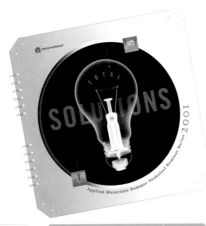

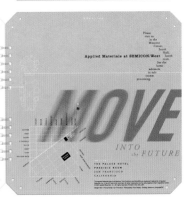

Applied Materials Reception Invitation

A blender creates the ideal metaphor for a cocktail reception bringing conference attendees together to mix and mingle.

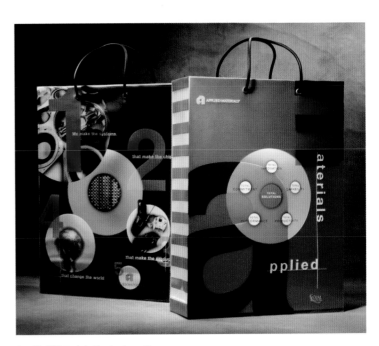

Applied Materials Tradeshow Bag

The company's innovation in silicon wafer manufacturing processes is reflected in the bag's unique combination of materials and unusual construction. A die-cut hole visually ties together the company's "Total Solutions" and "Complete Systems" messages.

Chronicle Books is an innovative publisher of high-quality illustrated books on design, food, literature, collectibles, pop culture and travel. Our best-selling book designs and groundbreaking tradeshow programs have been instrumental in creating a unique market niche for the specialty publisher.

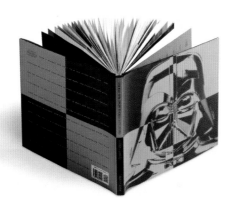

Star Wars: From Concept to Screen to Collectible Book
The positive/negative image of Darth Vader symbolizes the theme of good vs. evil central to the Star Wars trilogy.

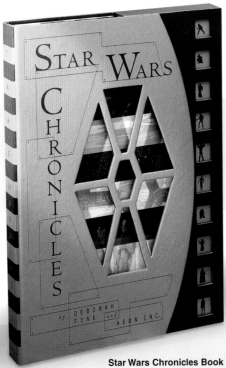

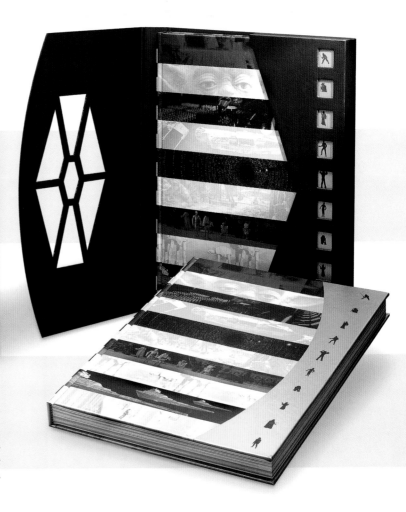

Star Wars Chronicles Book
A 315-page coffee table book of photographs, props and sketches from the Lucasfilm archives uses a die-cut cover to create a window into the world of Star Wars. Silhouettes of the movie's characters are showcased through die-cut squares symbolizing film sprocket holes.

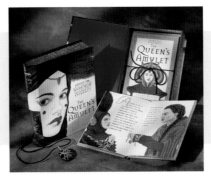

The Queen's Amulet Book
The story of Episode One's Queen Amidala comes complete with an illustrated book and functional keepsake locket housed in a reusable jewelry box.

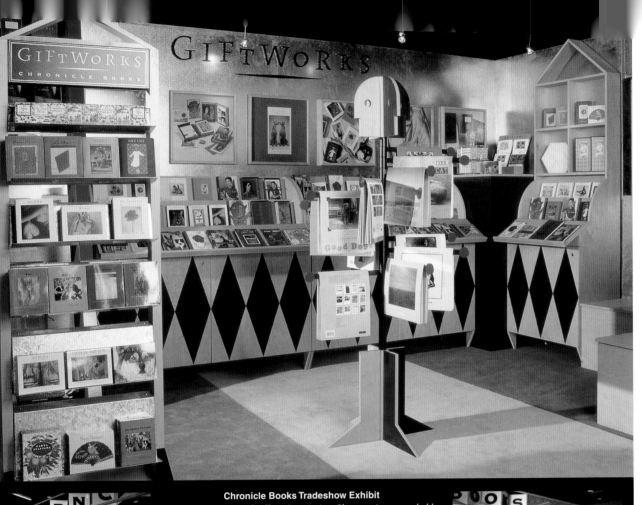

Chronicle Books GiftWorks Display

A division creating greeting cards, appointment books and calendars uses display units inspired by roll-top desks. A four-headed "man for all seasons" calendar rack allows product viewing from all directions.

Chronicle Books Tradeshow Exhibit

At the American Booksellers Association Show, a giant gear, ladder, staircase and human figure are used to represent the company's values of work, progress, attainment and humanity. Using a Constructivist aesthetic to create a "machine" for the display of books, natural wood and aluminum finishes provide the ideal neutral backdrop to highlight Chronicle's colorful collection. The highly unusual exhibit helped the San Francisco-based publisher stand out as a firm who "sees things differently".

Chronicle Books GiftWorks Display

The modular display units roll out of crates and are ready for use with a minimum of setup time. The reconfigurable fixtures double as attention-getting lobby displays when not in use at tradeshows.

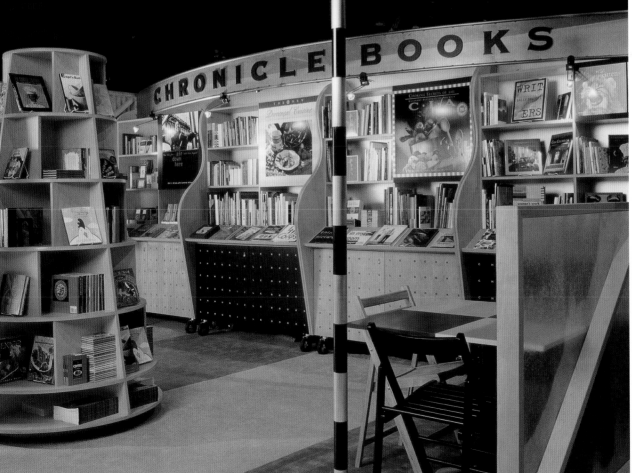

Design for Designers
We have been honored to contribute to
and advance our profession by creating
design solutions to promote AIGA, the
Professional Organization for Design and
other prominent industry organizations
and educational institutions.

AIGA/SF Environmental Poster
*Selected as one of 50 leading Bay Area designers
to create a public service poster promoting
environmental awareness, our solution encourages
peaceful coexistence with our surroundings.*

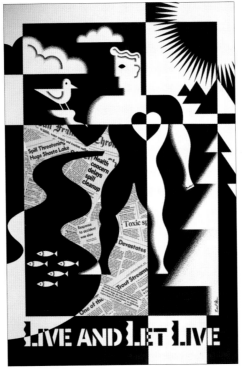

**Stora Enso Designer's
Luncheon Invitation**
*A paper company's promotional
luncheon for designers
combines utensils for eating
with tools for designing.*

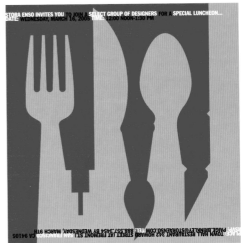

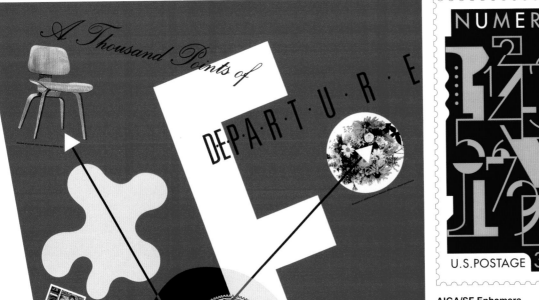

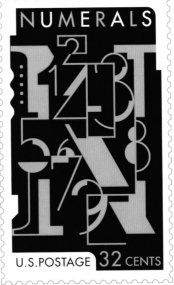

**AIGA/SF Ephemera
Philatelica Stamp**
*As one of 26 Bay Area
designers invited to create
a philatelic alphabet stamp,
our letter "N" stands
for "Numerals" and the
convention of using
numerals to denote a
stamp's value as postage.*

**AIGA/SF
Eames Lecture Poster**
*A lecture by author Ralph
Caplan on the design of
Charles and Ray Eames uses
their work in furniture,
exhibitions, film and graphics
as "points of departure"
for the design process.*

GEYRHALTER DESIGN

Established in 2001, incorporated in 2004.

» Focused on constructing brand atmospheres through identity creation, web site development and print, we design for clarity and impact.

» Located only two blocks away from the ocean in Santa Monica—this helps engage our senses.

» Comprised of six full-time talents from around the world, an intern and innumerable connections. We are approachable and personable, yet powerful beyond your imagination.

» Great design only comes from those who don't live solely at the office. Without a personal life, there is no professional inspiration. We translate our daily experiences into lively design inspirations that enrich your brand, and the lives of your customers.

» We know there's more to design than meets the eye: Vision, Inspiration, Usability and Engagement.

INNOVATIVE THINKING MADE VISUAL.

ENVISION

GD is built on the belief that design changes how you experience the world. Design trends come and go; successful design experiences are timeless and move forward. Our designs serve as change agents to transform your brand into an emotional connection with your customers. This emotional bond is formed through smart and innovative design, flawless execution and an intriguing user experience. A balanced approach that allows people to change their perception of your brand.

INSPIRE

GD is in the business of designing an experience that inspires your customers by stimulating all their senses, their curiosity, and above all, their imagination. An inspired person is open to new ideas, open to change their perception of the brand, open to conversing with you. Creating these eye-opening experiences is our passion.

ENGAGE

GD believes in the little things that make good design great. The little things that elevate your design from pretty to pretty engaging. The little things that turn your customers into brand ambassadors. Good design meets rational needs. Outstanding design captivates people, connecting with them on an emotional level. A respected brand claims respect. A beloved brand claims your heart.

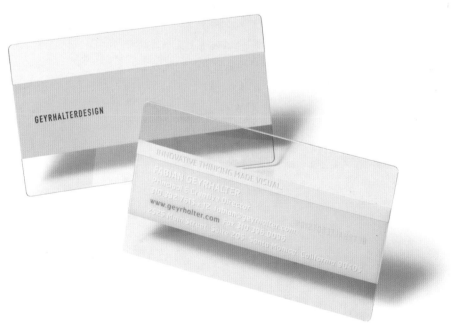

2525 Main Street Suite 205 Santa Monica, CA 90405 info@geyrhalter.com p 310.392.7615 f 310.396.0096 www.geyrhalter.com

web site for John Varvatos, men's lifestyle fashion designer

branding for Opal Capital Partners, a real estate investment and management services provider

USC

FEATURING INDUSTRY LEADERS
XBOX, Activision, Electronic Arts,
Sony PlayStation, and many more!

WORKSHOP DISCUSSIONS
Designing video games
Tips for becoming a game producer
Using music/audio to enhance video games
How to create mods
Creating mobile games on a variety of cell phones
Secrets from animation experts
Research in video games

REGISTRATION
Online Until November 19th:
http://www.itp.usc.edu/edge
On-Site Registration begins at 5:00 on November 20th

PRICING
USC enrolled students and faculty/staff: FREE
High school students with valid I.D.: $ 10
General public: $ 15

SCHEDULE
5:00 Doors open, On-site registration, Refreshments
6:00 Open Exhibits, Begin Tournament Play
7:00 Keynote Presentations
7:30 Workshops
9:00 Exhibit and Tournament Play
10:45 Raffles and Prizes
11:00 Event Ends

E.D.G.E.
ELECTRONIC DIGITAL GAME EXPO

INFORMATION TECHNOLOGY PROGRAM ITP

NOVEMBER 20TH · 5PM - 11 PM
TOWN & GOWN ON USC CAMPUS
WHERE ACADEMIA AND GAMING COLLIDE
GET YOUR GAME ON!

The USC School of Engineering's Information Technology Program (ITP) is pleased to announce its first annual "Electronic Digital Game Expo (E.D.G.E.)." This unique event brings together the interactive video game industry with university curriculum and research. Come witness the industries leading video game companies showcase their new games for the upcoming holiday season. In addition, learn about the exciting curriculum and workshop programs USC is currently teaching for the video game developers of the future!

poster for the Electronic Digital Game Expo at the University of Southern California

"What Is Gay," a social awareness web site for Public Interest, a non-profit media company

!nhance

1

DON JoAQUÍN

2

BANDITO BROS

3

brand identities: 1. Inhance Media, a music networking web site 2. Don Joaquín, maker of fine guacamole 3. Bandito Brothers, a full service media company

web site for Bandito Brothers

web site for Evolution, a fresh juice and food producer

Go Welsh

Go Welsh
3055 Yellow Goose Road
Lancaster, PA 17601
717 898 9000
www.gowelsh.com

A design studio located in Pennsylvania Dutch Country.

We value simple, strategic, memorable creative that turns heads and arrests attention. We challenge and encourage each other to accept nothing less than our collective best effort. There are no tricks or secret formulas. We work. We work hard.

We believe in what we do, love doing it, and are devoted to making it exceptional.

Let's do great work together.

Posters for Fonk Fest
Stationery for Fonk Fest

(Opposite Page) Buttons for Fonk Fest

Transit Ads for Brush. Brush. Smile!

Commercial Flooring Collateral for
Armstrong World Industries

Royer's Kids Club
Royer's Bouquets for Books
Blurt
Surface Studio
Music For Everyone
Borough of Swarthmore, PA

(Opposite Page) Label Design for
Appalachian Brewing Company

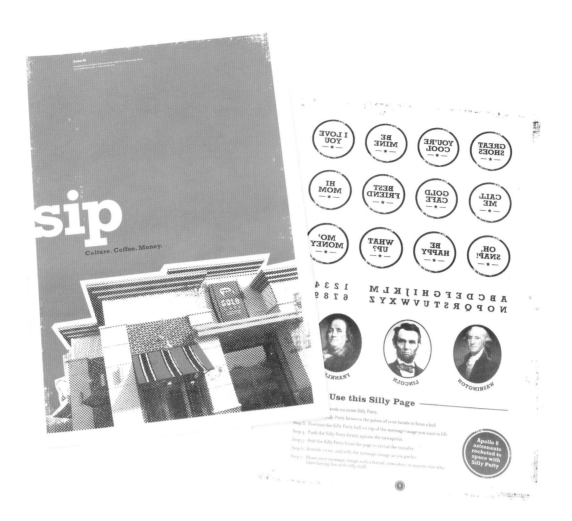

Put your mouth
where your money is.

www.goldcafes.com

Gold Cafe at Union National Community Bank. Member FDIC.

"Credit or Debit?" meets
"Regular or Decaf?"

www.goldcafes.com

Gold Cafe at Union National Community Bank. Member FDIC.

"Sip" Newszine for Gold Cafe
at Union National Community Bank

Outdoor Ads for Gold Cafe
at Union National Community Bank

Grady, Campbell Incorporated

Grady, Campbell Inc.
900 North Franklin
Suite 310
312.642.6511
www.gradycampbell.com

Grady, Campbell is a Chicago-based design firm owned and operated by it's founding Principals, Kerry Grady and Don Campbell. In addition to the two Principals, we employ a talented team of diverse and highly-trained designers. Despite our modest size, we have made a name for ourselves as one of Chicago's leading design firms, with numerous high-profile clients that include The American Red Cross, Morningstar, Motorola, IBM, Gilbert Paper, The Museum of Contemporary Art, The Harris Theater, Sony, and Swatch.

Everything we design has aesthetic implications. Our work reflects extraordinary quality and ideals and is far-ranging in scope. Our goals are pragmatic, and the work we do is useful, intelligent, and attractive. The quality of our work is measured by historical standards of excellence, by our competition, and ultimately and most importantly, by our client/partner's success.

At Grady, Campbell, we rely on our intuition that is conditioned by experience, training, ability, imagination, culture and reason. We believe that good design is a thorough merging of form and function and an awareness of human values expressed through the needs and desires of a caring, democratic community.

What we design is not limited to any idea or form. Grady, Campbell plans, designs and produces multi-dimensional solutions for corporate, cultural, academic, and government organizations. We embrace every kind of visual communication, from postage stamps to billboards, from websites to wrist watches, from art books to sign systems. We learn quickly, follow sound business practices, and we adjust to, and understand the differences between, our clients and their respective businesses.

Since our inception, Grady, Campbell has received international recognition for design excellence. Our award-winning work has been featured in magazines, journals, design annuals, and permanent gallery collections, that include: The American Institute of Graphic Arts, The International Academy of Communication Arts, Graphis, I.D. Magazine, The American Center for Design, The Art Directors Club of New York, Critique Magazine, and The United Kingdom Design Council.

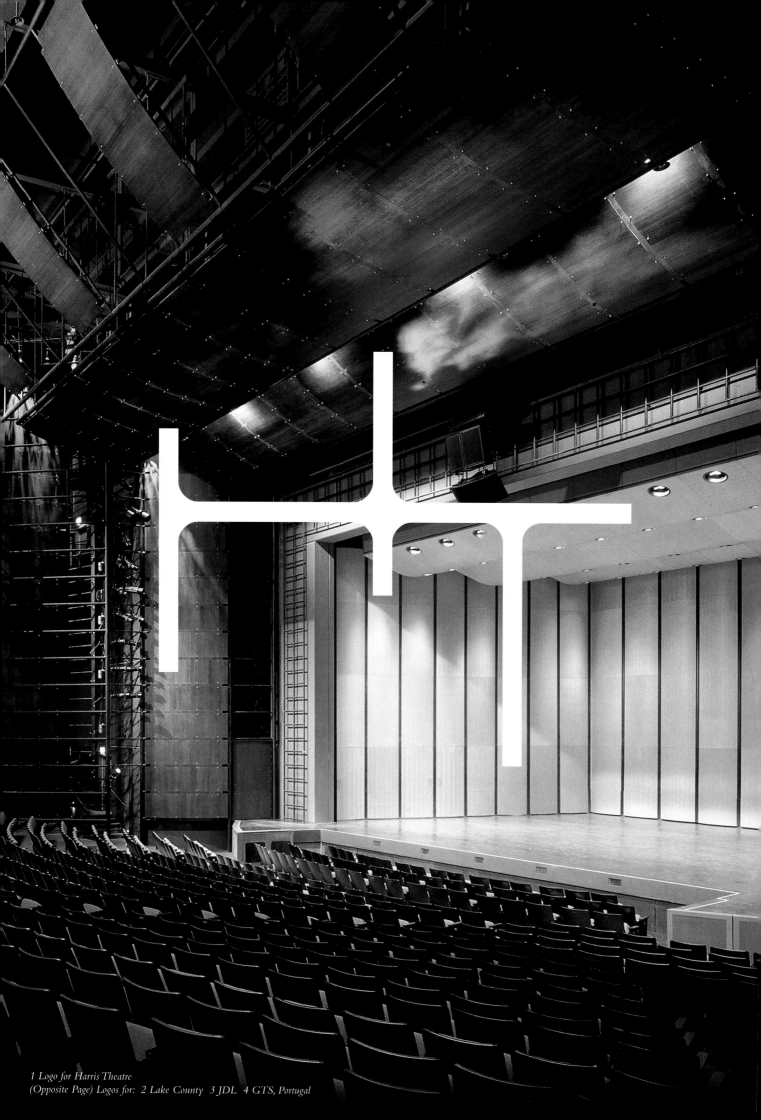

1 Logo for Harris Theatre
(Opposite Page) Logos for: 2 Lake County 3 JDL 4 GTS, Portugal

2

jdl.

3

4

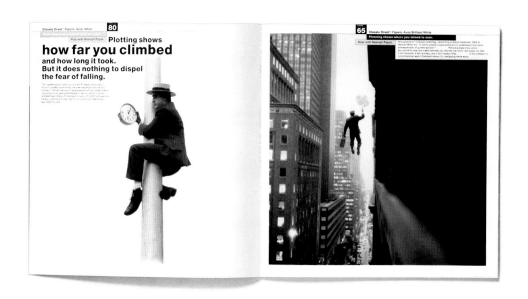

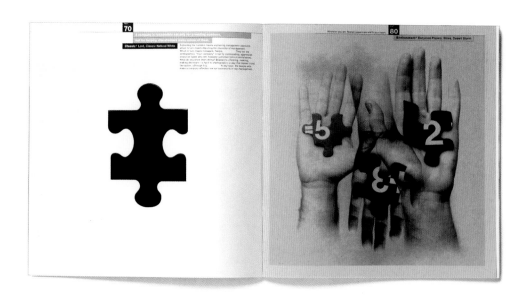

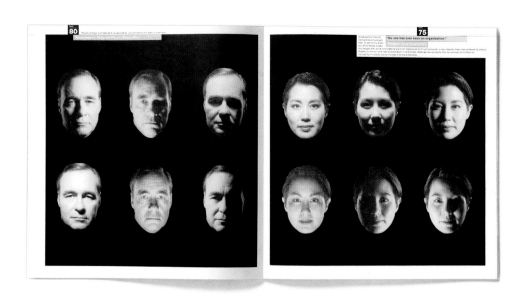

Brochure spreads for Neenah Paper - "Oil and Water"
(Opposite Page) Brochure for Morningstar - "Risk, Reward, and Reason"

risk, reward and reason

The Morningstar® Revolution

Logo/Poster for Novum Structures
(Opposite page) Website for Novum Structures

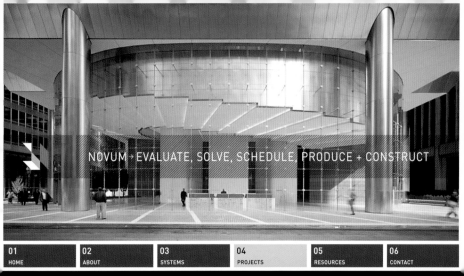

NOVUM→EVALUATE, SOLVE, SCHEDULE, PRODUCE + CONSTRUCT

01	02	03	04	05	06
HOME	ABOUT	SYSTEMS	PROJECTS	RESOURCES	CONTACT

PROJECTS←

PROJECT NAME: **ROLL OVER A PROJECT TO VIEW ITS NAME**　　　　LAST　　NEXT

CASE STUDY	ATRIUMS	CANOPIES	FACADES	ROOFS	OTHER
01	02	03	04	05	06
HOME	ABOUT	SYSTEMS	PROJECTS	RESOURCES	CONTACT

MILAN NEW TRADE FAIR

SPECIFICATIONS

Application: Exhibit Hall
Location: Milan, Italy
Size: 409,032 Sq. Feet (38,000 Sq. Meters)
System Used: FF
Year Completed: 2004
Architect: Massimiliano Fuksas

DESIGN SOLUTION

Novum Director of Engineering Soeren Stephan, was the lead technical manager for this incredible free form, clad structure. The project consists of a volcano shaped structure and a huge (nearly 1 mile long) open air canopy with contours designed to resemble the Alps mountain range. The "volcano" is clad in insulated glass and metal panels. Laminated clear glass is used to provide a transparent lid on the undulating, open air company. The vast majority of the structural connections were

IMAGES
1 2 3 4 5 ▶

BACK TO MENU

Graham Hanson Design

New York Office
60 Madison Avenue, Floor 11
New York, New York 10010
212 481 2858 telephone
212 481 0784 telefax
www.grahamhanson.com
info@grahamhanson.com

Hudson Valley Office
217 Primrose Hill Road
Rhinebeck, New York 12572
646 279 3277 telephone
hvo@grahamhanson.com

Graham Hanson Design is an internationally-recognized multidisciplinary design agency active in all areas of strategic design, including corporate identity, branding, print communications and advertising; Web design and other interactive media; and exhibit design, architectural graphics and wayfinding.

Long-time corporate clients include American Express, Dun & Bradstreet and Saks Fifth Avenue. Our firm also works with architects and developers on a wide variety of projects, and is well known for our long-term collaboration with Macklowe Properties. We are consistently developing projects for museums and other cultural organizations, including the Smithsonian American Art Museum, The American Institute of Architects, The Museum of Natural History and the Kuwait National Museum.

Our mission is to create compelling, dynamic, and timeless design solutions that effectively satisfy our clients' goals and objectives. Our experience with a truly diverse client base, and our belief that each project has its own unique context and set of circumstances, provides us with a rare and powerful perspective for every project we undertake.

**GENERAL
MOTORS
BUILDING
767 FIFTH**

red|seven
BY WOLFGANG PUCK

shopAmex℠

**Macklowe
Properties**

FairfieldMetroCenter

pasenger

OFF
5TH

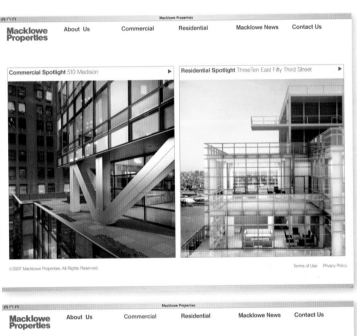

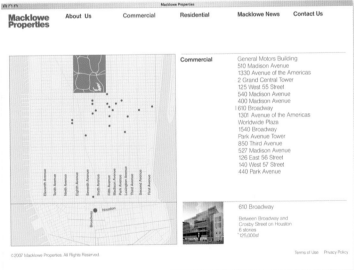

Macklowe Properties
Brand Development & Multi-Channel Integrated Design

Saks Fifth Avenue OFF 5TH
Brand Redevelopment & Multi-Channel Integrated Design

Three Ten
East Fifty Third Street

The Townhouse.

Sub-Zero Refrigerator-Freezer
Dual refrigeration system with two distinct temperature zones to ensure the freshest food and energy efficiency. Other features include easy-to-use digital controls, customizable shelves and drawers, and an in-drawer ice maker.

Thermador Dishwasher
Fully-integrated stainless steel four program dishwasher.

Maytag Neptune Washer-Dryer
Features Maytag's IntelliFill technology, which automatically sets the water level depending on load, and the Turbo Clean system, which continually turns laundry over to ensure rinse.

Axonometric Perspectives

Second Floor View

First Floor View

1

2

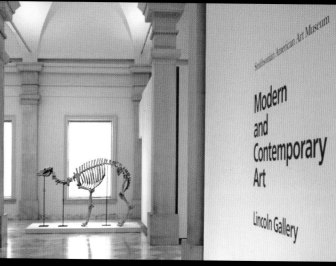

3

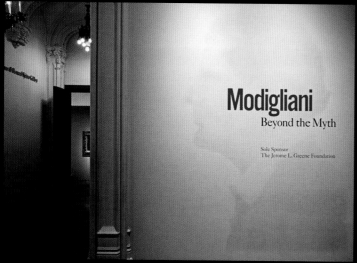

4

Environments & Exhibition Graphics
1 American Institute of Architects, New York
2 Smithsonian American Art Museum
3 The Jewish Museum: Modigliani
4 Winstar Communications
5 Gallery 340: New Design Providing

5

Skin Therapie Cosmeceuticals
Brand Development & Packaging

Graphic Content's name is a reflection of its philosophy—that good design means great communication. We focus on doing what works best for our clients. And we're consistently able to deliver award winning work, that wins customers for you. We invite you to review a few examples of our work. Because that's what really tells our story.

Dallas Cowboys, Pilgrim's Pride, Mothers Against Drunk Driving, Pet Ecology, The Vanilla Company, Zale Corporation, Siemens, Dallas Independent School District, Monster Legal.

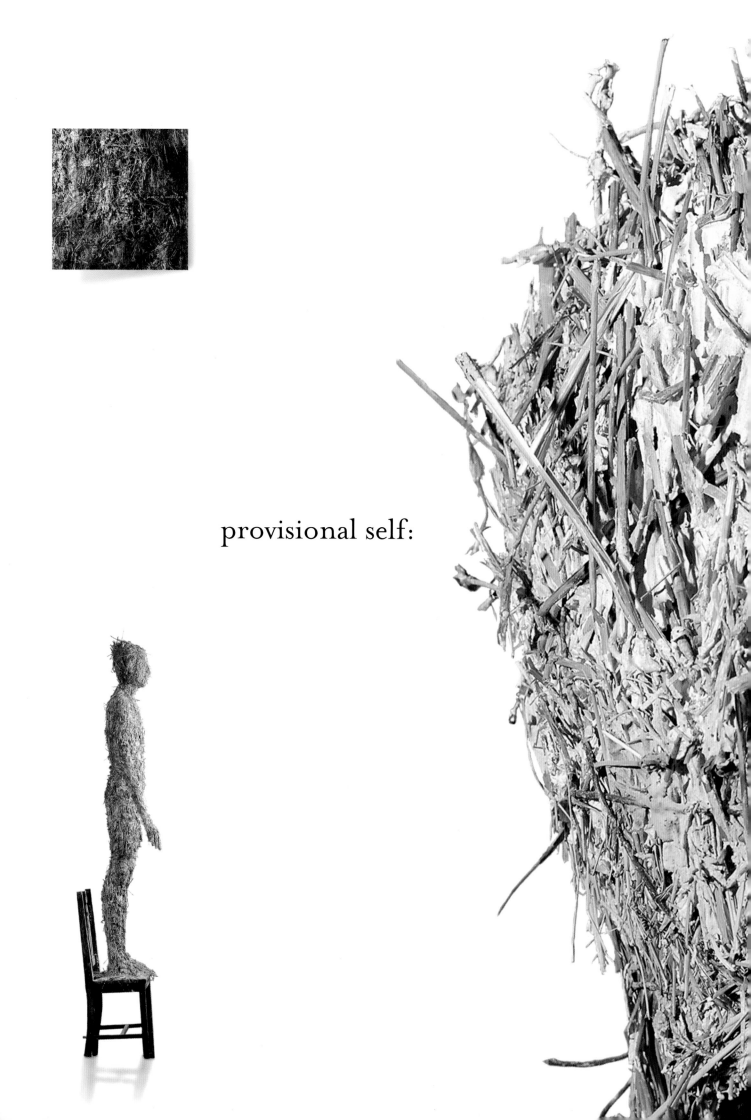

provisional self:

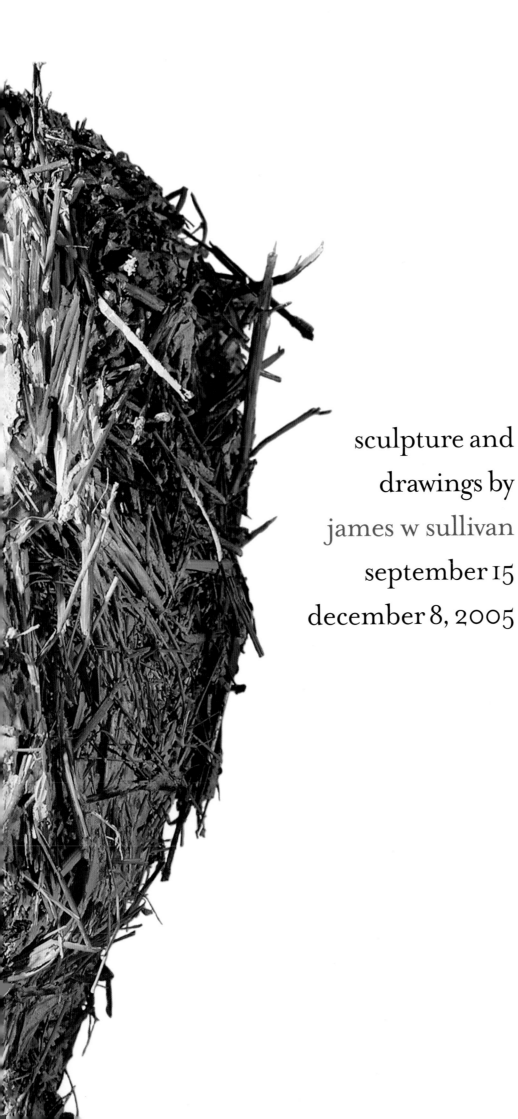

sculpture and
drawings by
james w sullivan
september 15
december 8, 2005

eauty

at's beauty.

Santa Regina : Manufacturing

DEFINING

moments

BAILEY BANKS & BIDDLE

WHERE TREASURES LIVE.®

Bailey Banks & Biddle : Retail, CJ Charles : Retail

Sello Imports : Retail

Sello Imports : Retail

Group 22, Inc.
1205 East Grand Avenue
El Segundo, CA 90245
310.322.2210
www.group22.com

Creating effective design that communicates is our job as designers. Most clients have a strong idea of what their company is without knowing how to bring that idea across. Our clients come to us so that we can use our talent to define their image. Through the years we've grown to a sizeable studio that has over thirty years of experience in the design field. From traditional print media to online and interactive work, we are ready for most any project. Our winning combination of vibrant creative energy and years of experience produces a unique personality found in few design firms.

That personality makes its mark in the passion and pride we take in our work and our studio. In turn, our clients benefit from personal attention, their own investment in the development of their identity and, most of all, branding that is as personal as it is effective.

In the end, the objective of great design is to leave a permanent mark in the minds of the consumer. If our clients don't stand out from the rest, we haven't done our job.

1 Schaar Homes & Buildings
Corporate Website

2 Schaar Homes & Buildings
Corporate Brochure

3 Schaar Homes & Buildings
Corporate Logo

2

3

1

*5 Slipcase and Binder for
 200 Pier Brochure and
 Various Collateral*

*6 Logo for 200 Pier
 property development*

Group 22 131

5

6

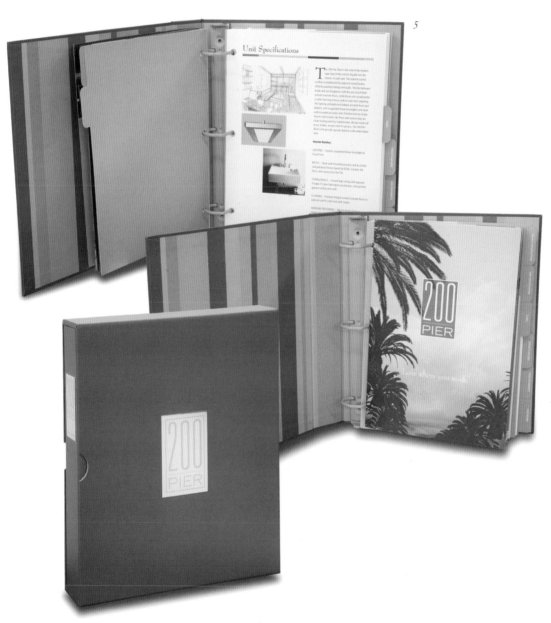

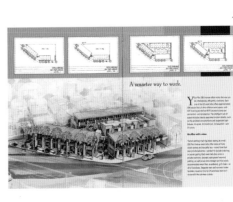

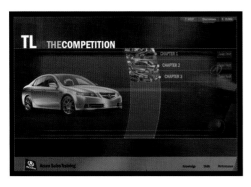

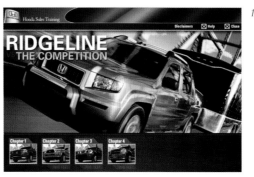

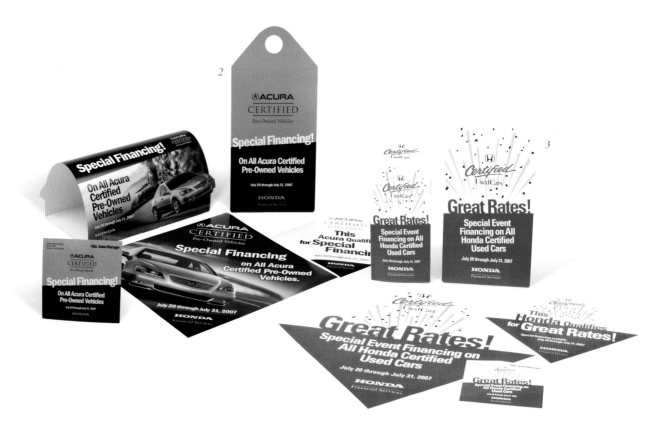

1 Acura TL vs The Competition
and Honda Ridgeline vs The
Competition Web-Based Training

Client: American Honda
Motor Co., Inc. and RPA

2 Acura Certified Pre-Owned Vehicles
Sales Collateral; Hang Tags, Table
Tents and Window Clings

Client: American Honda Finance
Corporation and RPA

3 Honda Certified Used Cars
Sales Collateral; Hang Tags, Table
Tents and Window Clings

Client: American Honda Finance
Corporation and RPA

4 2008 Acura Facts Guides
and Holder

Client: American Honda
Motor Co., Inc. and RPA

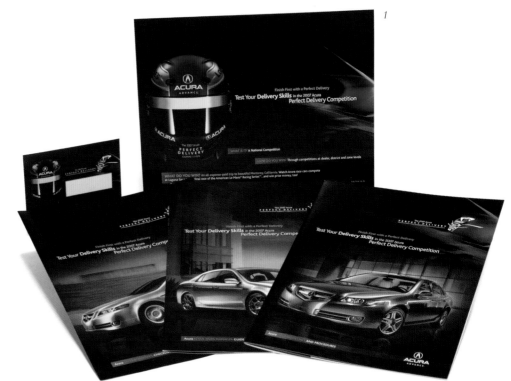

1 Acura Perfect Delivery Competition
Collateral Materials

Client: American Honda
Motor Co., Inc. and RPA

2 Acura Perfect Delivery Competition
Web-Based Training

Client: American Honda
Motor Co., Inc. and RPA

3 Honda Marine and Personal Watercraft
Sales Collateral; Hang Tags and
Window Clings

Client: American Honda Finance
Corporation and RPA

4 Honda Motorcycle Sales Collateral;
Hang Tags and Window Clings

Client: American Honda Finance
Corporation and RPA

*1 Mercury Media ONE Lounge
 Drink Ticket*

*2 Mercury Media ONE Lounge
 Convention Banner*

*3 Mercury Media ONE
 Advertising Campaign*

1

2

3

Where Your Car is the Star.

Everything For Every Car.

Get Your Free Web Page. Just Ask Us.

More Than a Car Site. It's Car Insight.

My Car Page

Everything For Every Car.

Get Your Free Web Page. Just Ask Us.

Your Car Can't Tell You What We Can.

Everything For Every Car.

Get Your Free Web Page. Just Ask Us.

*1 MyCarPage.com
Poster Campaign*

*2 ScreeningOne Corporate
Website*

*3 Loyola Marymount
University Website*

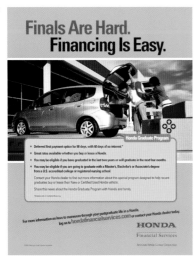

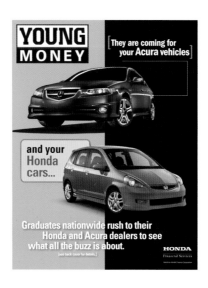

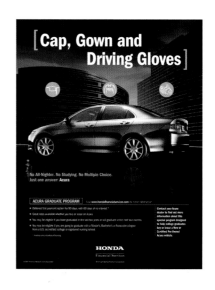

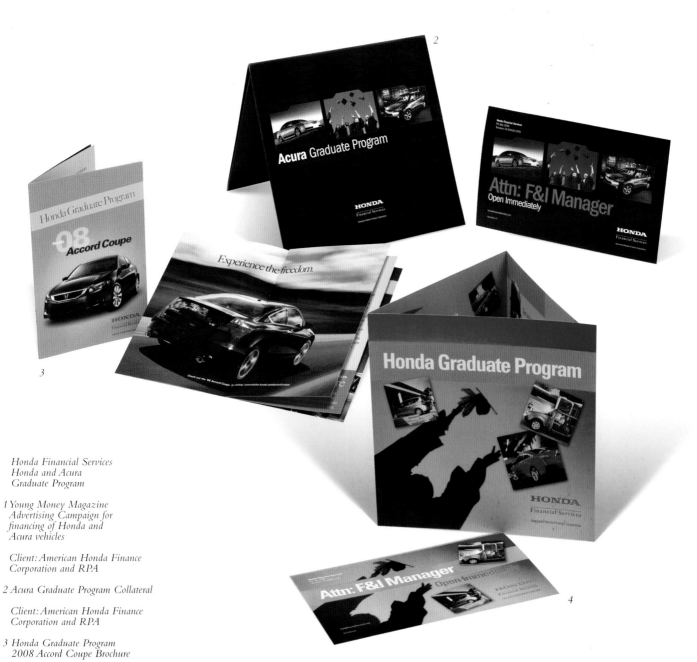

Honda Financial Services
Honda and Acura
Graduate Program

1 *Young Money Magazine*
Advertising Campaign for
financing of Honda and
Acura vehicles

Client: American Honda Finance
Corporation and RPA

2 Acura Graduate Program Collateral

Client: American Honda Finance
Corporation and RPA

3 Honda Graduate Program
2008 Accord Coupe Brochure

Client: American Honda Finance
Corporation and RPA

4 Honda Graduate Program Collateral

Client: American Honda Finance
Corporation and RPA

HARD ROCK HOTEL, SAN DIEGO : Lobby Grand Stair Wall

HARD ROCK HOTEL, SAN DIEGO : Pool side All-Star Wall Concept : Interior / Exterior Sign Program : Wall of Fame Graphic Program

CURRANT, AMERICAN BRASSERIE : Naming, Positioning, Identity, Signage, Menu Program

LOVE CULTURE

LOVE CULTURE : Naming, Positioning, In-Store Applied Design Concept, Sign Program

D'LUSH-DELUXE BEVERAGE JOINT : Positioning, Identity, Menu Program and Marketing Campaigns, Retail Display, Uniform, Package Design

EAST VILLAGE TAVERN + BOWL : Positioning, Identity, Signage, Uniform, Interior Graphic Program

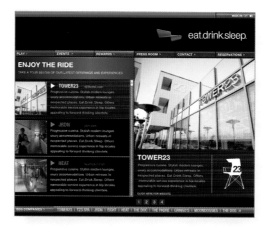

eatdrinkandsleep.net

ir2.com

kma-ae.com

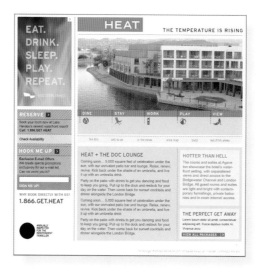

heathotel.com

Brand Integration, Positioning, Identity, Web Strategy and Development

From insight to invention, Hornall Anderson is heralded for brand design, interactive and strategic solutions. Our creative firepower is the center of who we are; however, one of our lesser known forces fuels our culture and carries a distinct reputation all its own. 17 guiding principles are core to our DNA. Gathered over 25 years, what began as experience-driven quotes have transcended mere expletives to become the bedrock of our Hornall Anderson family. *Work hard, play hard, don't take yourself too seriously.*

Autonomy and accountability are not mutually exclusive.

The fish stinks from the head.

Straight-over-tackle communication.

Think marathon, not sprint.

Know when to lead and when to get out of the way.

Share in success.

Crawl, walk, run.

Stand for something, not everything.

Focus, but allow happy accidents and epiphanies.

Hire people smarter than you.

Welcome change.

Embrace diversity.

Exercise humility. Don't believe your own press clippings.

Attendance does count.

Make mistakes. Course correct in real time.

Clients aren't the enemy.

Just because you can, doesn't mean you should.

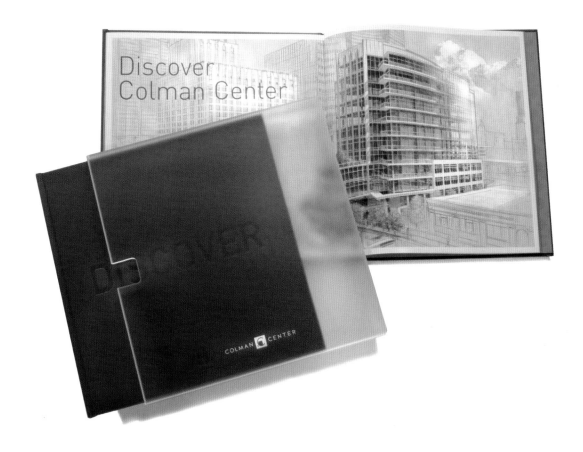

With the Colman Center's 12-story, 175,000-square-foot complex slated for new construction in downtown Seattle, we sought to bring the building's unique business environment alive through a sales book focusing on each distinct aspect of discovery within the complex. From inspiration, creativity and responsibility, to productivity and community, the Colman Center book expresses the idea of discovering the benefits of a new kind of workspace. In the spirit of this, we enlisted the work of six artists to interpret their visions of the Colman Center and all it has to offer those choosing to be a part of its exciting new location.

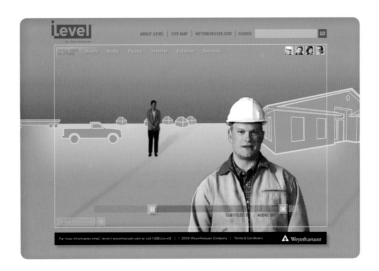

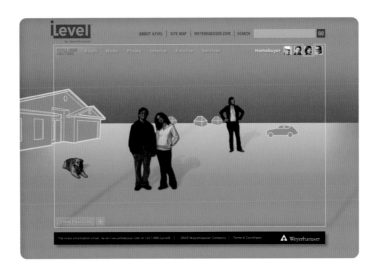

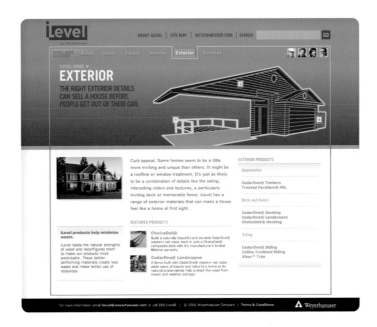

The story of iLevel.com reflects the powerful and diverse ways a brand can communicate directly and relate to multiple audiences on various levels. Weyerhaeuser, a Fortune 200 international forest products company, engaged us to analyze the current strength of various existing brands in the Residential Wood Products (RWP – a subsidiary of Weyerhaeuser) portfolio, and to recommend a brand strategy for taking this new venture to market. The RWP re-introduction was the largest brand launch in Weyerhaeuser's 106-year history. iLevel.com communicates Weyerhaeuser's new vision: to be the industry's first turn-key ISF solutions provider—to be "all in one."

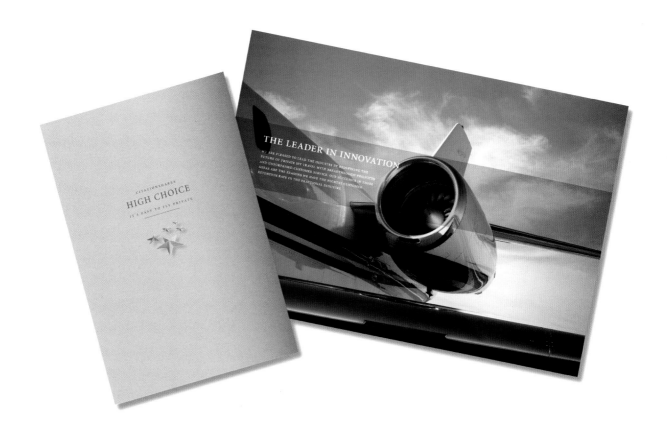

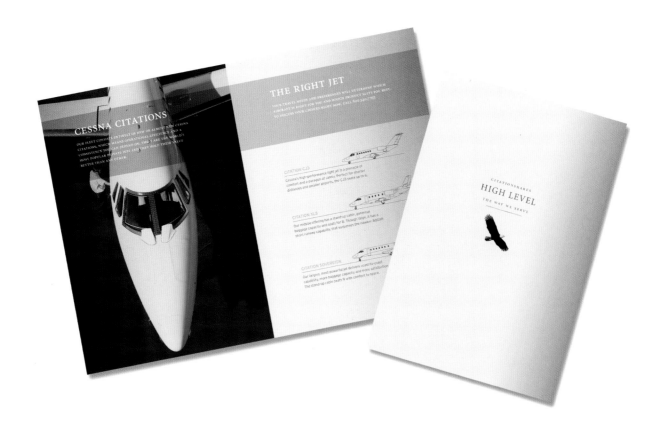

When faced with the challenge of communicating the benefits of CitationShares' service as a fractional jet ownership corporation, we chose to focus on simplified, yet strategic messaging, incorporating rich imagery and straightforward content. The resulting High Choice and High Level brochures reflect the company's vision and promise of quality service to their customers.

New package designs for Tahitian Noni's Hiro energy beverages, Tea Escapes' tea-infused candy created by Wrigley, and Publix soda pop lend a prominent shelf presence to the competitive marketplace. Bold graphics and colors not only reflect the focus behind these products, but also further enhance their consumer appeal.

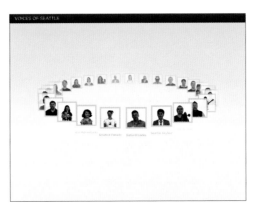

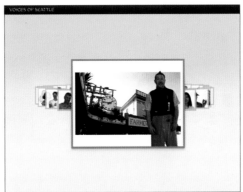

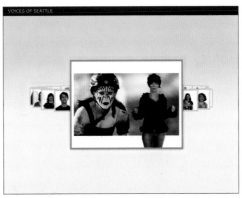

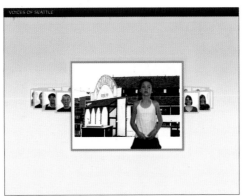

The Space Needle's SkyQ installation is a new Immersion Interactive Branding Experience comprised of five stations—each providing the user with a different interactive experience that literally extends the view of the city and the greater Seattle area. Flipping through a virtual carousel, visitors can watch a compilation of Voices of Seattle perspectives, available via a touch screen. The 27 vignettes showcase unique and authentic voices of Seattle residents, as they share personal experiences, from fish throwing at the Pike Place Market to the infamous Fremont troll.

 enertech

trupanion

O.C. TANNER
appreciate

SYSTEMS SERVICES
of AMERICA

SCHNITZER WEST

Citelines

TRUEBLUE

CO
RR
ID
OR
15

VSP

mNEMOSCIENCE

jobster

Microsoft
HealthVault

iconisus L&Y

Iconisus L&Y is about creating a story through design to reflect our clients' vision, culture and company. Our background in the entertainment field has helped us move forward with fresh ideas that extend into other markets such as corporate identities and websites. The Iconisus team has provided visual designs to top domestic and international companies, who entrust us with taking their product to new heights, making it different from anything else in the marketplace.

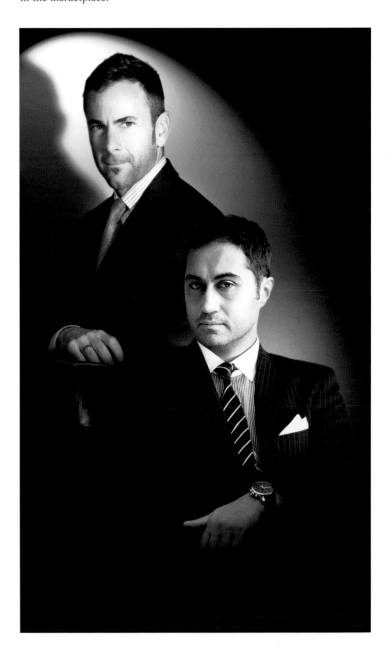

Iconisus L&Y
10000 Venice Blvd,
Culver City, CA 90232
Tel 310.202.1600
Fax 310.202.1008
www.iconisus.com

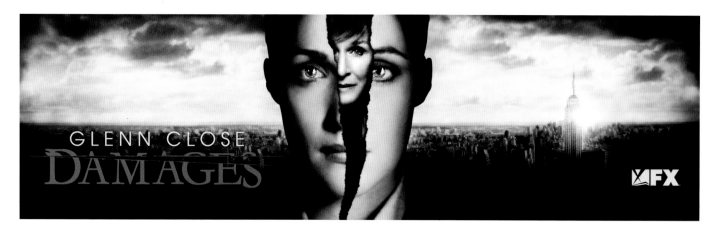

1

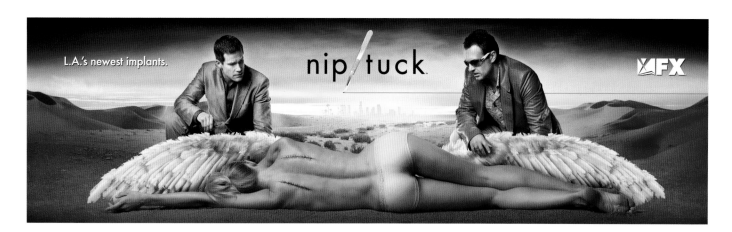

2

1 *FX Network, Nip/Tuck*
Season 5 Campaign

2 *FX Network, Damages*
Series Premier Campaign

(right page)
Twentieth Century Fox,
Fantastic Four: Rise of the
Silver Surfer Campaign

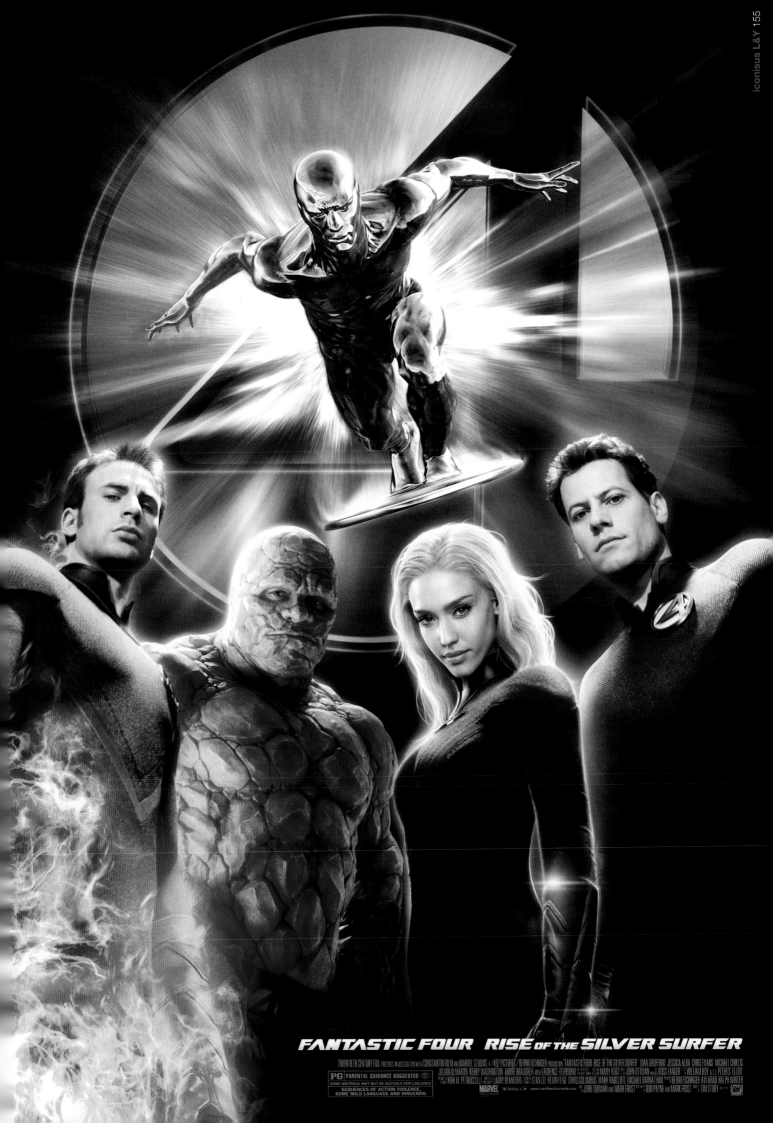

FANTASTIC FOUR RISE OF THE SILVER SURFER

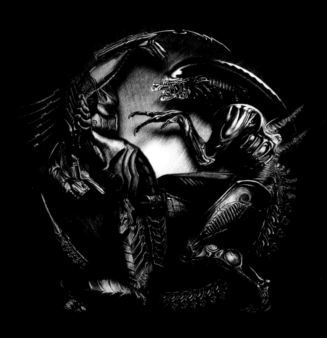

(left page)
Twentieth Century Fox,
AVP Campaign

Motion picture
print campaigns
for various
entertainment studios

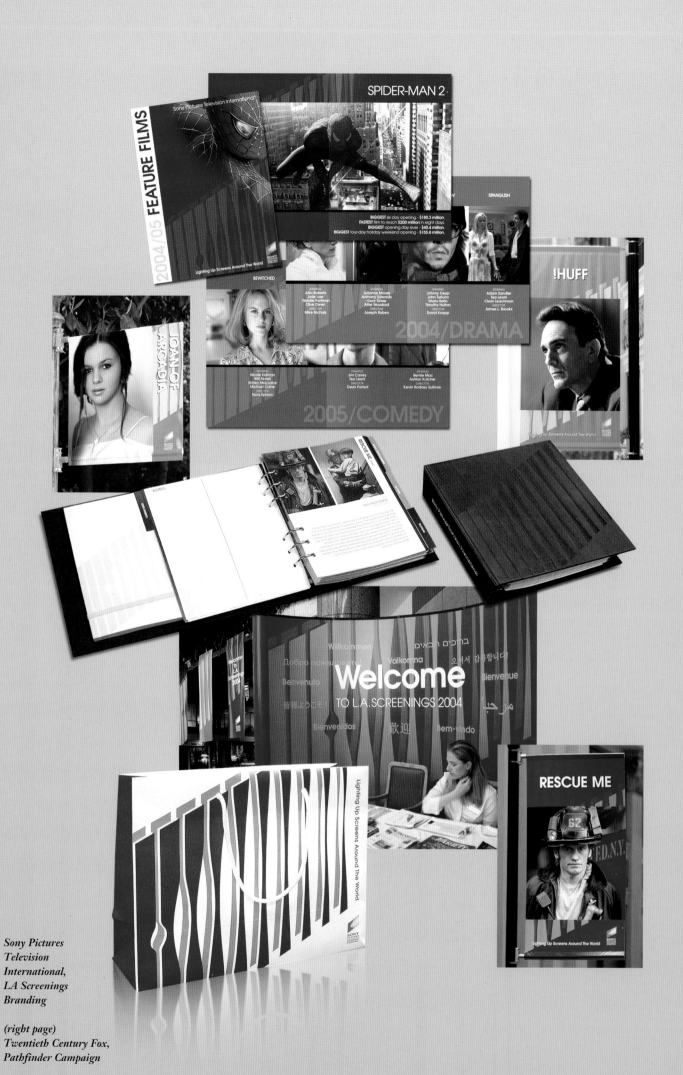

*Sony Pictures
Television
International,
LA Screenings
Branding*

*(right page)
Twentieth Century Fox,
Pathfinder Campaign*

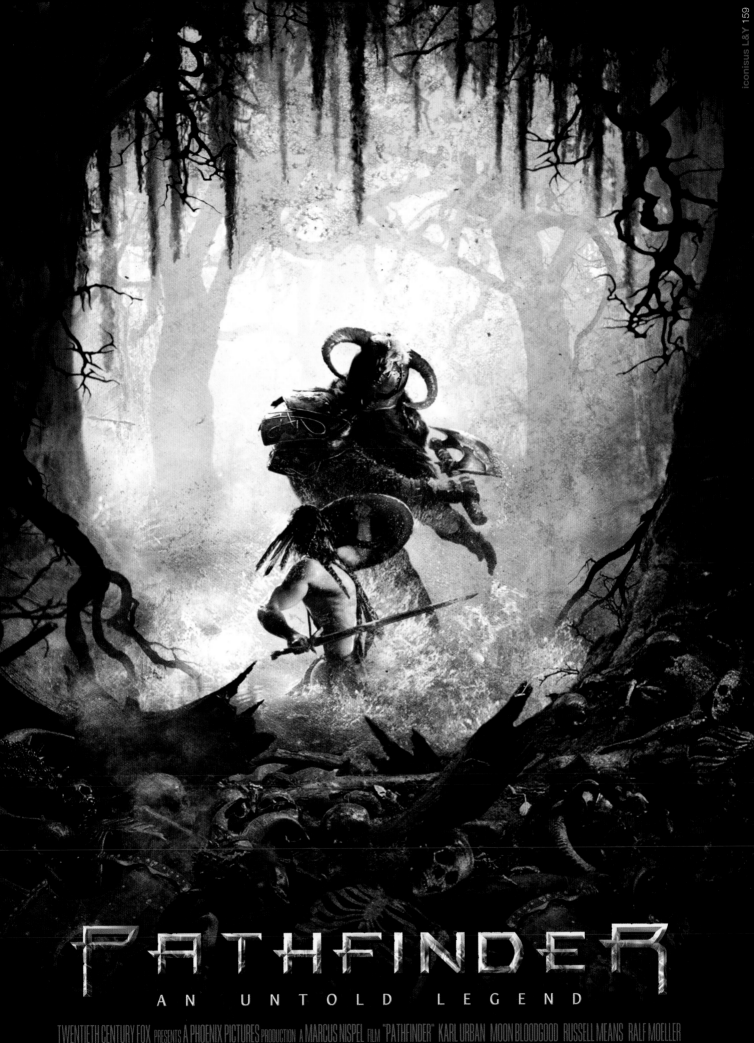

PATHFINDER
AN UNTOLD LEGEND

TWENTIETH CENTURY FOX PRESENTS A PHOENIX PICTURES PRODUCTION A MARCUS NISPEL FILM "PATHFINDER" KARL URBAN MOON BLOODGOOD RUSSELL MEANS RALF MOELLER
AND CLANCY BROWN MUSIC BY JONATHAN ELIAS COSTUME DESIGNER RENÉE APRIL EDITED BY JAY FRIEDKIN GLEN SCANTLEBURY PRODUCTION DESIGNER GREG BLAIR DIRECTOR OF PHOTOGRAPHY DANIEL PEARL CO-PRODUCERS VINCENT OSTER BARBARA KELLY LOUIS PHILLIPS
EXECUTIVE PRODUCERS BRADLEY J. FISCHER LEE NELSON JOHN M. JACOBSEN PRODUCED BY MIKE MEDAVOY ARNOLD W. MESSER MARCUS NISPEL SCREENPLAY BY LAETA KALOGRIDIS DIRECTED BY MARCUS NISPEL

www.pathfindermovie.com

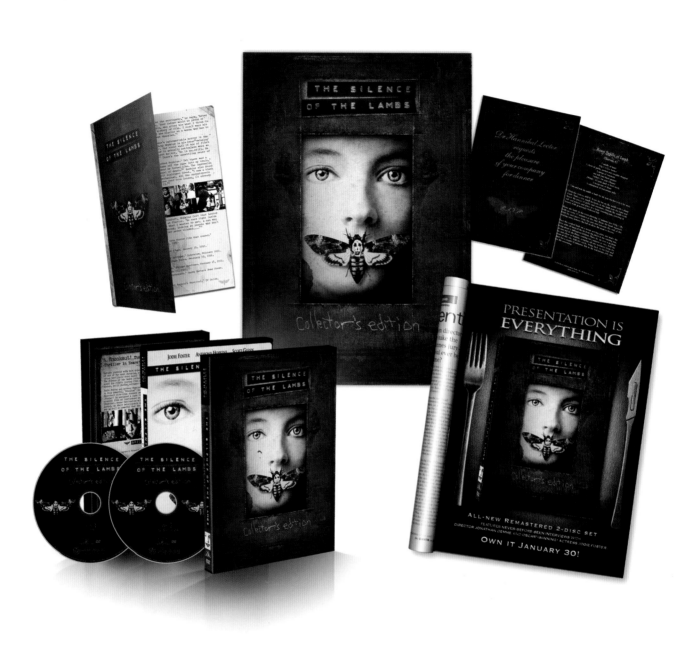

Twentieth Century Fox
Home Entertainment,
Silence of the Lambs
Collector's Edition Campaign

1

Suddenly he realized the shore was far, far away. He went to swim back. The undertow held him hard. The waves splashed over him, each one coming harder and faster. He had given up his faith many years before but found himself shouting out, "Get me back to shore and I will devote my life to you – I mean it!"

2

He looked up the aisle and saw her four rows back – long red hair, busty, fair skin dotted with freckles, long neck. She was his dream girl realized, the one he had loved in his mind for the last fifteen years. The lights dimmed and the show began, but he spent the whole time thinking, "I will make her mine – I mean it."

3

It was the third time that week John had caught Doug surfing the web instead of working. "It's enough," he said, standing above Doug in Doug's small cubicle. "Alright, alright." Doug raised his hands up in mock-surrender and closed the web browser.
John deepened his voice. "I mean it."

4

"David, I have something to tell you," Ada said. They had been in New York less than three months. He lived in a downtown dorm, she in the home-office of friends of family friends. "I slept with Donny." He imagined Donny, the skinny, oddball boyfriend of her best-friend. He went to Columbia. Pre-Med. David laughed and continued painting. She reached out and touched the arm he was painting with. "I mean it."

5

After getting to open her dorm door, Brad asked to hear the song she was playing. She strummed and began to sing. When she finished, he asked, "How long did it take you to write that?
"About ten minutes."
"What?" It would have taken Brad hours to write that good of a song – even if he could write something that smart and powerful. "That can't be."
She grinned. "No, really. I mean it."

6

He was the most beautiful thing she had ever seen. Red, tiny, screaming, but still beautiful – and all hers. He squirmed on her chest and for the first time in her twenty-six years, she felt whole. "I will love you no matter what." The baby looked up at her. "I mean it."

7

They were broke. All their belongings were crammed in the backseat. Jake turned to her and said, "I know I messed up, I know I hurt you and if I hadn't been so stupid we wouldn't be like this right now. Sweetie, I will fix this." She started to cry. He reached out to her. "Hey -- I mean it."

I mean it Creative
10556 Clarkson Road
Los Angeles, CA 90064
310.200 0007
www.imeanitcreative.com
www.emrahyucel.com

Left Page:
Magazine cover designs for
"Tasarim Merkezi Dergisi"

Right Page:
Poster design for New York
Brazilian Film Festival

Logo designs for:
UniMet Metal Trade
Il Faro Seafood Restaurant
You Network
Homemade Restaurant
Turkish American Business Forum
Jersey Cable Network
UzMan Construction
Istanbul Jazz Festival
TabCo
Mest Restaurant
Sea Council

BEDRI BAYKAM
THE BONE

Left Page:
Book cover design for
"The Bone"

Right Page:
Poster design for
Golden Orange Film Festival

44TH ANTALYA GOLDEN ORANGE FILM FESTIVAL

44.ANTALYA
ALTIN PORTAKAL FİLM FESTİVALİ
OCTOBER 19-28 EKİM '07

T.C. BAŞBAKANLIK
TANITMA FONU

T.C.
KÜLTÜR VE TURİZM BAKANLIĞI

ANTALYA
BÜYÜKŞEHİR BELEDİYESİ

Music CD design for
"Yalin"

What if you could tell the story of your brand with the excitement of an art installation? What if you could design a space that told your story better than a dozen brochures? What if you could fashion a point of view that didn't seem possible until you saw it?

We immerse ourselves in your brand and culture; synthesize it using our expertise in both brand building and design of the built environment.

The result: spaces that tell your story so that everyone from Wall Street investors to the new hire says, "Oh, I get it. We do that. And we do it very well."

Karen Skunta & Company

THE CRITTENDEN BUILDING
1382 WEST 9 STREET SUITE 201
CLEVELAND OH 44113-1231
216·687·0200 WWW.SKUNTA.COM

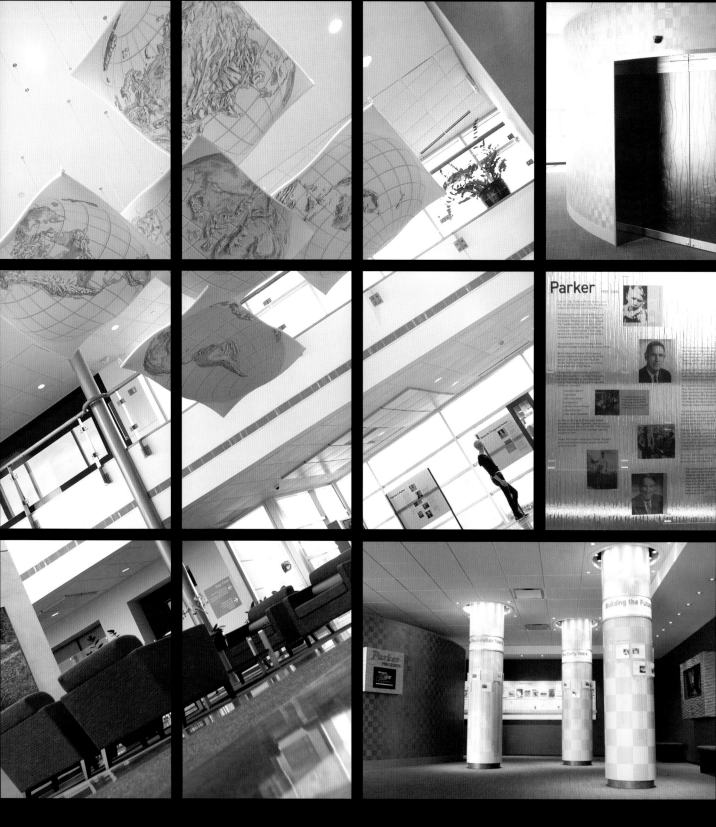

Parker Hannifin Corporation – Main Lobby & Theater Area

As you enter the lobby of this Fortune 500 company's corporate headquarters, you immediately grasp the impact of this global leader. Vibrant hanging scrims and a four-screen multimedia presentation are clear introductions to Parker's standing as the global leader in motion and control technology. The founding family members' important role is displayed front and center on cast art glass. Parker's quarterly video, available in four languages, is framed in a multi-lingual display along with "fun facts".

Adjacent to the main lobby, a state-of-the-art Dolby® Digital 5.1 surround sound theater presents an exciting 3-minute video showcasing the diverse ways that Parker helps improve the standard of living for people worldwide. Three columns display thousands of U.S. patents and together with the 30-foot history wall underscore Parker's innovation and strength.

Every inch of the space is designed to be as smart as the people that work there.

y Days
An Enthusiastic Start

...hur L. Parker founds the Parker ...Company in a tiny rented loft on ...e of Cleveland.

...first employee, Carl E. Klamm, ...ly to develop a pneumatic ...em for trucks and buses, which ...d on June 4, 1918.

While on a promotional road trip to Boston in 1919, the truck and trailer carrying the company's entire inventory loses a tire, literally sending the business over a cliff.

"Cheer up, we're both in one piece, still in our thirties, smart, single, and good engineers. The world really needs guys like us." — Art's words of comfort to his friend, Carl Klamm (based on a conversation Art had with his son, Pat)

The accident forces Parker's founder to file for bankruptcy and take an engineering position at Nickel Plate Railroad. But the optimistic entrepreneur is determined to make a comeback.

During the roaring 30's, the sky is the limit for automotive innovators and daring aviators who are kindred spirits with entrepreneurs like Art Parker.

In 1924, Art Parker starts Parker Appliance Company again, reinventing and expanding the business to include automotive and industrial fittings, including the revolutionary, patented one-piece flared tube coupling.

By the late 1920s, the company is recognized as the premier designer and manufacturer of precision hydraulic systems for the aviation and automotive industries.

Parker Hannifin Corporation – Innovation Area

Innovation at Parker is presented as an integral part of Parker's Win Strategy. The space has been designed to create a sense of motion, from the topographic ceiling to the innovation pinwheel walls where six multimedia displays engage, challenge and inform participants. The three floor-to-ceiling panels with ever-changing lights, symbolize the thousands of Parker distributor locations worldwide. The "inspiration lounge" allows people to have a quick meeting or a brainstorming session with colleagues. The floor incorporates engineering doodles by Parker engineers.

The wheel loader and plane X-ray images represent two significant markets, heavy equipment and aerospace, that employ Parker technology and systems. A unique 360° video display features ParkerStores, serving customers on a global scale.

This company lives and breathes innovation and this space is a reflection of that spirit.

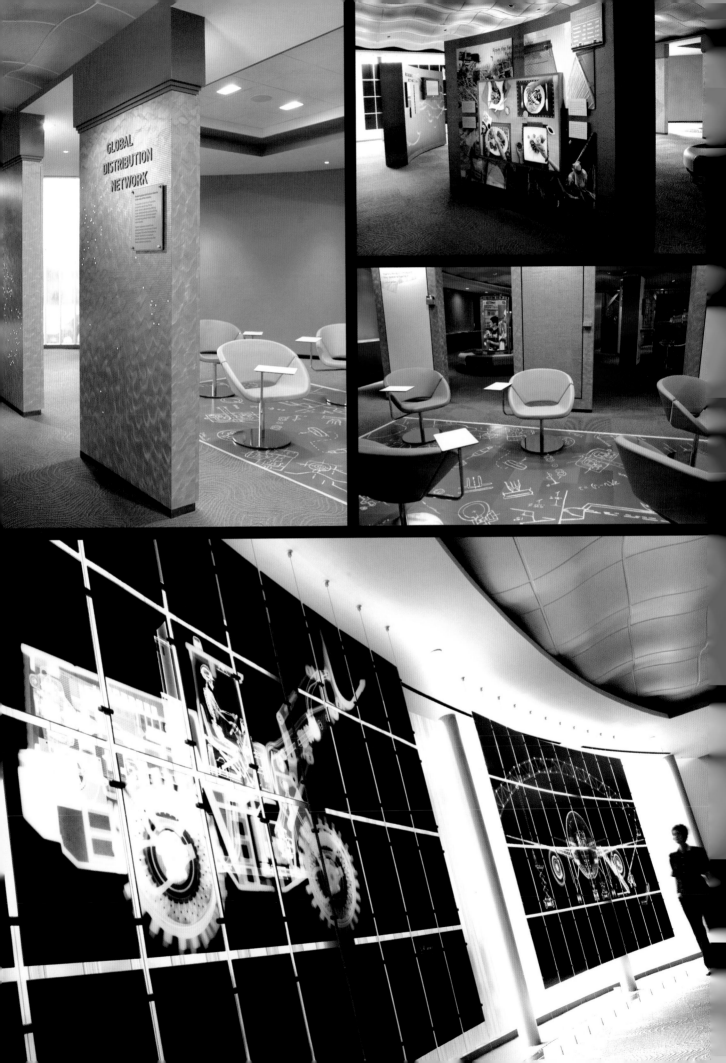

The Sherwin-Williams Center of Excellence

Imagine setting foot into a space that sends you on a journey through time to a fantastic, colorful place that showcases the heritage and inventions that made The Sherwin-Williams Company one of the largest and most recognized coatings companies in America.

The Center of Excellence consists of a reception area, 2,500-sq. ft. exhibit area, conference and meeting rooms. Designed to pay homage to the founders, employees, customers and technological contributions the Company has made during its 140-year history, the Center provides an enormous sense of pride.

No brochure or sales video could convey the Company's breadth and depth exuded in this space.

re invites us to come together

The Cleveland Play House

To create a bright future for the first regional theater in the U.S., celebrating its 90th season, we first looked into its past.

Stark, all-white walls, beginning in the main rotunda and continuing into the theater lobbies and walkways, were transformed into a space fitting of the Philip Johnson legacy design. The solution was to create a new interior palette based on jewel tones already found in the theater.

The result: a bold re-imaging where the audience is now welcomed into a warm, inviting and exciting space.

Design *engages:* It captures attention and holds interest. Design *inspires:* It changes minds and encourages action. Design *educates:* It explains, clarifies, and simplifies. Design *endures:* It provides continuity, cohesion, and order over time. Larsen is a communications design agency of 50 professionals in Minneapolis and San Francisco. Whether it's branding and identity, print collateral, interactive, or environments, the work we create focuses on extraordinary design. For over 30 years, we've helped hundreds of clients, large and small, use design to great advantage. **www.larsen.com**

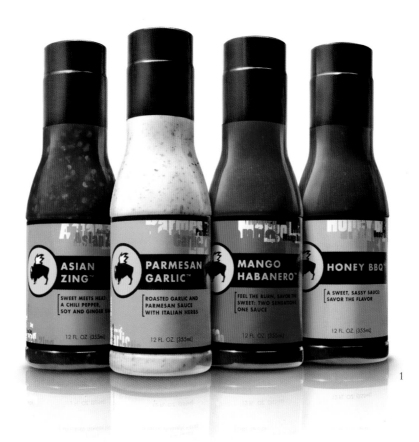

1

Naterra Land / naterraland.com

2 Litho of MN, Inc. / lithoinc.com

MIMA / event website

Enclos / enclos.com

AISLE 1

The Minneapolis Institute of Arts / signage

Minneapolis Public Library / signage

Old Republic Title / annual report

Wausau Paper / promotions

4 Minneapolis Public Library / collateral

Deluxe Financial Services / collateral

5

Saint Louis Art Museum / identity

5 Meyer, Scherer & Rockcastle / identity

Audibel / visual system

BCBS of Minnesota / visual system

LifeScience Alley / identity

College of Visual Arts / identity

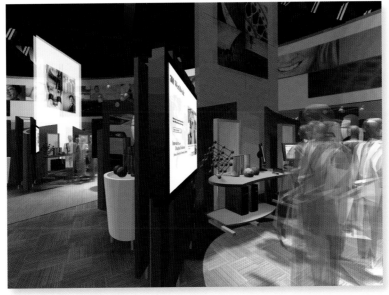

6

6 3M / customer center

Starkey Laboratories / tradeshow graphics

Wausau Paper / tradeshow graphics

SEMI / tradeshow graphics

Starkey Laboratories / collateral

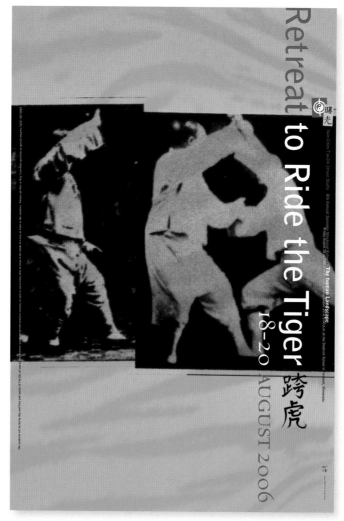

Penumbra Theatre / posters

7 Twin Cities T'ai-Chi Ch'uan / posters

Microsoft / poster

Poetry In Motion / posters

Lesniewicz Associates Inc.

500 East Front Street
Perrysburg, Ohio 43551
419.873.0500

900 Wilshire Drive, Suite 202
Troy, Michigan 48084
248.457.9088

4449 Easton Way, Suite 200
Columbus, Ohio 43219
614.231.4449

For over 30 years, Lesniewicz Associates (LA) has served the graphic design, advertising, and marketing communications needs of some of the world's largest companies, as well as a collection of smaller clients that have gone on to become leaders in their respective marketplaces.

The firm's creed: *Design to Influence*, is born from the company's desire and ability to influence a target audience with a focused message. Composed of

"thinking designers," the group boasts a Midwest design pedigree and pragmatism. Design pervades their culture, their environment, how they live, and ultimately, their work. They eschew passive experiences. What they do is active – with a goal to move people from persuasion to action.

How they achieve this is through a disciplined operational structure. They're practiced at the art of business, but more importantly, they've honed their internal processes and tools in order to

free themselves from the day-to-day machinations of running a business. "We'd rather devote our time to thinking about our clients' business and mission," says the agency's president, Rod Frysinger. "Our focus is their success."

www.designtoinfluence.com

Lesniewicz Associates Inc.

500 East Front Street
Perrysburg, Ohio 43551

What happens when *you* are the client? The company re-branded every customer touch point of its business, including sales materials, portfolios, and presentations. Even the organization's headquarters were relocated and designed to reflect a renewed commitment to employees and customers alike. "We're always instructing our clients to do this. It was time to turn our environment and culture into a living example of what we've been preaching for so long," says Terry Lesniewicz, Chief Creative Officer and founder of the firm.

Packaging brands. For its consumer goods solutions, LA firmly embraces the adage, "The package is the product." The group has designed packages and labels for a variety of foods, durable goods, and home improvement products. The pieces are designed for maximum shelf impact and longevity.

The Panther made us do it.
One of the nation's best known names in home improvement products, Owens Corning, selected Lesniewicz Associates to reinvent their brand – taking the venerable maker of pink insulation from a mere fiberglass manufacturer to a staple of Home Depot and Lowe's stores everywhere.

The agency redesigned the logo, overhauled the company's brand standards, and integrated the new mark into all packaging, literature, and corporate communications systems. LA was also chosen by Pink Panther licensor, MGM, to develop and illustrate a standards guide for Owens Corning's wily feline mascot.

Disciplined passion. Art, furniture, cars, running, food, collecting, fashion – the group's varied interests and passions are reflected in an eclectic and diverse portfolio, as shown here and on the following page. "The people in this group are interested in many different things, which benefits our clients," muses CCO, Lesniewicz. "We have a natural curiosity about the world, and products, and people, and the way companies work. That fuels what we do and keeps us focused on producing great work."

The company's strategies and solutions are formulated within six core areas: Branding, Advertising, New Media Design, Corporate Literature, Financial Communications, and Packaging. These disciplines are often combined into highly targeted, highly rewarding brand experiences.

Logo designed for Roach Graphics, Inc., a specialty screen printer of fine art serigraphs. ▶

WinShapes Software / Microsoft
Schmakel Dentistry
Trumelt Roofing Adhesive
Financial Design Group
Preview Home Inspection
Graebel Global Relocation
Austin Associates

Dunbar Mechanical
CommunitySafe
The Rouse Company
Zyndorf / Serchuk
Gary Osborne Associates
Waterhouse
Floyd's Barber Shop

Golden Retriever Rescue of Michigan
SV Floral Consulting
Jamiesons Audio/Video
Habitec Security / Energy / Internet
Gazelle Award
Medical Office Solutions
Flower Hospital

Frontpath Health Coalition
Construction Architects
SmallBiz Networks
Arbors Nursing Homes
PayXact Payroll Service
Ritter Plumbing
China Stone

109 Vickery Street
Roswell, GA 30075-4926
770.645.2828
www.lorencyoodesign.com
jan@lorencyoodesign.com

Lorenc+Yoo Design (LYD) boasts a broad skill set, specializing what it terms "environmental communication design," a creative genre that includes permanent exhibition design for museums and institutions; temporary design for trade shows; and retail space design, furniture and environmental graphic programs for a diverse base of clients. The firm has completed work for such clients as Sony-Ericsson, Samsung, and the Mayo Clinic, and has helped to reach their goals through a holistic and collaborative approach to design.

LYD has associations with firms around the world, which allow it to collaborate on significant projects internationally. In Dubai, the firm cooperates with HQ Creative, which opens the door to the business boom in the Middle East. Additionally, LYD's decade-long relationships in Korea have matured in numerous projects and connections with three associate firms: CDR; Box & Cox; and 607, a firm with which LYD is currently partnered on a project in Beijing, China.

Over the past decade, LYD has been associated with Pennsylvania-based Journey Communications, Inc. on all of its US-based trade show projects. Implementing LYD's designs, JCI facilitates exhibit construction, installation, and take-down for two to ten trade shows per year. This limited number of trade shows allow the firm's efforts to be especially focused in achieving a powerful client narrative that tells the client's brand story.

LYD founder and principal Jan Lorenc is a co-author of a newly published book from London entitled What is Exhibition Design? In the book, Lorenc chronicles the different types of exhibition design, the design process, and features some of the foremost international design firms.

Lorenc+Yoo Design is pleased to craft immersive, high-quality environments for each client. LYD's story is one of broad scope and unrivaled attention to detail in every project. Through an astute awareness of its own story, Lorenc+Yoo Design has a unique ability to communicate that of others.

(This spread) BlackRock Realty
ICSC
Las Vegas, NV

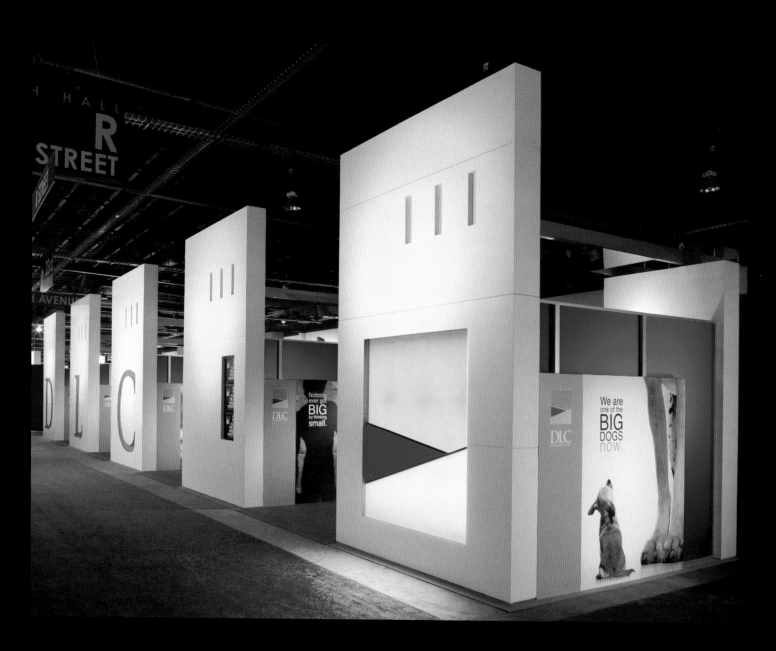

DLC
ICSC
Las Vegas, NV

(Opposite page) DLC
ICSC
Las Vegas, NV

Phillips Edison & Company
ICSC
Las Vegas, NV

X Team
ICSC
Las Vegas, NV

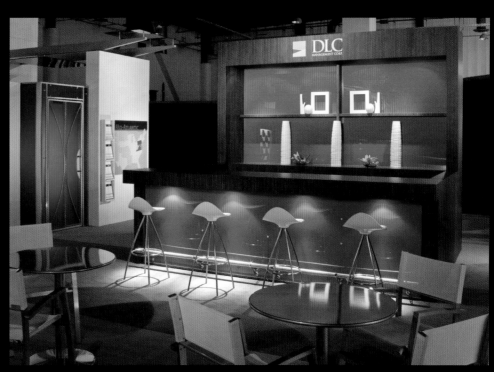

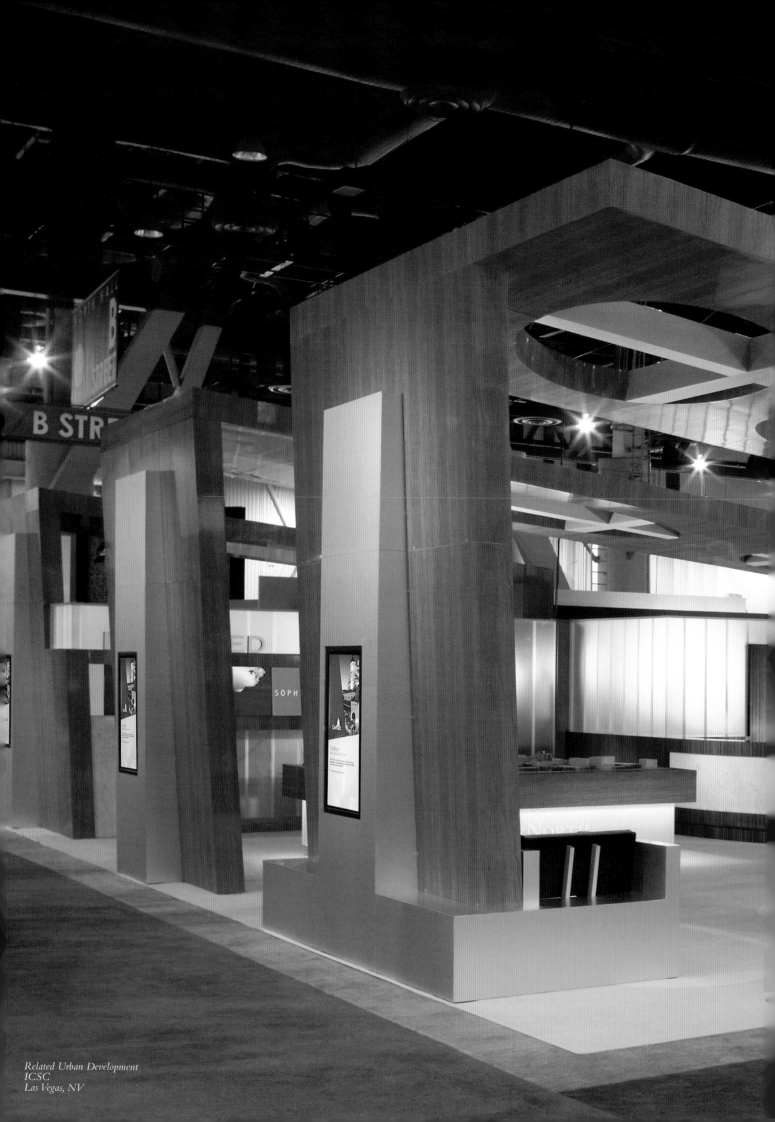

Related Urban Development
ICSC
Las Vegas, NV

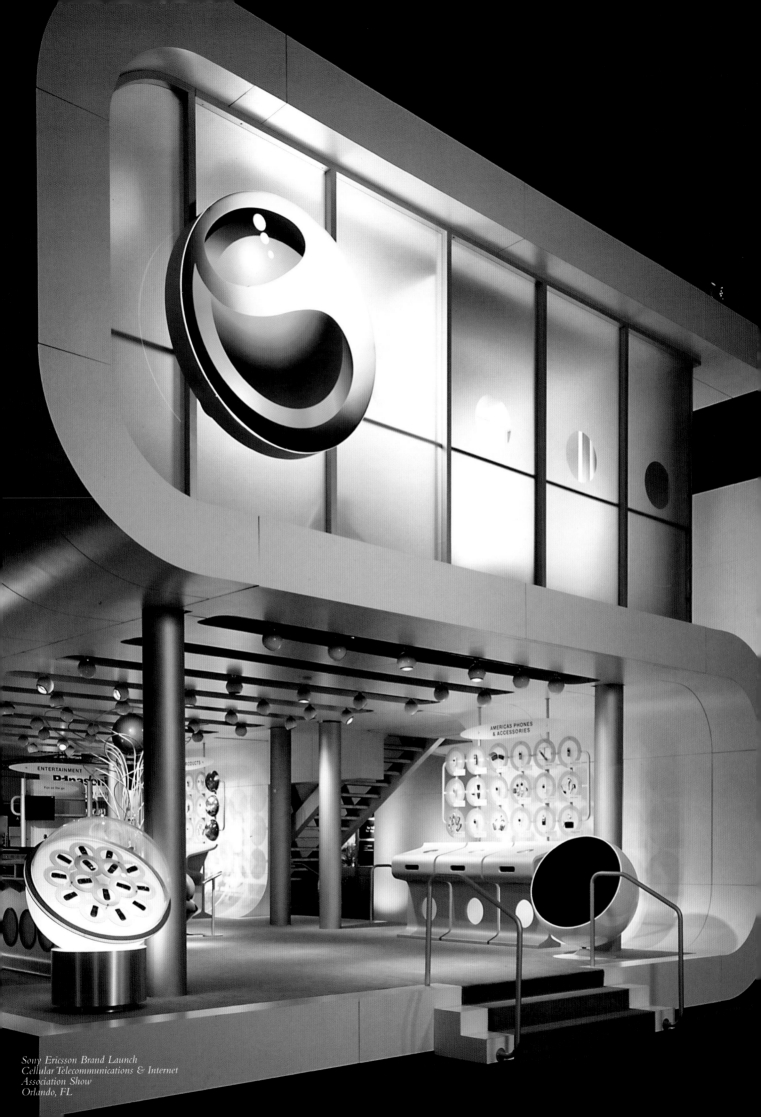

Sony Ericsson Brand Launch
Cellular Telecommunications & Internet
Association Show
Orlando, FL

Most consumers today make the decision to purchase products at the point of sale. It follows, then, that the ability of a brand or package to connect with a shopper matters enormously. The guise a brand takes on can literally make or break its sales. In an environment like this, any product could use a design edge over the competition. For more than 25 years we have been providing consumers with clearly presented stories of substance and believability with which they can connect. We shape each of our clients' products to provide consumers with experiences that are original, enjoyable, enduring and rewarding. We turn simple consumers into loyal friends. Our approach may not be right for every client or project. But work that provides a product with a unique marketplace edge is.

moi

Domingo's - Established in 1935. Traditionally made gourmet pork rinds. Photo is of original shop. Positioning strategy, naming, brand identity, packaging, collateral.

Branding Packaging Trademarks Collateral

Echo Falls - Best-selling premium smoked fish products in the U.S. Positioned as a Victorian era heritage brand. Positioning strategy, naming, brand identity, packaging, collateral.

PINNACLE

BALANCE • NATURAL

SUPERIOR CANINE NUTRITION

WHOLESOME

A CHICKEN-BASED SAVORY
BLEND OF NUTRITIONALLY BALANCED
NATURAL PROTEINS, FATS, GRAINS,
VEGETABLES, VITAMINS, MINERALS
AND PROBIOTICS

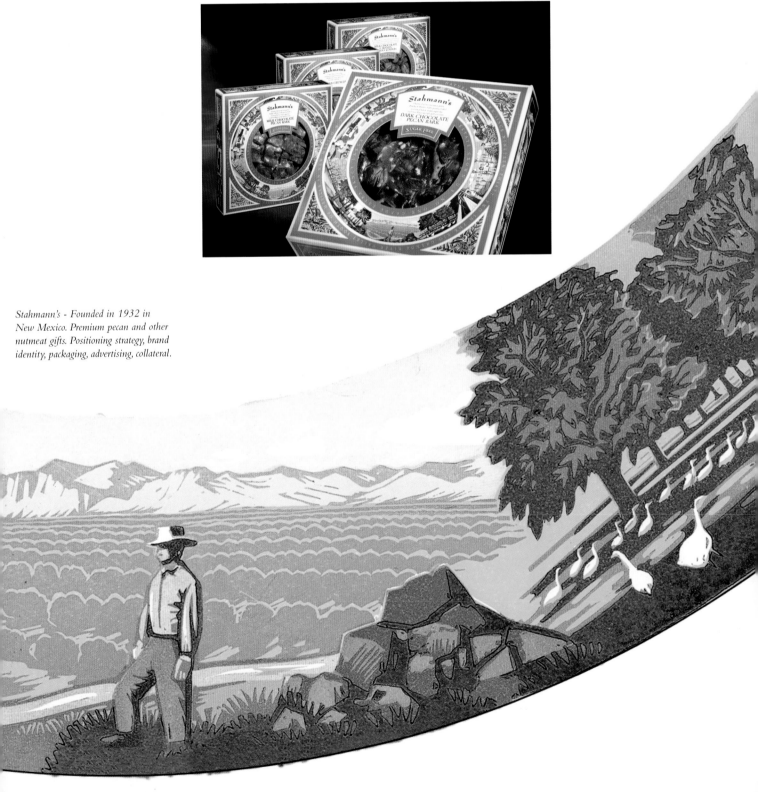

*Stahmann's - Founded in 1932 in
New Mexico. Premium pecan and other
nutmeat gifts. Positioning strategy, brand
identity, packaging, advertising, collateral.*

Trademarks

Honest Foods - Natural foods brand identity.
New Frontiers - Natural foods grocery chain signature.
Tribe Mediterranean Foods - Hummus food products signature.
Santa Ynez Valley Alliance - Rural community organization monogram.
Bellwether Farms - Artisan creamery brand identity.
Sta. Rita Hills - California viticultural appellation seal.
Motorhome America - Affinity Group, Inc. - RV club seal.
Pillar Rock - Alaskan seafood seal.

Mass
180 Varick Street Suite 1334
New York, NY 10014
212.989.6999
www.mass.com

MASS specializes in elevated brand expressions in all areas of design, art, fashion, technology and performance.

An idea begets a logo, a logo morphs into furniture, furniture becomes performance, people mutate into products, products spawn from packaging, animation turns interactive, interactive begets print advertising, a beautiful cycle of infectious cross fertilization: design as bridge between separated categories, as weapon to invade.

As brand identity is both corporate and individual, consumers have a right to influence the experience of the brand that they are consuming: with product ownership comes control. The multidisciplinary design consortium MASS acts as mediator between both interests, guaranteeing interactive experiences that not only include traditional interactive media such as the "internet", but enable people to play with packaging, retail environments, themselves.

German-french born founder Stephan (Valter) is spreading his personal brand of Design to an ever wider range of applications, merging MASS with LUXURY, and high concept with high design. The confluence of media, art and design sets a great stage for him to explore abstract concepts with commercial goals. The group includes the outstanding designers and partners Kai Zimmermann and Chen-Chieh Ni.

MASS invites you to join the company on its category-transcending path forward.

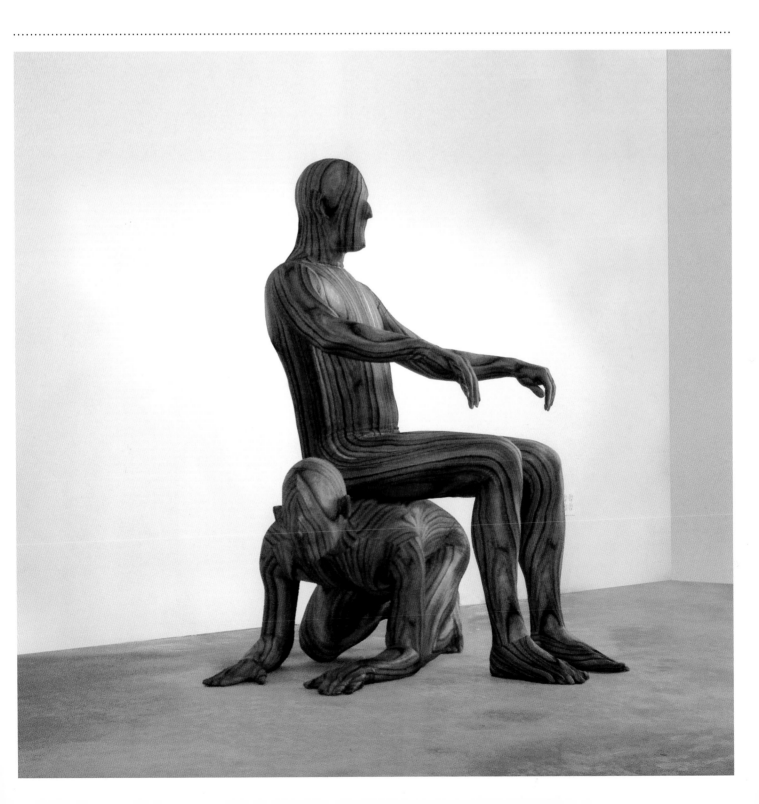

Logo Lounge
Logo identity and furniture design
*Conduct business or relax on the logo of Project, the leading
contemporary fashion tradeshow in Las Vegas.*

(Opposite page) Change Concept Store
with LaRok & 7 for All Mankind
Retail concept, store interior, identity & interactive video.
*Open for 2 weeks during the 06/07 holidays in NYC, this
concept store by Mass represents an industry first, elevating the
changing room from a neglected but necessary element to the
centerpiece of a retail operation, and creating an empowering
symbol of identity change.*
*Motion sensors and interactive video allow customers to control
and literally change their spacious room environment with a
wave of their hand.*
*Animated worlds and interiors are designed around the idea of
change: a Louis Quatorze boudouire changes into a super futur-
istic bedroom, summer changes to winter, body shapes change
from super wide to super skinny, women change into dolls, into
any style of any time.*
*View videos and interactive simulations of the installations at:
www.mass.com/change*

(Previous page) Human Furniture
Design performance during ICFF NY 2006
*Humans form usable furniture pieces allowing users to experi-
ence the ultimate design object: themselves.*
Depicted here: HF Armchair.
More at: www.mass.com/humanstore

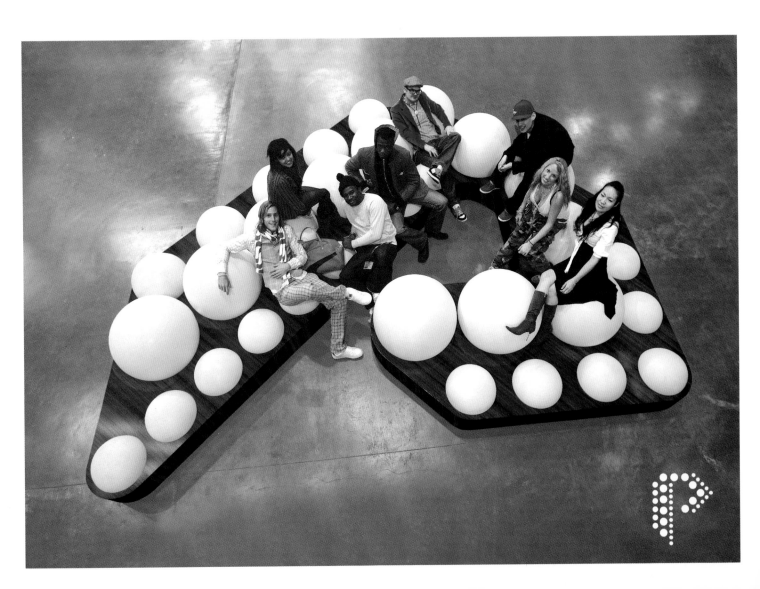

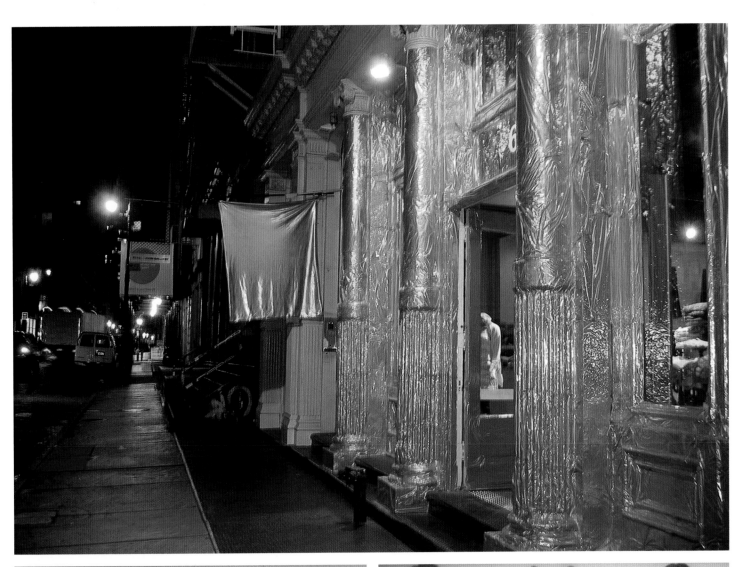

1 Website design
for Rémy Martin Louis XIII Black Pearl. louisxiiiblackpearl.com

2 Website design
for Rémy Martin V.S.O.P. mass.com/remysummer07

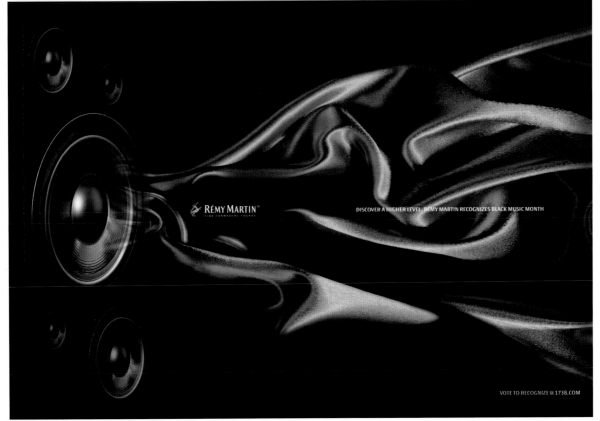

1 Website design
for Rémy Martin 1738, viewable at: mass.com/1738

2 Print Advertising XXL magazine, part of a 12-page sequence
for Rémy Martin 1738

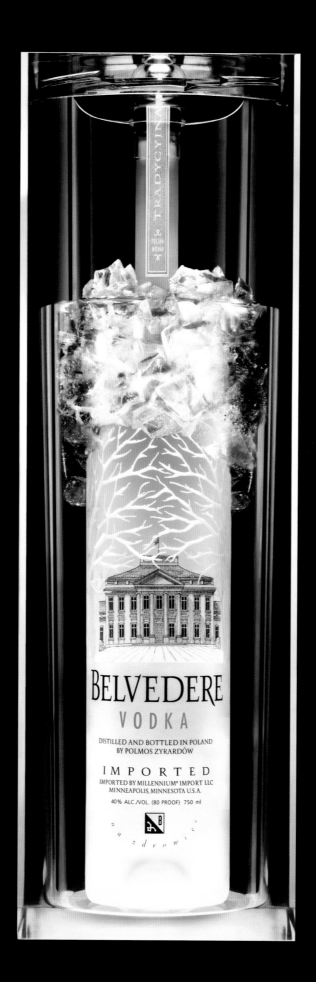

Ice Tower / Belvedere Vodka:
Design of an interactive retail packaging
that turns into a high-presentation ice
container for nightclubs and homes.
By adding water the visually distorted
bottle regains its shape. Acrylic.

(Opposite page) Ice Tower TV commercial.
3D by Funktrip

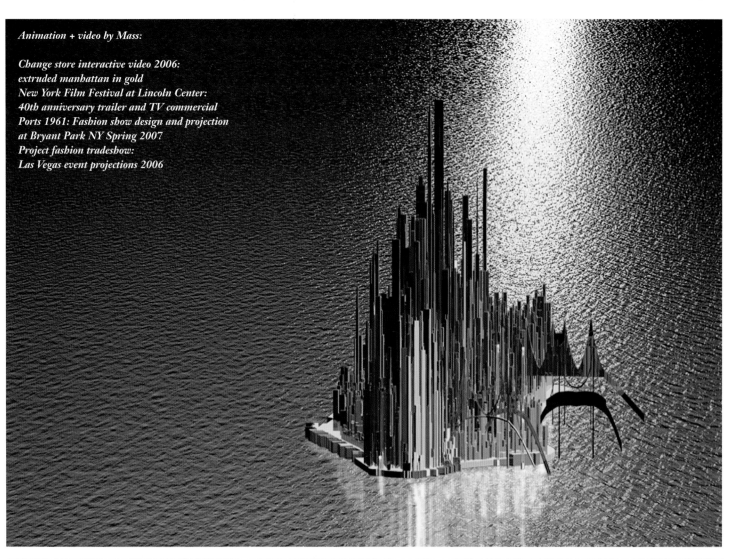

1 CITY

057 COUNTRIES

2150 STORIES

After twenty five years in communication design we know three things for sure. Design should engage the mind and heart. Design should inspire action and create loyalty. Design is ultimately about people and enhancing their lives.

We believe the true potential of design
is just starting to be delivered online...
where touch points become conversations,
and everyone has a voice.

National Geographic Magazine Minnetrista Cultural Center Iona College The Carter Center

September 2007 Table of Contents >

NATIONAL GEOGRAPHIC

Global Fisheries

YOUR SHOT

See our Daily Dozen photo selections. Then upload your favorite shot.

Carbon Diet

Get tips for reducing your impact on the environment.

More in Blog Central >

LATEST FEATURES

Ultra Marine
Discover the trove of biodiversity found in the phenomenal coral wilderness of far eastern Indonesia. >

Crown of the Continent
By 2030, Glacier National Park may have lost all its glaciers. But Glacier-Waterton will always be a wonderland. >

Tales from the Bog
Using current technology, investigators hope to make sense of the bodies preserved in Europe's wetlands. >

Cell Phonies
Browse through our photo gallery of disguised cell phone towers and see if you can spot the antennas. >

INTERACTIVES & MAPS

Decade Volcanoes
Explore 15 volcanoes with explosive histories and close proximity to human populations. >

Discoveries in the Dark
See eyeless spiders, translucent millipedes and other odd cave dwellers recently discovered by scientists. >

Test Your Maya Knowledge
Scholars have long puzzled over the rise and fall of the Maya. Now it's your turn: Try our interactive quiz. >

Featured Interactive
Read about America's offbeat edibles. Then you can eat your way across the U.S. by checking out these locals-only recipes. >

NGM PHOTOGRAPHY

Visions of Earth
Circle the world with *National Geographic*. Discover the bizarre and often quirky beauty of life on Earth. >

Photo Contest: Enter Now
Share your vision of the world through your own photography. Submit your entry online. >

Photo Galleries
See every photo from our recent stories, plus images from NGM photographers you can only find here. >

Tales from the Bog >
Struggle for Pakistan's Soul >
Glacier National Park >
Mexico's Pilgrim Cowboys >
New Orleans in Peril >

Our seven-year partnership with National Geographic has leveraged all that we offer at MDG – online brand planning, technology, design and interactive storytelling for three magazines and the Channel. Our focus has been

We have executed over 60 Flash documentaries called *Sights and Sounds* for National Geographic that present behind-the-scenes commentary from researchers and photographers featured in the magazine. Other features include minisites, games, contests, enewsletters, blogs and forums that are updated monthly using our online marketing management software, Nimbus.

The Smithsonian National Portrait Gallery engaged MDG to develop branding, print, online promotions, judging application, artist blogs, kiosk and an exhibition site for the inaugural Portrait Competition culminating in the Gallery reopening.

2006 OUTWIN BOOCHEVER

PORTRAIT
COMPETITION

PAINTING

SCULPTURE

CALL FOR ENTRIES
JUNE–SEPTEMBER 2005

WWW.NPG.SI.EDU

Smithsonian *National Portrait Gallery*

Smithsonian
National Portrait Gallery

downloadable flyer | e-mail this page to a friend

The Exhibition
People's Choice Award
Portrait of an Artist
For Educators
FACE IT!
About the Competition
National Portrait Gallery
Contact

The call for entries for the next Outwin Boochever Portrait Competition will be held in the summer of 2008.

THE OUTWIN BOOCHEVER 2006

PORTRAIT
COMPETITION
PAINTING & SCULPTURE

EXHIBITION
JULY 1, 2006 – FEBRUARY 19, 2007

Contemporary painted and sculpted portraits from throughout the United States.

Exhibition

Portrait of an Artist

FACE IT!
For Kids of All Ages

...is an educational site and exhibition organized by the High Museum of Art, Atlanta. The site included an interactive exploration of Florence, a day in the life of Verrocchio's assistant, 14 year old Leonardo da Vinci, games and educational videos.

Estate needed a
ould promote
nge of available
and activities
one-day house
ne visitors can
8,000-acre estate

SOLÍS™ CAMBRIA HOTEL & SPA
ADELBODEN, SWITZERLAND

ENGLISH · GERMAN

SPECTACULAR VIEWS INSIDE AND OUT

From our extraordinary location, nestled near a quaint village between two Alpine mountains, to our stunning views where skiers gaze over snow capped peaks, you will experience unprecedented personal attention. At Solis Cambria we provide a truly accommodating environment. Our dedication to the individual guest is thoughtful, reliable, consistent and complete – because we recognize that impeccable service isn't an amenity. It's a must.

ACCOMMODATIONS
50 Guest rooms · 19 Family Suites · 2 Presidential Suites

AMENITIES	MEETING ROOMS
Spa Solis / Fitness Center	Ballroom 1,100 sq feet
Kids Zone	80 seated / 160 Standing
Restaurant	Meeting Room 210 sq feet
Lobby Lounge	15 seated / 30 Standing
Garden Terrace	Meeting Room 250 sq feet
Bar / Lounge	18 seated / 30 Standing
Business Center	

OPENING WINTER 2007

41 33 673 83 83

Solis Hotels & Resorts
solishotels.com

Solis Cambria Hotel & Spa
Dorfstrasse 7 3715 Adelboden, Switzerland

Solís Hotels & Resorts is a new entry into the five star international hotel market. Communicating a commitment to personal service begins with the identity designed by MDG and is being implemented in print and online as the new hotels become operational.

MDG

M E L I A D E S I G N G R O U P

Online Strategy, Design Implementation
Flash, Video, Interactive Features
Nimbus 4.0 Online Marketing Management Software
Brand Development, Identity, Print, Collateral
Exhibit and Space Design

See our portfolio at www.melia.com

MetaDesign
615 Battery Street, 6th Floor
San Francisco, CA 94111
415.627.0790
www.metadesign.com

MetaDesign®

MetaDesign exists to combine the art and logic of design in ways that build significant social and economic value.

As Modernists, we strive to fit the best technologies of our time with the best ideas of our time to create communication that can be universally understood, used, and enjoyed. As Humanists, we believe we should act in ways that accommodate human nature, meet human needs, amplify human potential, and leave plenty of room for personal expression.

We work alongside a broad spectrum of leaders and are fortunate to have played a part in thousands of projects around the world. Through it all we have seen that small moments of communication can cause large, positive changes for people as they make their way through the dynamic and often complex systems of everyday life.

The new visual brand MetaDesign created for Adobe Systems Inc. addressed an emerging emotional disconnection between the company and its customers, and helped to reignite Adobe's reputation among creative professionals worldwide. The comprehensive program spanned packaging, corporate communications, services and screen-based interfaces.

(Left)
Artwork commissioned by MetaDesign and created by Peter Saville and Howard Wakefield. A digital 'remix' of the Creative Suite packaging imagery, this piece was distributed as a poster to design schools to build awareness of the Creative Suite among design students.

(Below)
Adobe Annual Report 2003 (print and online versions)

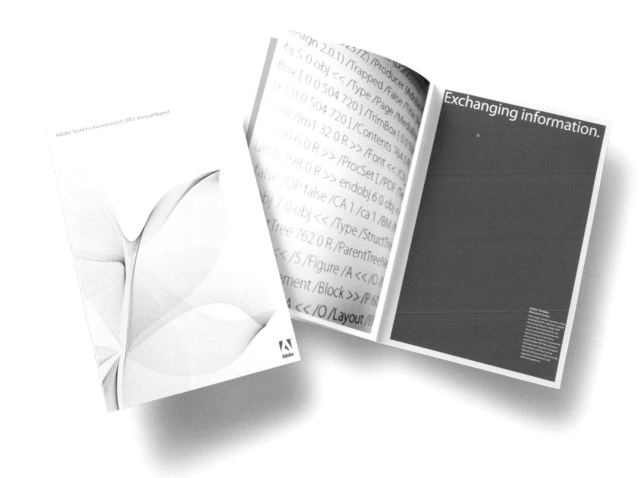

Information. Ideas. Memories. Communicating each of these elements invokes the power of both art and technology. One company builds platforms that bring the two together: Adobe Systems.

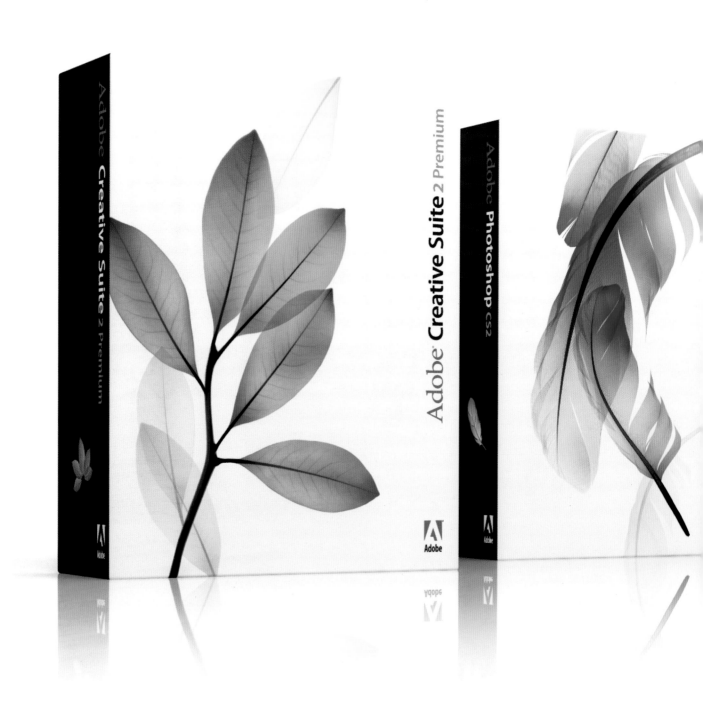

Adobe Creative Suite 2 packaging.
The images are actual x-rays of natural forms that
reveal the formulaic beauty within. The imagery
offered a metaphor for design software, which in itself
is a series of formulas based on creating wondrous
and varied visuals.

(Below, top to bottom)
A series of sub-brand symbols created for various Adobe
products and services:
Adobe Expert Support
Adobe PDF Print Engine
Adobe Stock Photography

Metal
2370 Market St. #408
San Francisco, CA 94114
415.285.2170
www.metal.cc

From our humble beginning in 1987, Metal has grown into a multi-faceted design firm with diversity in talents, backgrounds, interests, clients and design disciplines. We work in all forms of media and serve diverse clients whose work and vision intrigue and challenge us. This includes all areas of print communications, corporate branding, annual reports, all facets of web based communications such as internet/intranet/extranet, as well as interactive and multimedia presentation. We are the creative catalyst between the client's objectives and their results. Each of our clients' problems must be defined and solutions found that will adhere to their goals and just as important, their budget.

We believe that good design helps businesses clarify and realize their vision, enhance their products and services, and serve their customers better. Our goal is to help our clients gain and hold ever-higher footholds in their markets.

Given the studio's relatively small size, we accomplish a large amount of creative work. The strength of our design team lies in a blending of expertise that cuts across all design, marketing and related technical disciplines which gives it uncommon versatility. The firm is known for being unusually responsive to client needs and for delivering consistent top-quality, results-oriented creative products under virtually all conditions and all communication design disciplines.

Since 1987, one thing that has not changed--getting to work with some very brilliant clients who we continue to learn so much from everyday. The unanimous reason why they love working with us is simply because "Metal works" effectively as their strategic partners.

METAL.WORKS.

 annual report branding print interactive ads

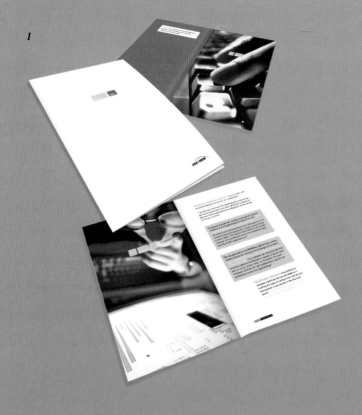

1

2

3

1. Control Risk. Maximize Return.
*An annual report for Bindview, an IT
risk management software company.
The report serves a dual purpose as
a capabilities brochure as well as an
annual report.*

2. Transforming
*For the past 5 years, Camden has been
transforming itself inside out. With the
creative usage of heat sensitive materials
on the cover, the Camden strategic
transformation story was slowly revealed
effectively from cover to cover in this
annual report.*

3. Time
*Reliance Steel & Aluminum Co. annual
report with the "Time" concept was
to convey to shareholders that things
may change through time and despite
economic ups and downs, Reliance
remains stable, strong and profitable.*

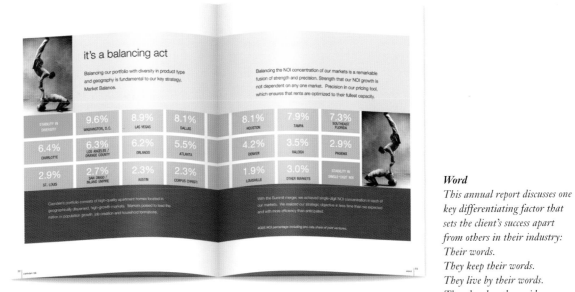

Word

*This annual report discusses one
key differentiating factor that
sets the client's success apart
from others in their industry:
Their words.
They keep their words.
They live by their words.
They do what they said.
Lenticular effect on the cover
is used to illustrate their
brand mission.*

MeritBank *1*

2

3

1. Merit Bank

2. PSP, an architecture/
engineering firm

3. Rain, a Japanese Bistro

4. Roar, a Soccer Team

5. Triad Resources, IT Staffing

6. Contract Resource Group
a contract furniture and space
planning company

4

TRIADRESOURCES

5

CONTRACT | RESOURCE | GROUP *6*

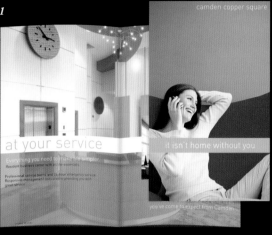

1.-2. Camden branding
The branding assignment for Camden is extensive. It includes all corporate paper systems, corporate brochure systems (some of which are shown here) as well as internet, intranet, extranet system branding, marketing materials, print and online advertising campaings, and signage.

3. Camden Rocks
2006 was a year to remember for this client whose financial results were the most spectacular in their 14-year history as a public company. Their annual report reflects not only their solid gold performance but the value of staying true to their mantra, living excellence.

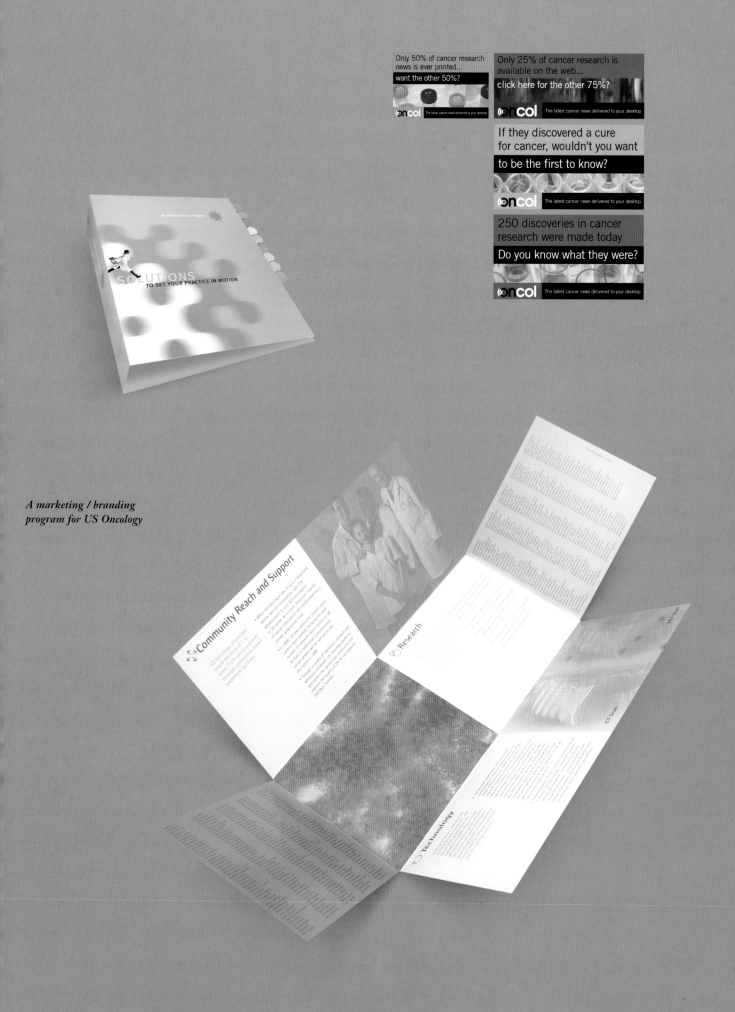

A marketing / branding program for US Oncology

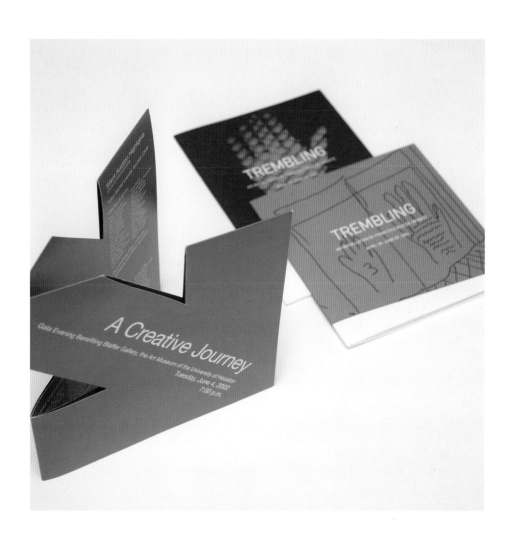

Trembling

Invitations for an exhibition called Trembling and a fundraising campaign "Creative Journey" were designed for the Blaffer Gallery on the University of Houston campus. The design for the artist reception communicates the theme of the show: a direction, a journey.

1. Create Your Space
An innovative online interactive
furniture arrangement developed
for Camden website allows you
to explore and design your living
space.

2. Apache
The Apache Recruitment site
was created as a resource for
graduates looking for a career
in oil and gas exploration and
development.

3. Aslan
Working closely with Aslan
senior executives, Metal reshapes
the Aslan corporate branding
and captures the right visual
signature for a very diversified
real estate holding company.

4. Give Thanks America
This spot developed for HP
promotes the effort of GTA
which is the only national
initiative that allows Americans
to send messages of thanks and
support to those in uniform.

"Daddy, tell me a scary story from when you were a kid."

"Did I ever tell you about the time your uncle got stuck at the top of our magnolia tree?"

"Yes, I like that one. Tell me again."

These stories connect our lives to our children's. Stories take images, ideas, and emotions from one mind and transfer them to another. When you tell me your story, I walk in your shoes, think your thoughts, taste your passions. And I *remember*.

We love to uncover and share our clients' stories. Whether it's zebras at Pete's Pond or the inner workings of a cylindrical lock or a third-grader discovering deep sea creatures – you have a great story to tell. When you tell it well, people will connect, imagine, click, register, call, buy, apply.

We are storytellers. Let us tell yours.

NATIONAL GEOGRAPHIC

WILDCAM AFRICA

HOME WILDCAM ANIMAL GALLERY WALLPAPER & POSTCARDS BLOG MAP WHY PETE'S POND? TECH TALK

VIEW THE WILDCAM ✤

▶ SWEEPSTAKES: REGISTER FOR A CHANCE TO WIN A SAFARI.

THE ANIMAL GALLERY

WHY PETE'S POND?

One man's passion to protect Botswana's wildlife and give them room to run free in expanded territory has led to a success story at Mashatu Game Reserve. And there's still more to come.

Learn More >

Set off on an interactive photo safari to see the kinds of animals that gather at Pete's Pond. Just shuffle through this set of WildCards.

Learn More >

THE RESEARCHERS

Meet two Mashatu researchers dedicated to learning more about leopards and elephants and resolving conflict between their wild charges and humans.

Villiers Steyn > Jeanetta Selier >

RESOURCES CREDITS

1

2

3

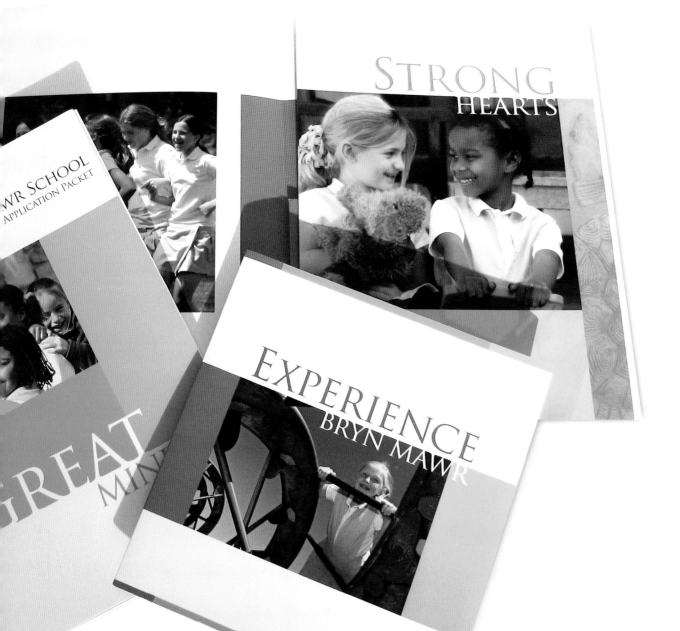

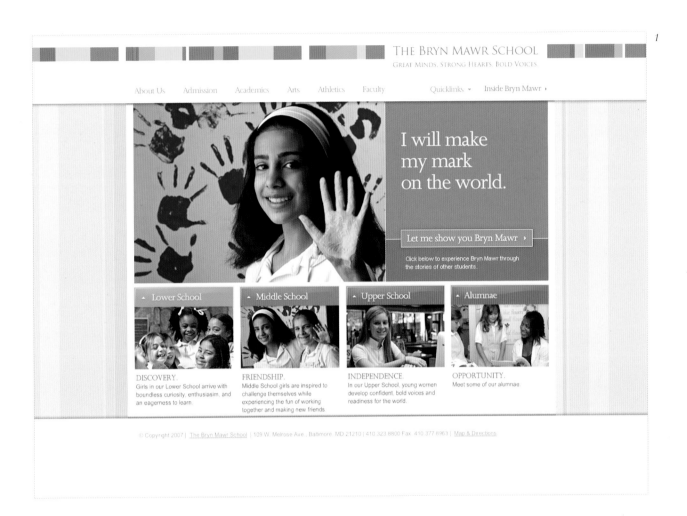

The Bryn Mawr School rebranding campaign.

(Opposite page) The Bryn Mawr School viewbook and admissions packet.
(This page) 1 The Bryn Mawr School website 2 Stationery 3 Postcard campaign.

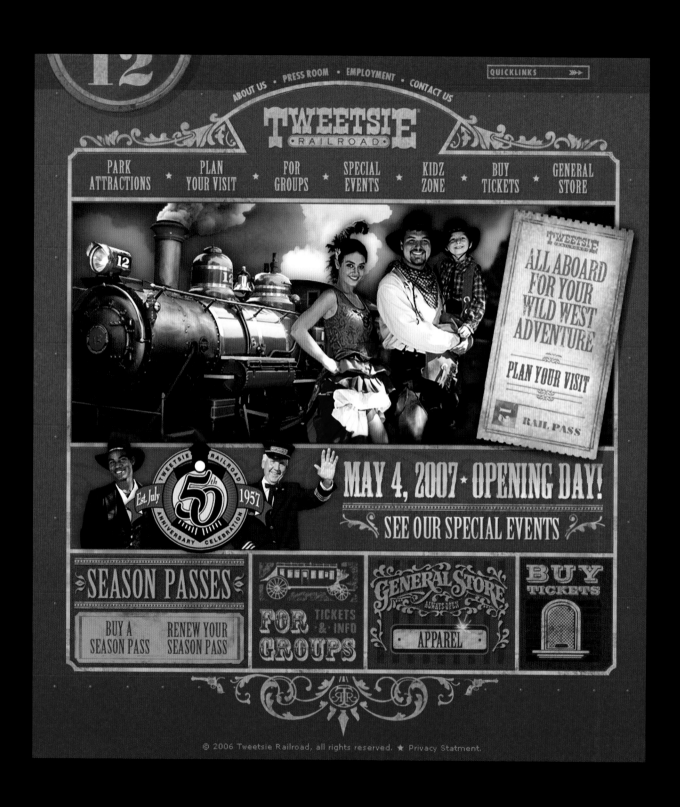

(This page) Tweetsie Railroad theme park website.

(Opposite page) Roanoke Valley SPCA website
1 RVSPCA Homepage 2 Adopt A Pet profile page.

Gentle giant seeks affection & companionship.

Mission Statement:
The Roanoke Valley Society for the Prevention of Cruelty to Animals is a non-profit organization whose purpose is to improve the quality of life for animals and the people they touch in the Roanoke Valley.

✣ **MEET YOUR MATCH™**
Let us help you find your ideal match. (dogs only) ›

Success Stories
Adoptions since Feb 1, 2003

Latest adoptions:
Molly
Mr Tickles
Champ

View More>

5,204

Looking for a lost pet?
Visit the RCACP >

Make an impact through giving.

Your support provides:
- Medical attention to injured & sick animals
- Sheltering homeless & unwanted animals
- Finding loving homes for animals

Donate ›
Volunteer ›

ROANOKE VALLEY SPCA'S
Spay-ghetti
supper
OCT. 24th
serving
4:30 - 7:30

When: Oct 24 - 4:30 - 7:30 pm
Friendship Retirement Center, 347 Hersberger Rd., Roanoke. All proceeds benefit the spay/neuter clinic.
Read more › Download the PDF flyer.

What's New + All Events ›

Kroger Cares Gift Card Program
Help the SPCA when you shop at Krogers!
Read more › Download the PDF flyer

Basic Canine Manners Class - Ongoing
Any dog adopted from the RVSPCA is eligible for this free class. Read more ›
Download the PDF flyer.

6th Annual Art in the Atrium - Oct 24 (5pm to 8pm)
Fitzpatrick Hall in the Jefferson Center. This art show by local artists will benefit local charities. Read more ›

Our 2008 Pet Calendar
Available in September, 2007.
Pre-orders on the 2008 Pet Calendar are being accepted online only! View Merchandise ›

Open to the public Mon-Sat at 11:30 a.m. Click for full schedule • 1340 Baldwin Ave., N.E. • Roanoke, VA 24012 • 540.344.4840 • Directions Contact Us

Adopt A Pet

Meet Your Match (dogs only)
Animal Gallery ▸▸▸
Learn About Breeds
The Adoption Process

Pet Health - Ask The Vet
Behavior Tips & Training

Success Story
Name:
Mitzey Moppet
Adopted:
Jan 27, 2007
more ›

Looking for a lost pet?
Visit the RCACP >

Our 2008 Pet Calendar
Available in September, 2007.
Pre-orders on the 2008 Pet Calendar are being accepted online only! View Merchandise ›

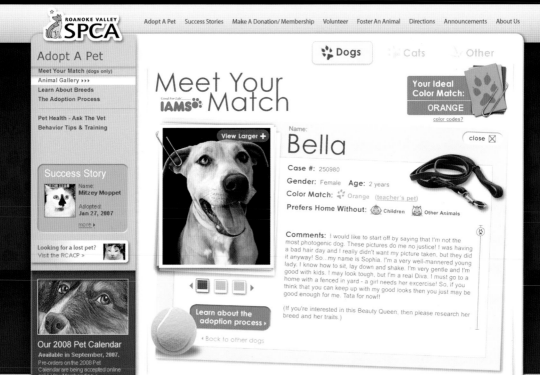

✣ **Dogs** Cats Other

Meet Your Match
Good For Life
IAMS ✣

Your Ideal Color Match:
ORANGE
color codes?

View Larger +

Name:
Bella

close ✕

Case #: 250980
Gender: Female **Age:** 2 years
Color Match: ✣ Orange (teacher's pet)
Prefers Home Without: 👶 Children 🐾 Other Animals

Comments: I would like to start off by saying that I'm not the most photogenic dog. These pictures do me no justice! I was having a bad hair day and I really didn't want my picture taken, but they did it anyway! So...my name is Sophia. I'm a very well-mannered young lady. I know how to sit, lay down and shake. I'm very gentle and I'm good with kids. I may look tough, but I'm a real Diva. I must go to a home with a fenced in yard - a girl needs her excercise! So, if you think that you can keep up with my good looks then you just may be good enough for me. Tata for now!!

(If you're interested in this Beauty Queen, then please research her breed and her traits.)

Learn about the adoption process ›

‹ Back to other dogs

Open to the public Mon-Sat at 11:30 a.m. Click for full schedule • 1340 Baldwin Ave., N.E. • Roanoke, VA 24012 • 540.344.4840 • Directions Contact Us

What's your story?

newcitymedia

1872 Pratt Drive, Suite 1250
Blacksburg, VA 24060
540.552.1320 800.955.4918
www.newcitymedia.com

optimasoulsight.com 847.681.4444

Optima Soulsight is a group of global reach agency partners in North America, Latin America, Europe, Asia and Africa. We offer a full range of integrated brand consulting and creative design services. Our focus is on identifying each brands' greatest potential and elevating the brand experience through smart, intuitive creative solutions.

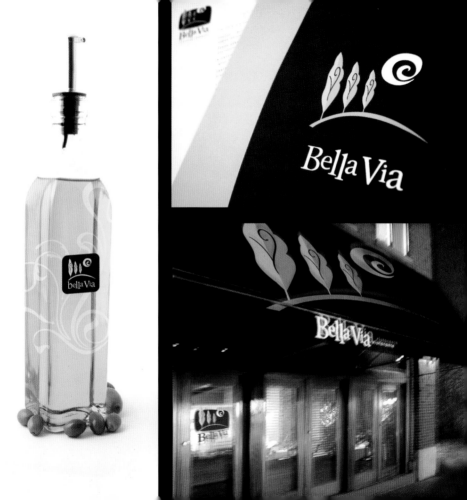

1. Miller Chill Packaging & Branding 2. Coca-Cola Holiday Packaging 3. Red 7 Wine Label Design

Lake Champlain
CHOCOLATES

small world
Truffles

Opposite: Small World Truffles Packaging
1. Lake Champlain Fall Selections 2. Lake Champlain Organic Packaging 3. Small World Identity

Dvolve Brand Innovation, Aggressive Skate Graphics, Apparel design and Collateral

MODULAR

1. Stinger Pro Lures 2. F & F Exposition Company 3. Modular Housing Solutions 4. Kona Surf Guides

Philographica
1318 Beacon Street
Suite 12
Brookline, Massachusetts
02446
www.philographica.com

Are you ready for a fresh look? No need to stand on your head or twirl until you're dizzy. It's possible to discover something special in the most common places. That's what we do. We peel away the layers until we find the truth. We use great design to show your authentic self. That's when your target audience will make the best connection.

Maybe you've been struggling for a while trying to design something with the same old team. If the challenge is keeping you up at night, you may need the advice from a new perspective. Free from the organization's daily struggle, it's sometimes easier for an "outsider" to figure out what's worthy of reporting.

We have a diverse client base spanning over ten years and the firm's two principals have a total fifty years of combining great strategy and great design for print and electronic communications. And we always have fun.

We inform, delight and inspire in unexpected ways. We can tell your story as it's never been told. You'll have the results you've been dreaming of.

So, how about we go together for a spin? Phooey to the mundane and the way things have always been (unless, of course, that's working for you). We're here if you're ready to mix things up a bit.

(Opposite page)
KENYON COLLEGE
Capital campaign communications
Annual fund communications
Brand identity

(This page)
SUFFOLK UNIVERSITY
SUFFOLK UNIVERSITY LAW SCHOOL
Capital campaign communications
Admission communications
Brand identity

Dexter School

...education for boys from preschool through Class 12
Brookline, Massachusetts

Dexter's earlyfocused
on developing aand
curiosity for learningnurturing
environment. Activitiesgrate language
and mathematics with science and social studies.
Music, movement, and art help students
develop fine and gross motor skills. An emphasis
on social development encourages students
to move beyond a self-centered perspective to
cooperation with others.

...to do a little good every day...

Kindergarten 1
and Kindergarten 2
lower school

Southfield's early childhoodis focused
on developing a strong f... ...
curiosity for learning i... ...
environment. Activ...
and mathematic...
...ic, mov...
...p f...

Southfield School

A classical education for girls from preschool through Class 12
Brookline, Massachusetts

Living in a
Community

(Opposite page)
MIT SLOAN SCHOOL OF MANAGEMENT
Admission communications
Alumni publications
Program identity

(This page)
MIDDLEBURY COLLEGE
Admission communications

THIS IS YOUR PLACE TO

Sharpen Your Mind

Community by the Numbers:

Dorothy Shanahan-Roberge

Poulin + Morris Inc.

Poulin + Morris Inc.
286 Spring Street
Sixth Floor
New York, New York 10013
212.675.1332
212.675.3027 fax
www.poulinmorris.com

Poulin + Morris Inc. is an internationally recognized, multidisciplinary design consultancy, founded by Richard Poulin and Douglas Morris, involved in all areas of visual communications, including environmental graphics and wayfinding sign programs, exhibition design, graphic identity, interactive media, promotional print, and publication design. We solve design problems for an extensive range of clients, from architects, corporations, and real estate developers to cultural, educational, governmental, medical, and non-profit organizations.

Our ability to undertake challenging projects, varied in nature, size, and scope, is our primary strength. Our reputation is built on our ability to listen intently, responsibly, and decisively to our client's needs. Experience has demonstrated that although each task demands its own unique approach and individualized solution, certain basic principles can be applied to all design problems.

As designers, we believe that it is particularly important that graphic design be considered as a rational, problem-solving process; one in which the designer is called upon to communicate specific information effectively and sensitively; in the right place, the correct scale, and in the appropriate context. We also believe that as visual communicators or storytellers that barriers or boundaries need not exist with the stories we need to tell or with the mediums we ultimately determine are the most effective and meaningful for each story.

Our studio is rooted in education, investigation, and the sharing of ideas and information. Our experience, staff, resources, and working knowledge of visual communications, materials, processes, and current technologies has given us the flexibility to undertake projects of varied scales, requirements, and context. Whether developing design solutions for a large corporation or a small non-profit institution, our involvement always remains the same – an in-depth, working relationship with our clients, as well as hands-on involvement of the firm's principals throughout all phases of the design process, ensuring effective, appropriate, and timeless design solutions.

Redwood Library and Athenaeum

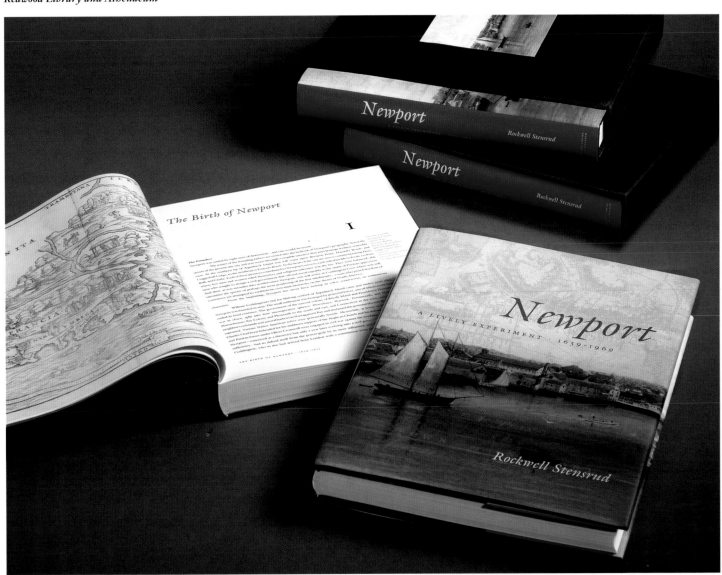

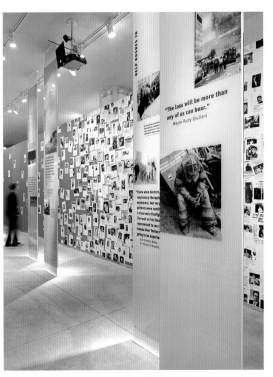

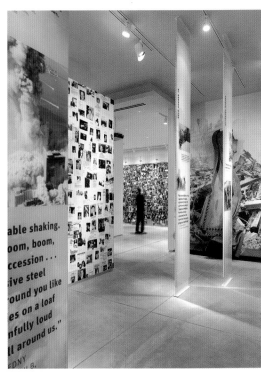

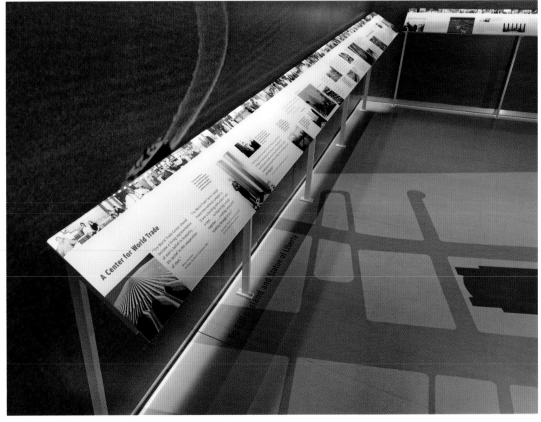

Tribute World Trade Center Visitor Center

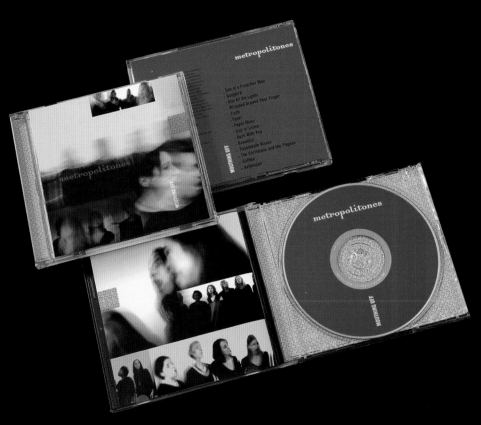

Metropolitones

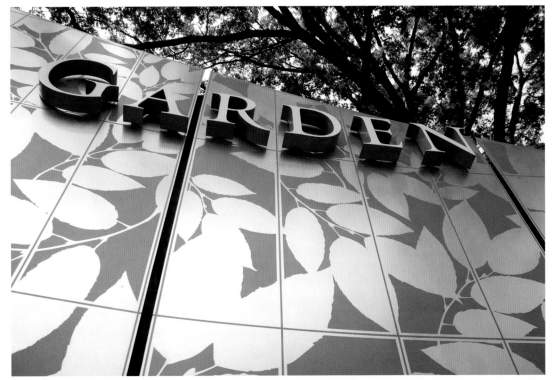

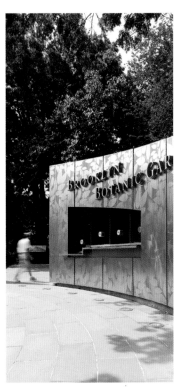

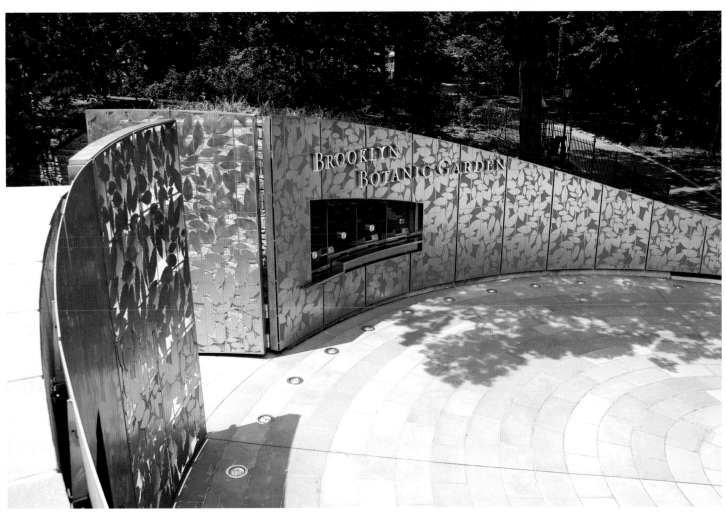

Brooklyn Botanic Garden

Tilles Center for the Performing Arts

ACQUIRE

NEW YORK

NEWSEUM

GUMBERG GLOBAL

Acquire, Newseum, Gumberg Global

brandston partnership inc.

lighting design

new york beijing shanghai

brandston partnership inc.

lighting des

bpi

brandston partnership inc. lighting design

new york beijing shanghai

bpi

bpi

Brandston Partnership Inc.

Richard Harrison Bailey | The Agency
121 South Niles Avenue
South Bend, IN 46617
574.287.8333

233 McCrea Street 587 Virginia Avenue
Suite 800 Number 1003
Indianapolis, IN 46225 Atlanta, GA 30306
317.634.2120 404.551.3922

www.rhb.com

We help great causes succeed.
As a marketing communications firm serving not-for-profit and service-rendering organizations, we are more focused on people than products, more concerned with capturing the character of an institution than glorifying the features of widgets. Our work reflects an elegant collision of design, writing and sound marketing—it must in order to serve our clients.

As both a marketing firm and a creative agency, we often find ourselves walking the razor's edge between creating design work that is aesthetically beautiful but also serves as a functional marketing tool that will allow our clients to reach their goals. And, while we realize the immediate impression that stunning design can have on target audiences, we are aware that beauty without rationale does little to serve our clients in the long run.

Hence, we've adopted a distinctive approach that we call Beyond Branding: Coherence®. While branding is a way to distinguish an organization from competitors by managing customer expectations, truly effective marketing goes beyond branding. It links marketers and their audiences not only through shared expectations, but also through a common language and a partnership that grows stronger with each interaction. In order for this relationship to thrive, both parties must communicate clear, concise and accurate messages about who they are and what they expect from one another. At Richard Harrison Bailey/ The Agency, we call that kind of marketing "coherence."

Design, informed by extensive market research and wed with compelling messaging, plays an integral role in achieving coherence for our clients. In these pages you'll find a collection of our work that exemplifies both aesthetic beauty and coherent marketing. You'll find design that captures the character of our clients. You'll find design that helps great causes succeed.

25/1000 Proximity Mossberg

Mossberg & Company Inc. (South Bend, IN)
75th anniversary poster and corporate materials

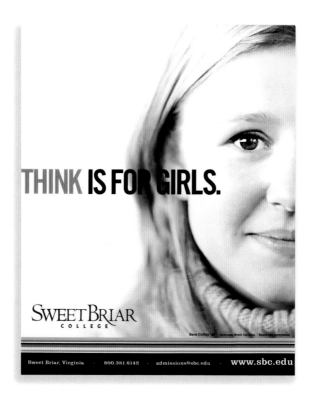

THINK **IS FOR GIRLS.**

SWEET BRIAR
COLLEGE

Sweet Briar, Virginia · 800.381.6142 · admissions@sbc.edu · www.sbc.edu

Sweet Briar College (Sweet Briar, VA)
student recruitment campaign

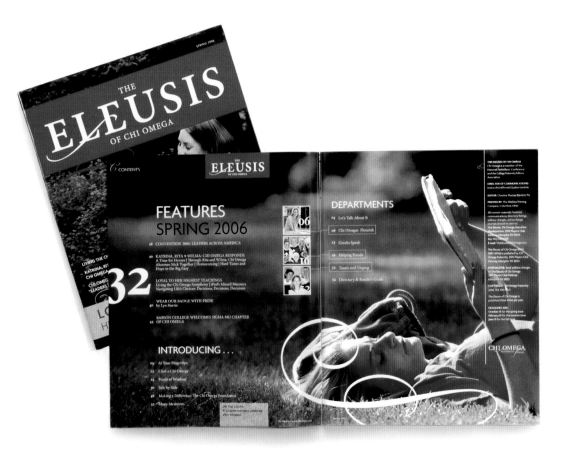

1

2

1 Chi Omega Fraternity (Memphis, TN)
alumnae magazine

2 Saint Mary's College of California (Moraga, CA)
student recruitment viewbook

1

2

1 *Beta Theta Pi Fraternity (Oxford, OH)*
folder and overview booklet

2 *Roberts Wesleyan College (Rochester, NY)*
student recruitment viewbook

1

2

3

4

1 Chi Omega Fraternity (Memphis, TN)
institutional identity

2 Warner Pacific College (Portland, OR)
institutional identity

3 Alma College (Alma, MI)
institutional identity

4 ArtsEverywhere (South Bend, IN)
institutional identity

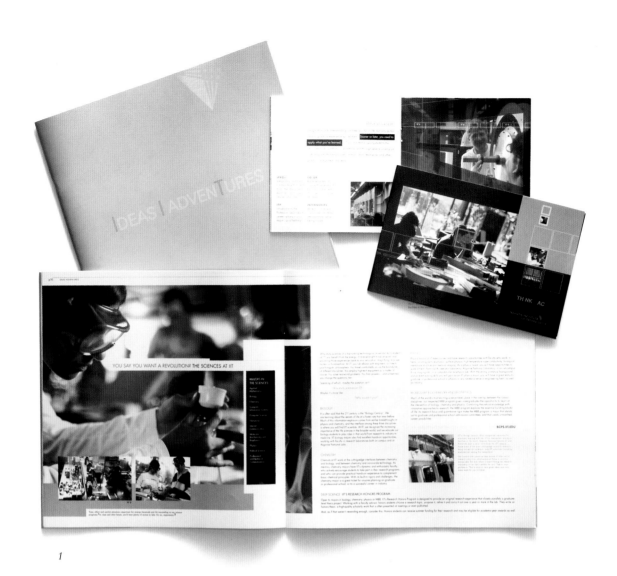

1

2

1 Illinois Institute of Technology (Chicago, IL)
student recruitment campaign

2 Gordon College (Wenham, MA)
student recruitment viewbook

ROC Co.

158 Greenwood Avenue
Bethel, CT 06801
203.778.2303
www.therocco.com

Mark Richardson and Nancy Campbell founded ROC in 1994, after years of collaborating on award-winning designs for exhibitions, trade shows, trademarks, identity programs and marketing strategies.

ROC intentionally remains a boutique company of broadly skilled design and communications professionals, supported by experts in every aspect of design, technology and advertising. The team's agility and flexibility allow fast, inventive response to each unique design challenge. Every marketing program and communications solution is spirited, distinctive and focused specifically on the client's target market.

Serving government, corporate and international organizations, ROC takes pride in long-term client relationships to produce a succession of custom designs for each ensuing project.

ROC's more recent signature work serves prominent developers in residential real estate throughout Manhattan, the boroughs, Philadelphia and Washington, DC.

Branding urban real estate is neighborhood, block and building specific and must appeal to a unique demographic for every program. The winning marketing package creates a seamless mood and energy that motivates that defined target audience.

ROC's process celebrates teamsmanship with the client, allowing the best ideas to flourish and develop in an open, good-humored interaction that encourages group ownership of every final product.

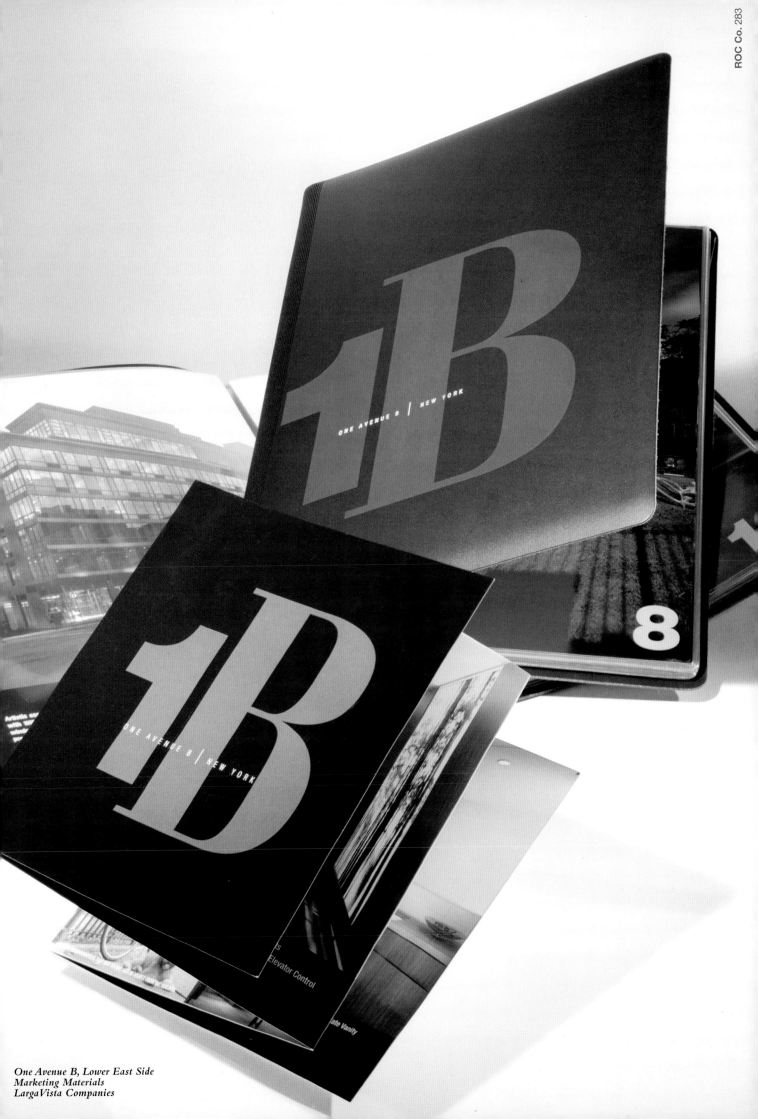

One Avenue B, Lower East Side
Marketing Materials
LargaVista Companies

What's in the Mail For You!
Permanent Interactive Exhibition
National Postal Museum,
Smithsonian Institution
Sponsored by Pitney Bowes

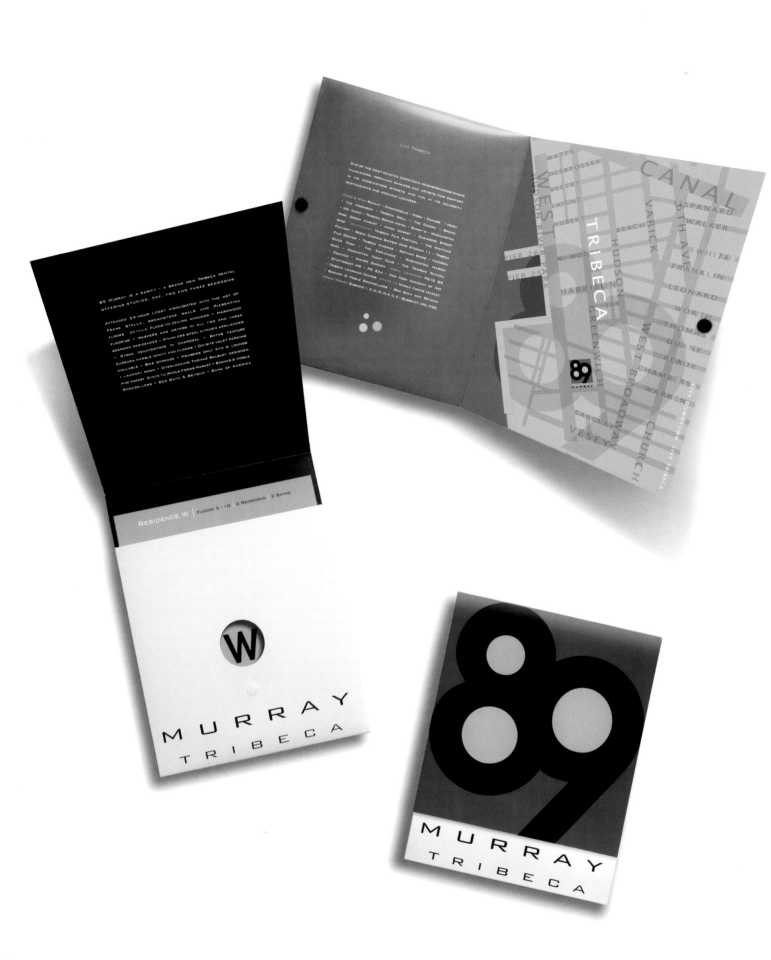

89 Murray, Tribeca
Marketing Materials
Edward J. Minskoff Equities

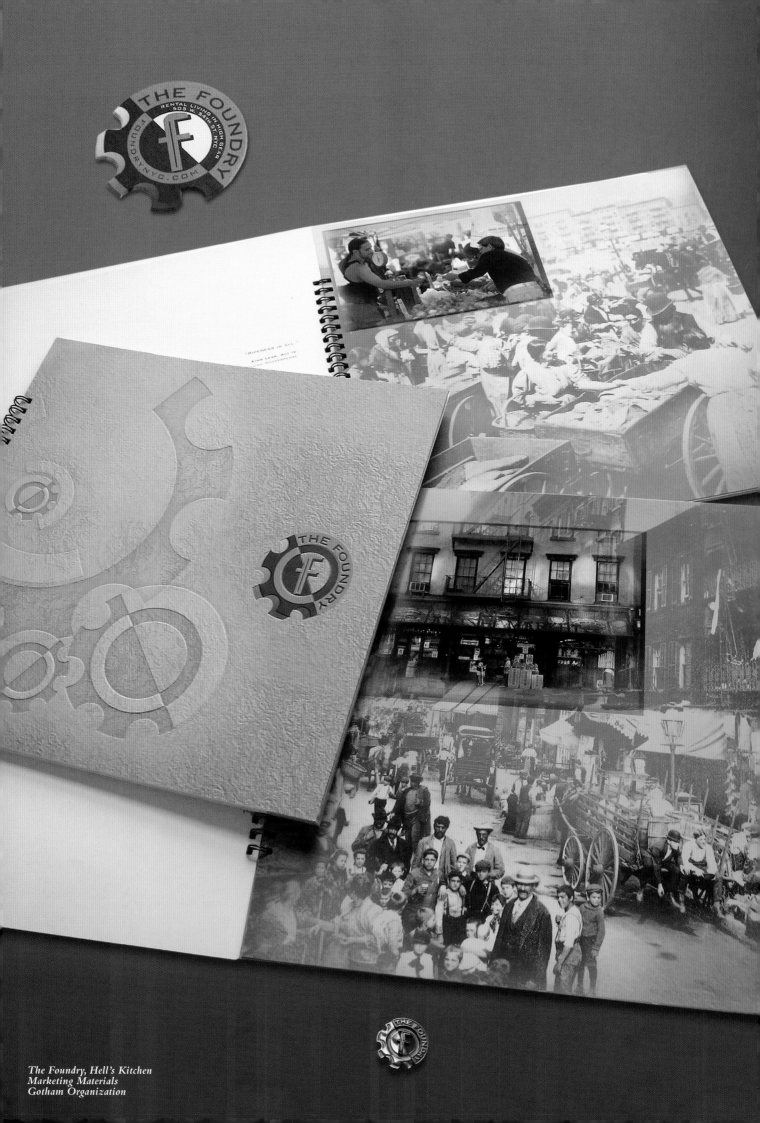

The Foundry, Hell's Kitchen
Marketing Materials
Gotham Organization

Sibley/Peteet Design, Austin
522 East 6th Street
Austin, Texas 78701
512.473.2333
www.spdaustin.com

At Sibley/Peteet Design, Austin we provide strategic marketing and design solutions for a wide range of corporate, consumer and institutional clients. We work closely with our customers to uncover their authentic brand and connect with their audiences in a meaningful way—ensuring compelling, consistent brand experiences that win both hearts and minds.

Founded in Dallas in 1982, the Austin office was established by partner Rex Peteet in 1994. Since that time, our nationally recognized expertise in brand identity development has expanded to include a full range of strategic and creative capabilities, including: strategic marketing, communications planning, naming, brand identity systems, interactive and environmental design, package design, annual reports and book design. Our portfolio includes brands you'll recognize from around the corner and around the world.

Left to Right: Kris Worley, Susan Birkenmayer, Gerald Tucker, David Guillory, Kathy Field, Rex Peteet, Amanda Soisson, Elisha Moore, Matt Wetzler, Flint LaCour, Oscar Morris, Joseph Blalock

Motive Bison Stampede

HALF MARATHON

NOVEMBER TWELFTH / 7:30AM

2006

Featuring the TriWest Elite Challenge

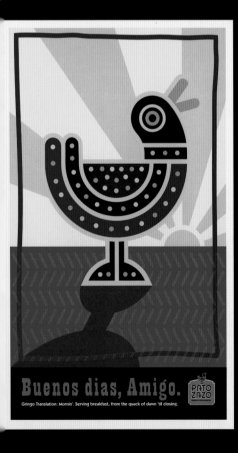

Buenos dias, Amigo.

Gringo Translation: Mornin'. Serving breakfast, from the quack of dawn 'til closing.

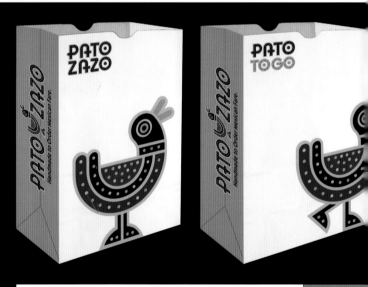

Big Pato. Little Bill.

PATO ZAZO
Handmade to Order Mexican Fare.

 Fly in. **Fly out.**

PATO ZAZO
Handmade to Order Mexican Fare.

Sibley/Peteet Design, Austin 291

(Top) Poster for the 2007 Texas Book Festival (Bottom) Fund-raising brochure for the University of Texas Executive Education and Conference Center.

(Top) Sales enablement website for Tigé Boats (Bottom) Virtual runway website for Susan Dell's clothing line, Phi

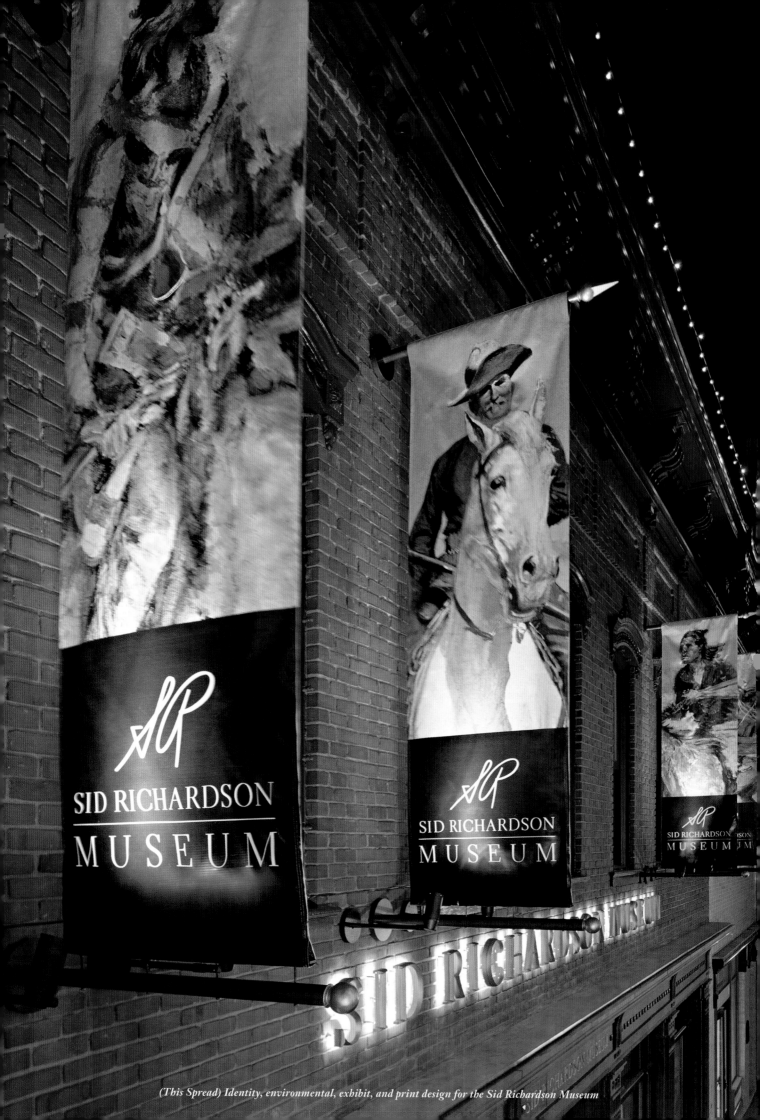

(This Spread) Identity, environmental, exhibit, and print design for the Sid Richardson Museum

SID RICHARDSON
M U S E U M

SID W. RICHARDSON
FOUNDATION

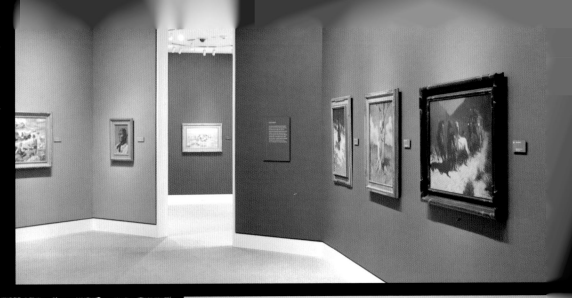

Frederic Remington 1861–1909

"I knew the wild riders and the vacant land were about to vanish forever, and the more I considered the subject, the bigger the Forever loomed."

Frederic Remington was born in northern New York and lived the life of a prominent artist and illustrator during his 25-year career. As a teenager, he had a passion for the West, which culminated in an extensive body of work that captured the essence of the American frontier. Living in the West for one year, then returning there periodically, he spent the majority of his time working and showing art in New York. He died at the height of his career at the age of 48. Remington is regarded as a Master of imagination, fusing romantic ideals and authentic details of the West in illustration, literature, painting and sculpture.

People from all wal...
...haracter as a true gentle...
...asing Western art in 19...
...s in the Western...

Emergency Exit
Alarm will sound.

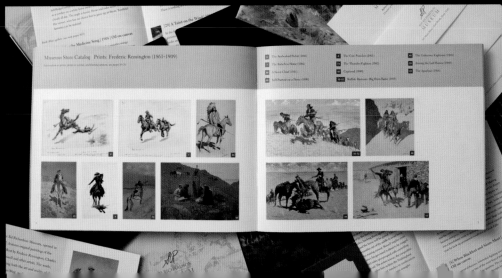

A

A

B

C

D

E

1 2 3 4

A1 American Heart Association	A2 Michael & Susan Dell Foundation	A3 Forté Foundation	A4 Texas Tech University System
B1 Haggar Apparel	B2 Romano's Macaroni Grill	B3 Shiner Brewery	B4 Tequilla Mockingbird
C1 Austin Film Festival	C2 Southwestern University	C3 Chili's	C4 Adobe Texican Cafe
D1 Pato Zazo Tex-Mex Cafes	D2 Mary Kay Cosmetics	D3 Gatti·Town	D4 Forestar Real Estate Group
E1 Sid Richardson Museum	E2 GSD&M	E3 Lajitas Resort	E4 The 401k Company

Siegel+Gale
437 Madison Avenue
New York, NY 10022
212 817 6650
siegelgale.com

Simple is Smart. Siegel+Gale applies the art and science of simplicity to create branding programs that have helped many of the world's best-known organizations excel. Driven by our philosophy of Simple is Smart, Siegel+Gale leads the way in bringing innovation to communications at every level. We transform the complex and incomprehensible into clear language.

From locations in London, New York, and Los Angeles, we help clients create a distinctive brand experience across all touch points. We transport brands onto the Internet, align the brand experience with the brand promise, and create visual systems that engage the consumer while furthering the brand promise. A full-service, strategic branding firm, our capabilities include brand strategy, brand research, brand architecture, naming, identity and visual system design, brand experience, Internet strategy, design, user experience, and simplification.

Ameya

King Abdullah University
of Science and Technology
(KAUST)

KAUST
King Abdullah University of
Science and Technology

Institute of Material Science and Engineering

Institute of BioSciences and Engineering

Institute of Resources, Energy and Environment

Agility

Agility

A New Logistics Leader

New School

THE NEW SCHOOL

A UNIVERSITY

The Port of
LONG BEACH
Your Environmentally Friendly Port

June, 2007 Our Educational Community Plan
Education Strategies Through 2020

The Port of
LONG BEACH

June, 2007 Our Community Master Plan
Growth Strategies Through 2020

The Port of
LONG BEACH

June, 2007 Our Economic Master Plan
Business Strategies Through 2020

The Port of
LONG BEACH

Dolce

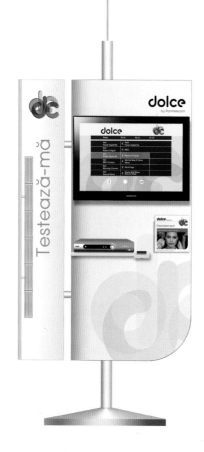

SITEK DESIGN

12104 melrose
overland park, KS 66213
913.322.9093

www.sitekdesign.com

SITEK DESIGN is a corporate branding design firm recognized for high standards of design excellence and innovation. We help corporations achieve their business objectives and market potential through innovative brand communications. Our comprehensive communications services include brand strategy and development, brand management, identity systems, corporate communications, marketing collateral, environmental graphic design, signage and wayfinding, package design, and interactive design. We are headquartered in the central Midwest.

THE ELDRIDGE
EST. 1925

HISTORIC HOTELS
OF AMERICA
NATIONAL TRUST

701 Massachusetts Lawrence, KS 66044
P:(785)749-5011 F:(785)749-0163
WWW.ELDRIDGEHOTEL.COM

THE ELDRIDGE
EST. 1925

701 Massachusetts Lawrence, KS 66044
P:(785)749-5011 F:(785)749-0163
WWW.ELDRIDGEHOTEL.COM

THE ELDRIDGE
EST. 1925

THE ELDRIDGE
EST. 1925

THE ELDRIDGE
EST. 1925

KENDRA HATFIELD
ASSISTANT GENERAL MANAGER
KENDRA@ELDRIDGEHOTEL.COM

701 Massachusetts Lawrence, KS 66044
P:(785)749-5011 EXT.163 F:(785)749-0163
WWW.ELDRIDGEHOTEL.COM

701 Massachusetts Lawrence, KS 66044
(800)527-0909 F:(785)749-0163
WWW.ELDRIDGEHOTEL.COM

SITEK DESIGN

913.322.0093

SITEK DESIGN 913.322.0093

913.322.0093 12104 MELROSE
LAND PARK, KS 66213 SITEKDESIGN@SINE.NET

SITEK DESIGN

913.322.0093

SITEK DESIGN

SITEK DESIGN

SITEK DESIGN
913.322.9093

SITEK DESIGN

Alpha-1
Association

Support, Education and Advocacy since 1991

Alpha-1
Association

Support, Education and Advocacy since 1991

Alpha-1
Association

Support, Education and Advocacy since 1991

ALPHA-1 ASSOCIATION
VISUAL IDENTITY, CORPORATE BRANDING, STATIONERY, MARKETING COLLATERAL,
ANNUAL CONVENTION SIGNAGE AND PRINT COLLATERAL

creative
leadership
conference
2004

FEBRUARY.28-29.2004

UNION STATION / SCIENCE CITY

CULTU
URE
G

JOHN GILLIS

XPRESSION

XCHANGEXCHANGEXCHANGE

XCHANGE

2:00 **WAYNE HUNT** designer
Entertainment Design

2:45 **LORRAINE WILD** designer
Revisiting Craft

3:30 break
3:00 **JAN MURLEY** group VP marketing

4:30 **PAUL BARKER** senior VP - creative
closing
4:45 Conference concludes

FEBRUARY
29

SITEK DESIGN

12104 melrose
overland park, KS 66213
913.322.9093

www.sitekdesign.com

Studio @ One Zero Charlie

One Zero Charlie
5112 Greenwood Road
Greenwood, Illinois 60097
815.648.4591

www.onezerocharlie.com

Mary Ervin Designer
Andy Heintzelman Executive Designer
Liz Schaefer Designer
Michael Stanard Creative Director
James Westwood Designer
Laura Witlox Account Planner

Greetings from the middle of a corn field, in the middle of America.

After working in Manhattan for seventeen years, design pioneer Lester Beall found the lure of a full-time pastoral setting irresistible. In 1950 he purchased a small farm in Brookfield Center, converting his barn into a studio. Beall described it as "a place for living the business of working."

In 1939, Chester Gould moved his home and studio from Wilmette to Bull Valley, Illinois, a storybook setting just down the road from One Zero Charlie's airport-based studio.

For over 38 years, on an almost daily basis, Gould made the 54 mile commute to Tribune Tower in the heart of Chicago. Time traveling was spent dreaming up story ideas for his world-famous comic strip detective, Dick Tracy.

In 1999, inspired by both Gould and Beall, Michael Stanard relocated to rural Northwest Illinois, establishing One Zero Charlie (named after the airport's FAA identifier) on the grounds of his grassroots airfield.

In addition to the internet and the technologies not available to Gould or Beall, One Zero Charlie has the added advantage of travel by air to serve clients throughout the Midwest.

"There is nothing special about the services we provide. We offer what virtually every firm offers," says Stanard. "However, we do produce clever, yet practical, results for our clients. I suppose that's a result of our being Midwesterners."

Purdy
PROFESSIONAL PAINTING TOOLS

HANDCRAFTED IN USA
Guaranteed Against
Defects In Workmanship
And Materials

2 1/2"
Thickness: 5/8"

FOR LATEX PAINTS
ROUND EDGE
STAINLESS FERRULE
100% DYED NYLON
BRISTLE

HANDCRAFTED IN USA
Guaranteed Against
Defects In Workmanship
And Materials

3"
Thickness: 1/2"

FOR LATEX PAINTS
SQUARE EDGE
STAINLESS FERRULE
100% DYED NYLON
BRISTLE

the premium stapler premium program

FOR PAINTING TIPS VISIT:
WWW.PURDYCORP.COM

MADE IN USA

Purdy WhiteDove™
PROFESSIONAL PAINTING TOOLS

LINT FREE

ALL LATEX AND OIL
BASED PAINTS

Very Smooth to
Smooth Surfaces

1/4" Nap

Suitable For All Paint Finishes

Woven Dralon® Fabric

9" ROLLER

IRWIN
BOLT-GRIP® From the Makers of VISE-GRIP
Damaged Nut & Bolt Remover

4

CHICAGO EXECUTIVE AIRPORT

Opposite Page:
Purdy Corporation
ACCO / Swingline Staplers
Zurich American Insurance
Irwin Tool Company
Chicago Executive Airport

This Page:
Washburn Guitars

Tank
158 Sidney Street
Cambridge, MA 02139
Telephone 617 995 4000
www.tankdesign.com

Tank NY
526 West 26th Street, Unit 1015
New York, NY 10002
Telephone 212 627 8662
www.tankdesign.com

Tank is a design firm that integrates strategy, design and technology to help companies and organizations create memorable brand expressions, applied across multiple channels. Founded in 1994, Tank has provided award winning work for some of the world's most recognized brands. Their work ranges from complete brand development for new organizations to fresh thinking for established brands. All clients enjoy Tank's ability to explore, discover and deliver original design solutions.

Tank is based in Cambridge, MA and New York, NY. Clients include Cole Haan, Ebel International, FedEx, MIT, Puma, SmartBargains, Sony, Symantec, Via Spiga and Virgin.

Rugby World cup advertising campaign for Puma.

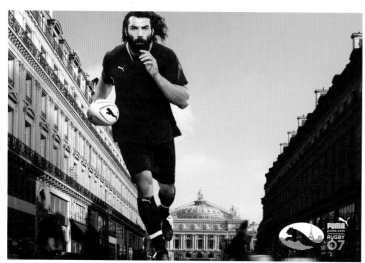

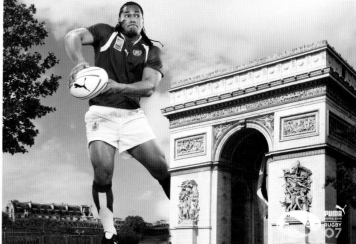

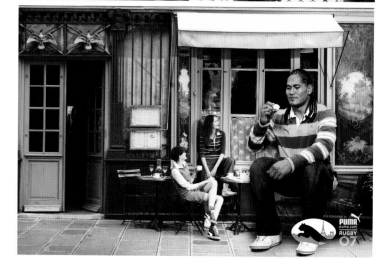

I'm Going advertising campaign for Puma.

Packaging design for Bumble and Bumble.

Brand positioning and art direction for Ebel Paris.

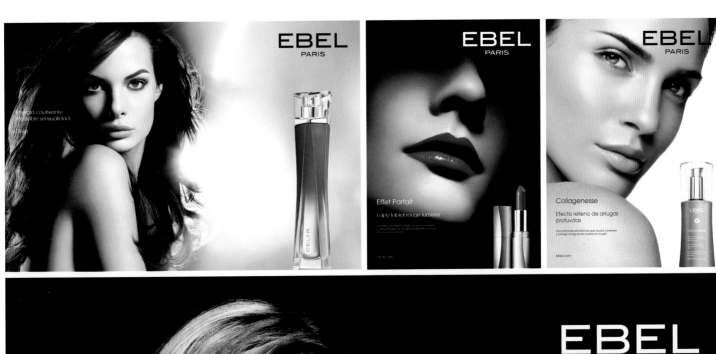

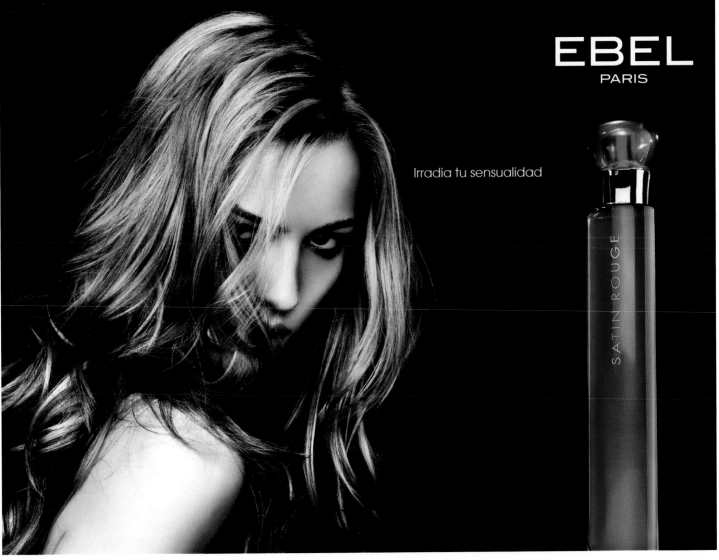

Website and awareness program for Dalai Lama: *The Missing Peace.*

THE
MISSING
PEACE

The Dalai Lama Portrait Project

Website for Essential Design.

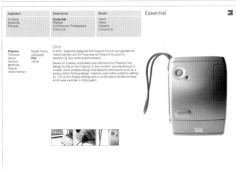

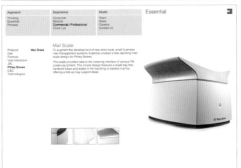

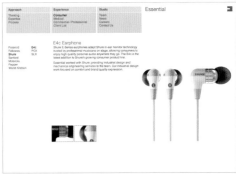

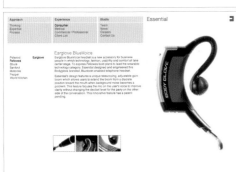

SONY

PARIS

Essential

EYP/

parabolica

REDSTAR ★

TAMCO

VERACODE

World Learning

THIEL Design

FOCUSED CREATIVITY. It describes how we combine strategic left-brain thinking with right-brain creativity, bringing life and enhanced meaning to brands across a full range of media. We develop ideas that resonate—integrating all points of contact; establishing a point of difference.

Thiel Design
325 East Chicago Street
Milwaukee, WI 53202
414.271.0775
www.thiel.com

THIEL
DESIGN

Thiel Design is a consulting design firm specializing in the development of integrated brand identity programs. We serve clients in diverse industries—from professional service, finance, manufacturing and health care to education, retail, fine arts and urban development. We're committed to helping our clients achieve success by design.

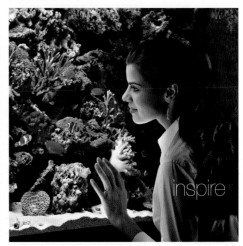

Diverse Manufacturer
CPA & Financial Services
Insurance & Financial Services
Tools Manufacturer
Hospital & Health Care

Architectural Firm
Regional Clinic
Division I University
Custom Woodworking
Private Equity Investments

Law Firm
City Downtown
High-end Aquariums
Business Consultants
Interior Design

eppstein uhen : architects

A future-oriented comprehensive brand identity program is launched to communicate this large architectural firm's 100th anniversary. The new brand is effectively positioning the firm to grow, and helps to raise awareness of the firm's services "Beyond : Design."

components

Brand Strategy
Visual Identity
Key Messaging
Stationery
Web Site
Brand Launch
Collateral
Signage

components

Brand Strategy
University Visual Identity
Athletic Visual Identity
Print Communications
Brand Standards
Exterior Wayfinding Signage
Interior Signage Program
Environmental Graphics
Donor Recognition
Merchandising
UWM Foundation Identity
UWM Alumni Association Identity

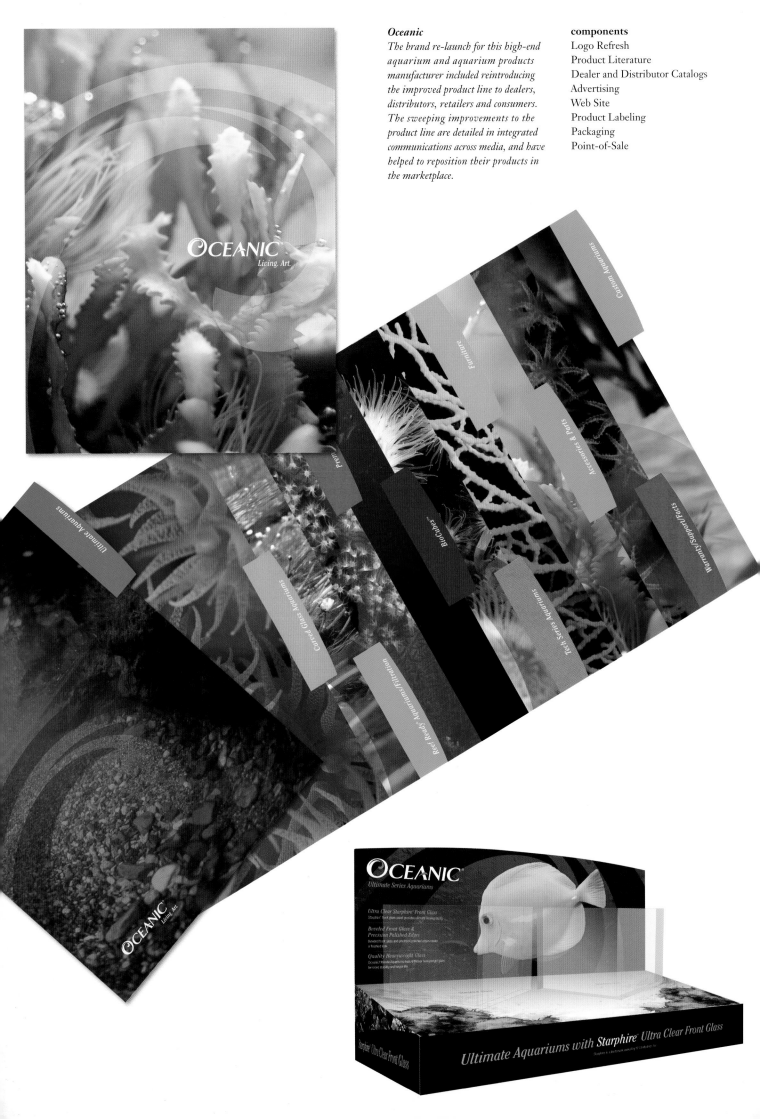

Oceanic
The brand re-launch for this high-end aquarium and aquarium products manufacturer included reintroducing the improved product line to dealers, distributors, retailers and consumers. The sweeping improvements to the product line are detailed in integrated communications across media, and have helped to reposition their products in the marketplace.

components
Logo Refresh
Product Literature
Dealer and Distributor Catalogs
Advertising
Web Site
Product Labeling
Packaging
Point-of-Sale

Bostik
This industrial adhesives manufacturer, with multiple divisions serving multiple markets, is developing and launching integrated communications that strategically speak to each audience segment with solutions and messages that stick.

components

Key Messaging
Marketing Strategy
Product Naming
Product Literature
Direct Mail
Trade Show Exhibits
Videos
Merchandising
Posters

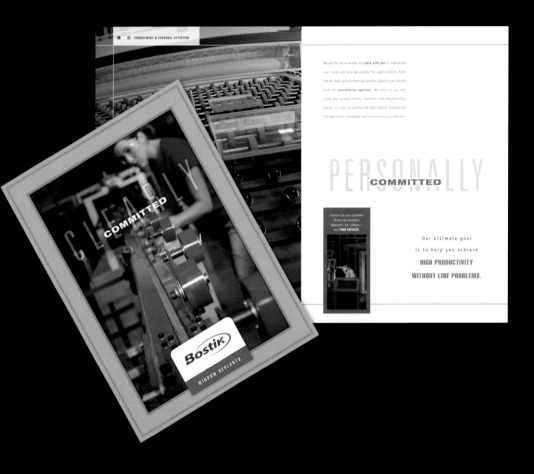

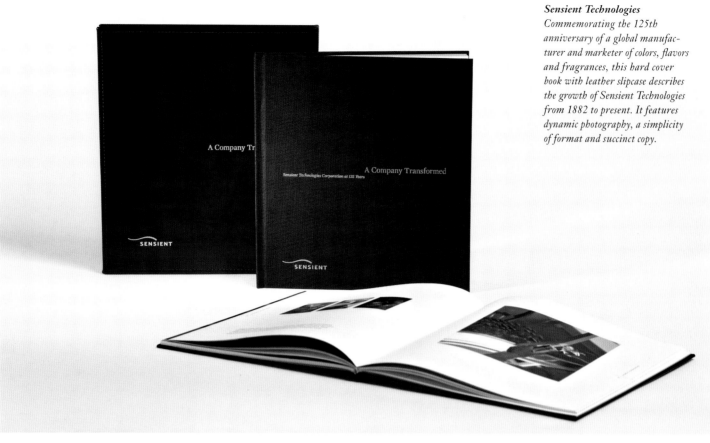

Sensient Technologies
Commemorating the 125th anniversary of a global manufacturer and marketer of colors, flavors and fragrances, this hard cover book with leather slipcase describes the growth of Sensient Technologies from 1882 to present. It features dynamic photography, a simplicity of format and succinct copy.

A NEW GLOBAL COMPANY

When the Company marked its 100th anniversary in 1982, it was a domestic food business with insignificant revenue from international sales. Twenty-five years later, Sensient is a billion-dollar global company with facilities on six continents. The Company's unique corporate culture enables it to meet regional demands in all markets.

World Headquarters
Milwaukee, Wisconsin, U.S.A.

FLAVOR SYSTEMS

Sensient uses advanced, proprietary technologies to develop customized flavor systems that enable food and beverage manufacturers to succeed in highly competitive markets.

A Growing Global Demand for Prepared Foods

Superior Products, Technologies and Services

Organic Color Systems

Food-Grade Inkjet Inks

Advanced Coating Applications

Combined Flavor and Color Systems

PHARMACEUTICAL COLOR AND COATING TECHNOLOGIES

Sensient has leveraged its expertise in highly purified color systems to build a world-leading pharmaceutical color and coating business. The Company's pharmaceutical unit develops and supplies customized systems for manufacturers of prescription and over-the-counter medications, nutritional supplements and other health-related products.

Exceptional Products and State-of-the-Art R&D

Expertise to Meet International Safety Guidelines

STRATEGIC INVESTMENTS

Facilities Improvement for Greater Efficiency

Investments in Personnel

VaughnWedeen

Vaughn Wedeen is a creative consultancy that combines outstanding design and advertising talent with exceptional strategic skills. For more than 25 years our focus has been on the marketing processes of positioning, branding and imaging. Our clients range from small retail operations to Fortune 500 companies. Our multidisciplinary capabilities allow us to employ a full spectrum of tactics including print, electronic, virtual and spatial. We are experts in comprehensive and encompassing programs for businesses, organizations and destinations.

Selected Clients

Advent Solar	Flying Star Café	New Mexico Department
Albuquerque Isotopes	Forest City Covington	of Transportation
Animal Humane Association	Green Rubber Global	Penny Singer Design
Arizona Cardinals	Guidance Endodontics	PNM
Bresnan Communications	Heel Pharmaceuticals	RailRunner Express
Charter Communications	HomeAid America	Satellite Coffee
Citicorp	Hunt Development Group	SunCal Companies
City of Albuquerque, NM	Madison Development Group	Spaceport America
City of Clearwater, FL	National Hispanic Cultural Center	Ultramain Systems
City of Santa Fe, NM	New Mexico Economic	Walt Disney Imagineering
Comcast	Development Partnership	X Prize Foundation

Vaughn Wedeen Creative, Inc.
116 Central SW
Suite 300
Albuquerque, NM 87102
505.243.4000
www.vwc.com
inquiries@vwc.com

Logo Designs:
Albuquerque Isotopes, Animal Humane Association of New Mexico and Cordero Mesa/Rio Development Corp.

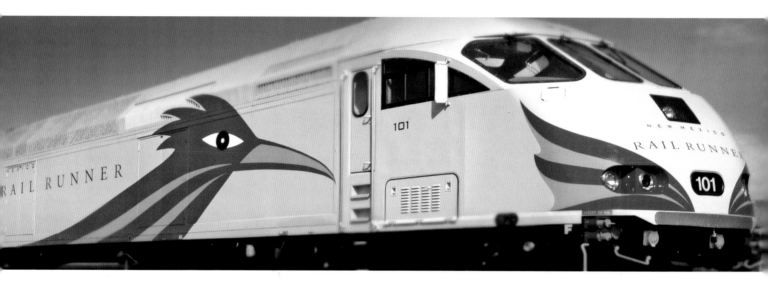

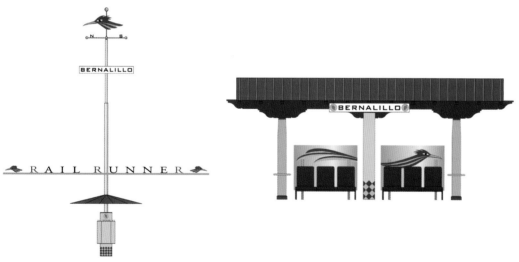

Project: New Mexico RailRunner Express Comprehensive Brand Development

Client: Mid-Region Council of Governments and State of New Mexico

Assignment: Comprehensive brand design for commuter rail service.

Scope: Naming, testing, designing of train exterior and interior,

stations and platforms, signage, collateral, uniforms and advertising, as well as

authorship of comprehensive strategic marketing plan.

PHOTOSTYLE: NO MORE MR. NICE GUY

The red attitude is expressed in photography as well. Tough. Gritty. Threatening. Focused. Mean. Aggressive.
The Arizona Cardinals will now show their colors in another way.

Project: Arizona Cardinals Rebrand & New Stadium Launch
Client: Arizona Cardinals Football Club
Assignment: Rebranding and repositioning of NFL football team.
Scope: Comprehensive strategic rebranding plan, brand design
and graphic standards, electronic and print collateral, promotions,
communiqué and advertising.

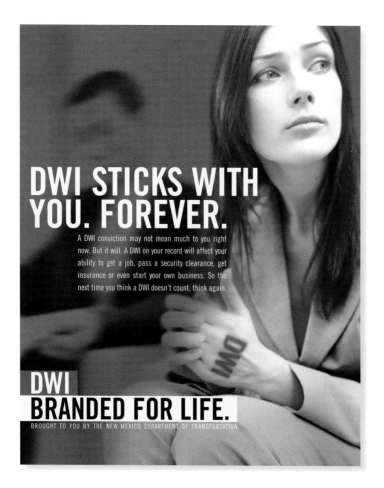

DWI STICKS WITH
YOU. FOREVER.

A DWI conviction may not mean much to you right now. But it will. A DWI on your record will affect your ability to get a job, pass a security clearance, get insurance or even start your own business. So the next time you think a DWI doesn't count, think again.

DWI
BRANDED FOR LIFE.

BROUGHT TO YOU BY THE NEW MEXICO DEPARTMENT OF TRANSPORTATION

NMDOT

Project: Anti-DWI and Traffic Safety Campaigns and Programs

Client: New Mexico Department of Transportation

Assignment: One of many campaigns created to prevent drunk driving.

Scope: Print, outdoor, television, radio, internet and other tactics to promote safe and sober driving.

YOU CAN HELP.

HomeAid *America, Inc.*

3919 Westerly Place
Suite 200
Newport Beach, California
92660-2324

homeaid.org

HOME

DONATE
HomeAid's General Mission
Gulf Coast Rebuilding Fund
Get Involved

NEWS & EVENTS

HomeAid

ABOUT HOMEAID
PARTNERS
CHAPTERS
NEWS & EVENTS
SHOP
CONTACT
CHAPTER PORTAL

WE REBUILD LIVES

HomeAid America is committed to building shelters across America that will help individuals and families regain lives of self-sufficiency. The HomeAid program provides for more than safe, dignified environments. We link to care providers with programs that include the job and life skills training necessary to gain self-sufficient men, women and children from all walks of life who need a hand-up, not a hand out.

MONTHLY
NEWSLETTER

HOMEAID.ORG

HomeAid

Project: HomeAid America Rebrand

Client: HomeAid America

Assignment: Comprehensive rebranding and design for a non-profit arm of the National Association of Home Builders, which builds shelters and transitional housing for homeless across the United States.

Scope: Logo, collateral, annual report, website and other identity materials.

HOMEAID ANNUAL REPORT 2005

Project: *Penny Singer Design Brand Identity and Collateral*

Client: *Penny Singer Design / Legends Santa Fe*

Assignment: *Comprehensive brand identity for Native American owned fashion apparel and accessories company.*

Scope: *Logo and collateral design, packaging and apparel identification and labeling.*

Santa fe

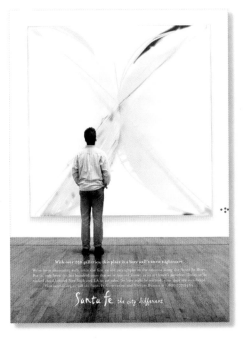

Project: Santa Fe Convention & Visitors Bureau Tourism Advertising, Marketing & Branding

Client: City of Santa Fe, NM

Assignment: Comprehensive rebranding and tourism advertising.

Scope: Comprehensive strategic marketing plan, print and internet based advertising program,
new brand identification system and promotional tactics.

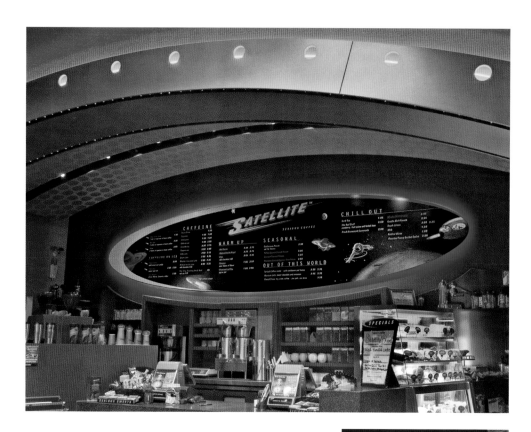

Project: Satellite Coffee Comprehensive Rebrand

Client: Satellite Coffee

Assignment: Comprehensive brand design of chain of coffee shops.

Scope: Logo and identity design, exterior and interior retail graphics
and signage, menus, collateral, packaging, restaurant supplies,
promotional and retail items, apparel and china.

everything you should know
before hopping in bed with a virgen

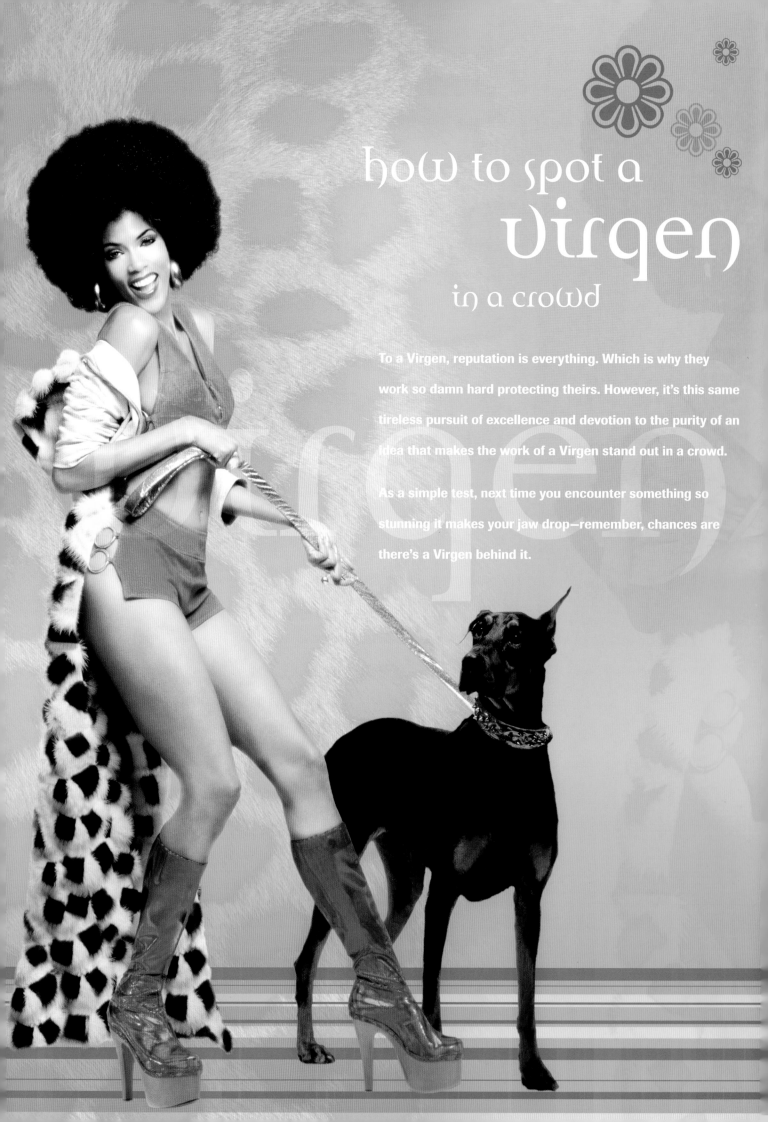

how to spot a
virgen
in a crowd

To a Virgen, reputation is everything. Which is why they work so damn hard protecting theirs. However, it's this same tireless pursuit of excellence and devotion to the purity of an idea that makes the work of a Virgen stand out in a crowd.

As a simple test, next time you encounter something so stunning it makes your jaw drop—remember, chances are there's a Virgen behind it.

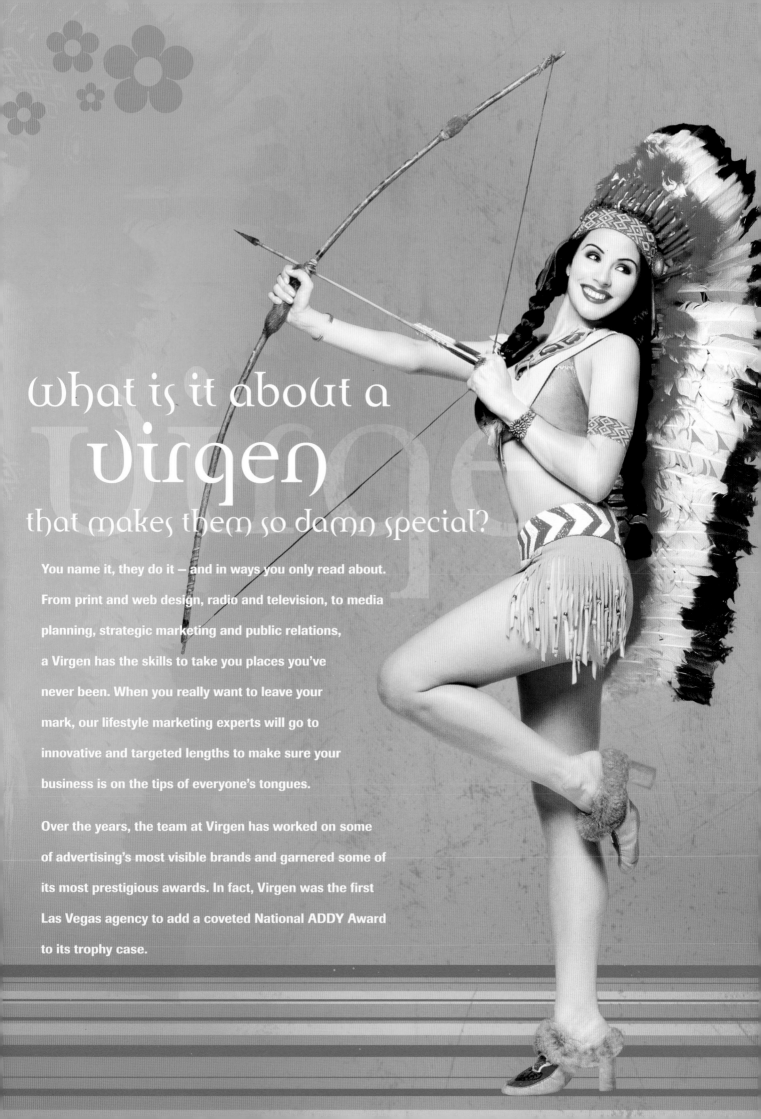

what is it about a
virgen
that makes them so damn special?

You name it, they do it — and in ways you only read about. From print and web design, radio and television, to media planning, strategic marketing and public relations, a Virgen has the skills to take you places you've never been. When you really want to leave your mark, our lifestyle marketing experts will go to innovative and targeted lengths to make sure your business is on the tips of everyone's tongues.

Over the years, the team at Virgen has worked on some of advertising's most visible brands and garnered some of its most prestigious awards. In fact, Virgen was the first Las Vegas agency to add a coveted National ADDY Award to its trophy case.

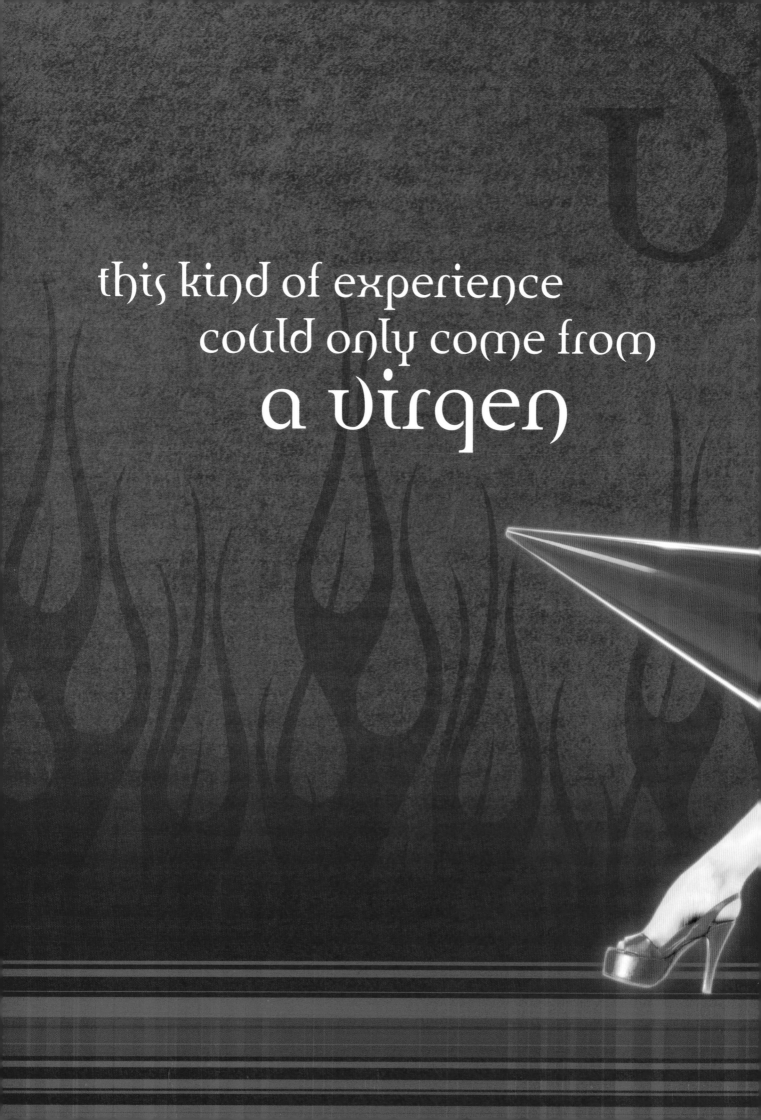

this kind of experience
could only come from
a virgen

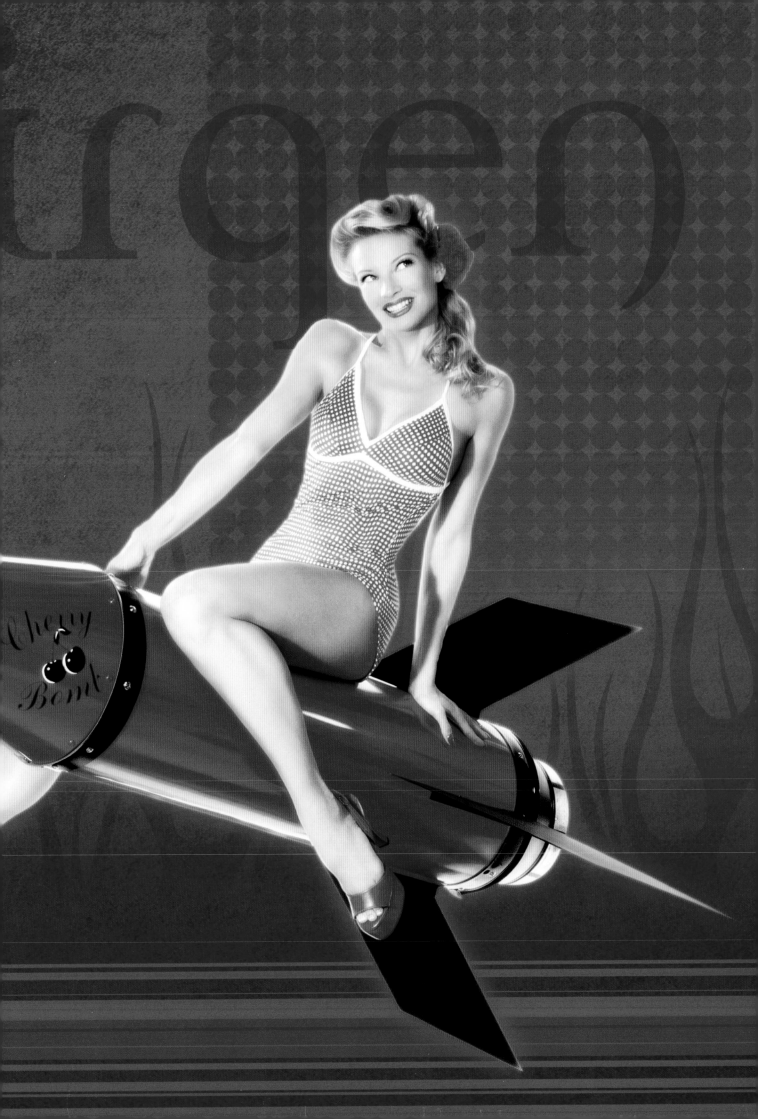

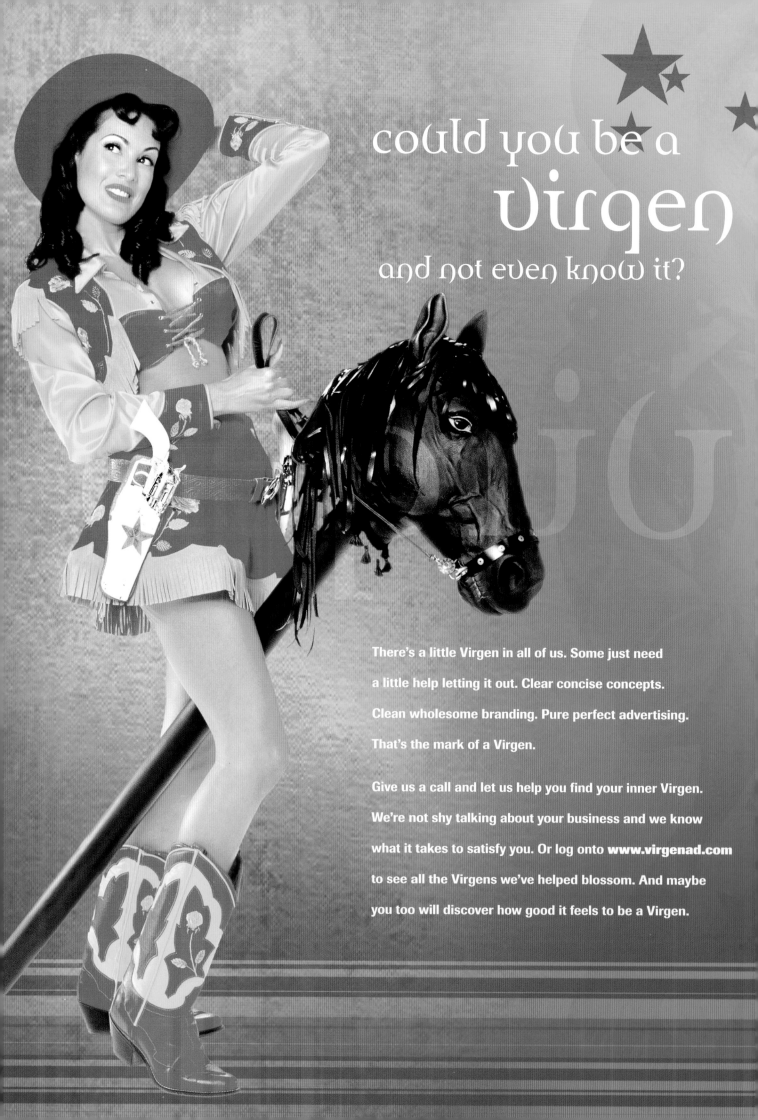

could you be a **virgen** and not even know it?

how to approach a
virgen

It's really quite simple. The important thing is not to be

shy. Once you get over those initial jitters, simply pick up

the phone, dial **702.616.0624** and ask to speak to

a Virgen. We promise to be gentle.

Virgen Advertising Corporation
151 East Warm Springs Road
Las Vegas, Nevada 89119

www.virgenad.com

eight years in las vegas and still a virgen

Voicebox Creative, Inc.
Three Meacham Place
San Francisco, CA 94109
415.674.3200
www.voiceboxsf.com

Voicebox Creative is a San Francisco-based brand identity and packaging design firm dedicated to translating a client's vision into innovative design solutions. Founded in 2002 by Managing Partner Sean Ziegler, and joined by Managing Partner and Creative Director Jacques Rossouw in 2005, Voicebox has developed a reputation for its high-level creative thinking and design standards, as well as its specialization in products and services that celebrate and enhance life, including wine and spirits, craft beverages, organic and specialty foods, hospitality and entertainment. Our strategic design services include naming, identity development, packaging systems, print and retail merchandising programs.

At Voicebox, we pride ourselves on translating client ideas and vision into innovative, compelling branding and packaging that resonates with its target audience. Our most recent work includes developing and refining brands for wine & spirits companies that target the emerging, non-traditional market of young "millennial" consumers between the ages of 21-30. When these consumers purchase a brand designed by Voicebox, our goal is that their appetite for exploring and experiencing new products and services results in a positive discovery that develops a lasting and lifelong bond of preference and loyalty.

Voicebox Creative is comprised of twelve strategic design professionals housed in a historic brick-front studio space located in downtown San Francisco. Voicebox also has an industry-leading Advisory Board made up of veterans of the food, beverage and hospitality industries who meet regularly to offer management counsel and advice.

1

2

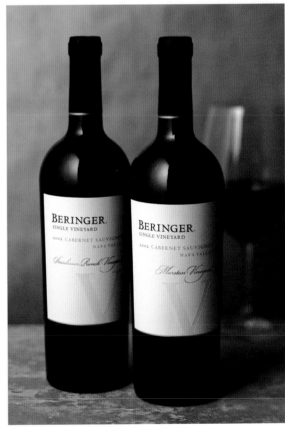

3

Naming, packaging and
merchandising system for
Beringer Vineyards
1 Beringer Third Century
2 Beringer Private Reserve
3 Beringer V Single Vineyards

(Opposite page) Packaging for
Rodney Strong Single Vineyards

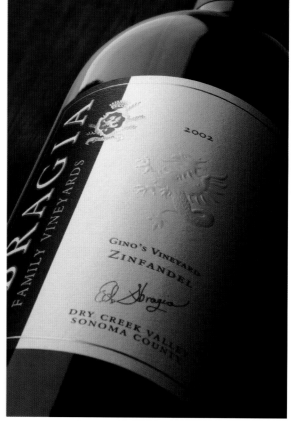

*Packaging, collateral
and business system for
Sbragia Family Vineyards*

*(Opposite page)
Packaging and merchandising
system for Souverain*

1

2

3

1 Naming and packaging
system for HobNob Wines

2 Packaging for Freakout
by Luna Vineyards

3 Packaging and merchandising
system for Sonoma Vineyards

(Opposite page)
Naming, packaging and
merchandising system for
The Spanish Quarter

*Naming, packaging and
merchandising system for
Bivio Italia*

Volume Inc.
2130-B Harrison Street
San Francisco, CA 94110
415.503.0800
www.volumesf.com

WHEN WE SAY we want to bring greater *volume* into our lives, we usually desire more meaning, more purpose, more significance, and more feeling. Volume Inc. was founded on this desire by Adam Brodsley and Eric Heiman at the dawn of the new millenium, and has continued to champion a holistic design practice where the long view is always in sharp focus.

IF WE CREATE media that is disconnected from the human experience, it leaves no lasting impression. Every successful job requires a degree of strategic planning, but strategy alone treats us like empty vessels. Strategy doesn't get our attention, connect us to the world, or make us care. The unexpected makes us stop, look and listen,

beauty gives us visceral pleasure for making the effort, and a compelling story helps us commit the experience to memory. Our work is about facilitating this emotional connection with an audience.

DESIGN CAN FOSTER precision, clarity, and commerce. It can also enable imagination, philanthropy, and the chance to take a deep breath. There are different *volume* levels for every person, every cause, and every message. Through a variety of media we help entities—corporate, community and cultural—fine tune these levels to connect with their patrons in memorable, efficient, and ultimately profitable ways.

SINCE ITS INCEPTION, Volume has designed comprehensive identity programs, environments, books, web sites, promotional collateral, and films for a wide variety of clients. Our work has also been exhibited, honored, published and spoken about extensively worldwide. Adam and Eric are also both Professors of Design at the California College of the Arts (CCA) in San Francisco, and Eric's writing on design has been featured in a variety of publications.

CD WALL MURAL

Have you switched to the soft pack of CDs? Are all your empty jewel cases starting to block the way to the kitchen? Time to make something from that mess of plastic brittle. Remember, jewel cases are fabricated from Thermoset, which can't be melted down and turned into two-liter Coke bottles. It's our way or the highway to the dump for these fellers. But look at all they have to offer: protection against the elements; translucency; clean, modern lines. For all those reasons and more, use your empties to make a wall mural. It's yet another step in your march against passive domesticity.

**ReadyMade: How to Make (Almost) Everything
book:** *Written by the co-founders of* ReadyMade *magazine, this hybrid of how-to, editorial and historical content appealing to the young, environmentally-conscious set yielded a design that is simultaneously smart and fun, structured yet chaotic, sophisticated yet accessible.*

Square Enix E3 Exhibition Booth: A 100 x 100 ft. exhibit-as-altar created for a leading video game developer. The entire space is built as a ramp with a central backlit walkway leading to the Square-Enix temple—a 360° rotating theater—where the visitor pays homage to the company's yearly offerings.

Heath Ceramics visual identity and collateral: Since 1948, Heath Ceramics has been a producer of ceramic architectural tile and dinnerware. Volume completely revamped the visual identity to appeal to a more design-savvy audience, but also retain the long history of custom designs and handmade craft.

All the collateral utilizes an inventive use of materials and handmade processes—such as the "glazing" of the business cards and book cover—while also highlighting the depth and richness of Heath's product through immediate, striking photography and weaving in parts of the company's long, illustrious history.

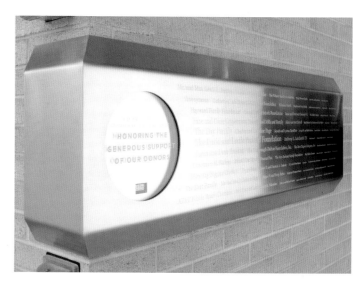

Lexy™

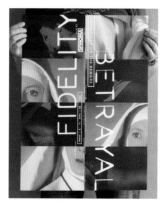

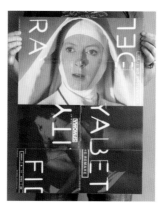

The Bridge Fund 2002–2004 annual report: The
*Bridge Fund assists the people of the Tibetan plateau
who also crafted the annual's handmade paper cover, the
woodblock print, and yak horn letter opener. The annual
embodies the Buddhist concept of Terma—hidden
treasures in sacred teachings meant to be discovered when
they are needed most. The book initially appears to be a
simple 2-color text narrative, but once one tears the
perforated signatures it reveals beautiful 4-color imagery of
the people, places and results of the Bridge Fund's work.*

VSA Partners
1347 S. State St.
Chicago, IL 60605
312.427.6413
www.vsapartners.com

VSA was founded as a graphic design office, and design is still our center of gravity. But from our first day as a firm, we've been asking a fundamental question: "Where does design end?" As we've grown and evolved, organizations have increasingly challenged us to explore the boundaries of their businesses and brands, and to find new relationships between aesthetics and economics, technology and audiences, communication and culture, brands and experiences. Having deep roots in the discipline of design enables us to envision the effect we want to create and to explore the most productive path for getting there.

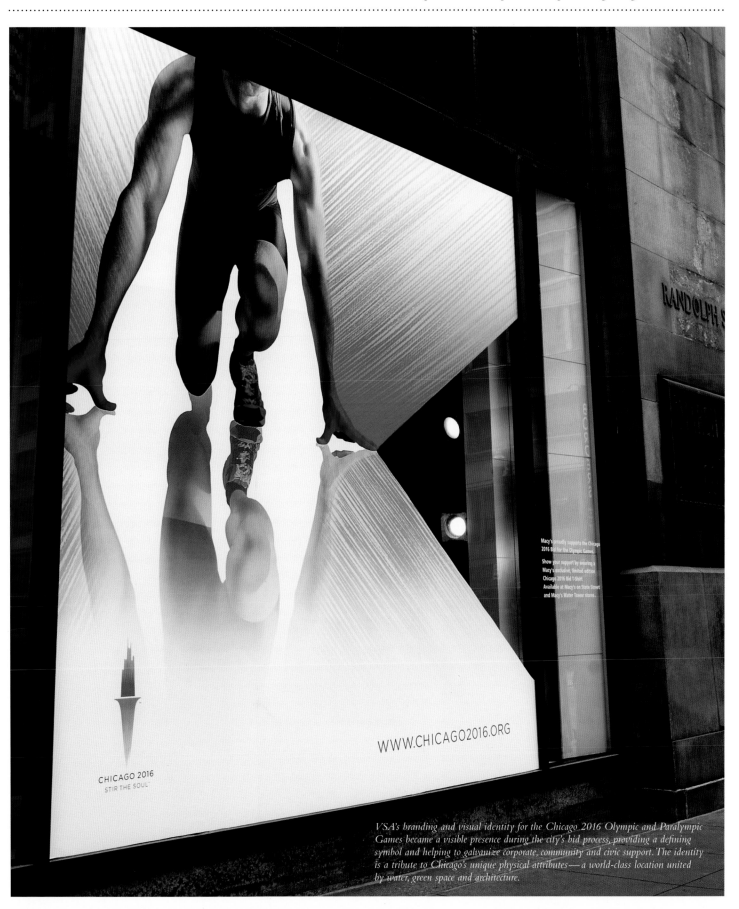

VSA's branding and visual identity for the Chicago 2016 Olympic and Paralympic Games became a visible presence during the city's bid process, providing a defining symbol and helping to galvanize corporate, community and civic support. The identity is a tribute to Chicago's unique physical attributes—a world-class location united by water, green space and architecture.

THINK

Since 2000, VSA has collaborated with IBM on everything from brand strategy and design to key investor, partner and corporate communications. The goal is to infuse the brand with clarity, humanity and wit—everywhere, from print and Internet-based tools to inspirational brand presentations for business groups companywide.

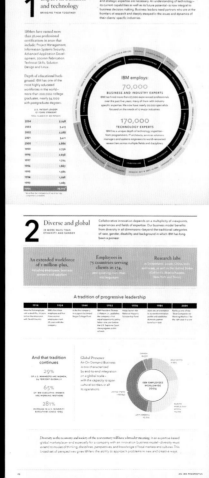

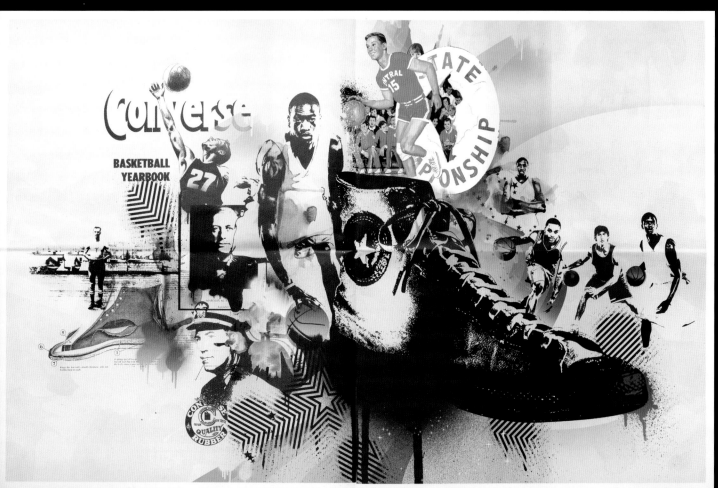

VSA's creative work for Converse's (PRODUCT) RED print advertising campaign debuted in July 2007. The print campaigns, including point of sale and outdoor, were created by VSA, with freehand illustrations created by Chicago artist Nigel Evan Dennis.

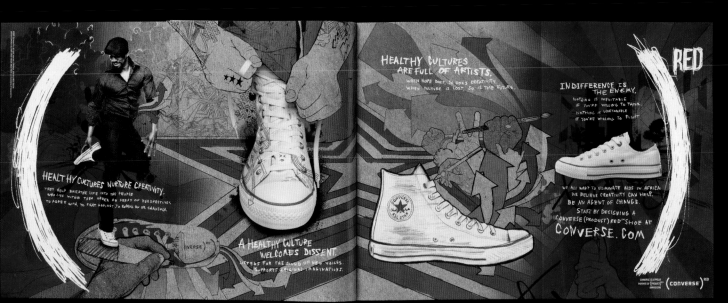

Wilson Golf asked VSA to reinvent and redeploy its time-honored Wilson Staff brand, addressing everything from design of the products to advertising through customer experience. By leveraging and reinventing Staff's 90-year legacy in the game, the relaunch has helped focus, align and motivate the sales force, and inspired new consumer confidence in one of golf's most esteemed brands.

OPPOSITE PAGE
Incorporating Tibetan tapestry design and colors from "freedom flags," VSA created a branded identity for a 2007 visit to Chicago by His Holiness the Dalai Lama. The identity program supported the daylong event and teaching, and included signage, apparel, programs and this commemorative poster.

The Tibetan Alliance of Chicago
WELCOMES HIS HOLINESS
THE 14TH **DALAI LAMA** OF TIBET
MAY 6, 2007 · MILLENNIUM PARK · CHICAGO, ILLINOIS

HARLEY-DAVIDSON® 2007 GENUINE MOTOR ACCESSORIES AND GENUINE MOTOR PARTS® SUMMER SUPPLEMENT

HARLEY-DAVIDSON® FIFTY FACTORY CUSTOMS: 2000~2005

FTY FAVORITES FROM GENUINE MOTOR PARTS AND ACCESSORIES

Rider's Edge

Teach a person to ride, and you'll have a customer for life.

HARLEY-DAVIDSON
EAGLETHON 1997

HA
DA
2003
DEAL

As one of our most enduring collaborations with one of America's most revered brands, our work with Harley-Davidson ensures that the company's brand experiences are as powerful as its product experiences. VSA's strategy, creativity and execution involve practically every touchpoint between the company and its vast audience: motorcycle marketing, catalog merchandising, online communications, environmental design, investor relations and more.

CAPITOL DRIVE PLANT HARI

Ea

"We ride with you."

HARLEY-DAVIDSON

THE 1903 SINGLE

Rider's Edge
New Rider Course
Marketing Toolkit

1992
HARLEY-DAVIDSON®
DAY AUGUST 16

HARLEY-DAVIDSON
MODEL YEAR
AD PLANNER

THE
ART & SCIENCE of
Harley-Davidson

GENERATIONS DETERMINATION DEDICATION

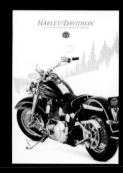

HARLEY-DAVIDSON

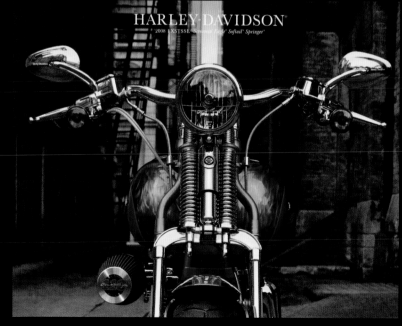

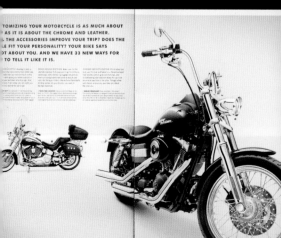

The Howard Hughes Medical Institute is a biomedical research endowment that funds the work of more than 300 independent scientists, including half a dozen Nobel Prize winners. HHMI is the force behind many of today's groundbreaking scientific discoveries in biomedical research. VSA works with the institute to project its brand identity and overcome the challenges in communicating to its diverse stakeholders.

Stan Church/Wallace Church, Inc.

Wallace Church, Inc.
Strategic Brand Identity
330 East 48th Street
New York, NY 10017
212.755.2903
www.wallacechurch.com

As founder, Managing Partner and Creative Director of Wallace Church, Inc., Stan Church has been the creative visionary behind over 30 years of award-winning design. Throughout his career, he has seen many changes in the field of graphic design, but passion, innovation, and high expectations have been his key to developing and inspiring revolutionary branding.

The passion Stan brings to his craft is what pushes him to create meaningful design. He has not only held a life-long appreciation for design, but is dedicated to sharing this understanding with others. Through his teaching and scouting the world over, Stan has found others with the same sensitivity and has created an organization of talented individuals in an environment that is fueled by his love for design.

At Wallace Church, innovation is the standard and is often stimulated by factors that have a strong influence on pioneering design—technology, lifestyle, fashion and more. "Our minds are our creative resource giving us the freedom to develop a range of original ideas. Our goal is to be the first to get there; to do what people wish they could have done first," says Stan. Wallace Church's work is not defined by a particular look or style, but is inspired by each unique brand.

Stan believes that it is important to maintain a focus on quality, first and foremost, and to produce work that is of the highest standard. He is involved in every project and creative decision. These high expectations apply to both Wallace Church design and the client. With a unique strategic approach, Wallace Church is able to motivate clients into feeling comfortable with taking revolutionary steps and making the right creative decisions.

iTuna
8.17.05
Wallace Church New York NY

Designed by Wallace Church Inc. in NYC

Menu

Warkulwiz Design Associates
211 N. 13th Street, Suite 702
Philadelphia, PA 19107
215.988.1777
www.warkulwiz.com

One of the advantages of being in business over 30 years is having satisfied clients. We let them speak for us here:

"Bob Warkulwiz works hard to make his clients look good. He helps businesses succeed because he makes them look successful in print and on the web. He's an amazing graphic designer at the top of his field and a pleasure to work with."

– *Vice President, Human Resources*
International Banking

"Bob is a terrific talent scout who has built a top notch team from the best young designers in the region."

– *Public Relations Professional*

"Projects designed for me have not only surpassed my stated communication goals, but they also have won every major graphics and communication award and have been displayed in museums!"

– *National Communications Consultant*

"The firm is 'refreshingly original' — in its design and in its relationship with clients. They never recycled a design and always tried to combine aesthetics and practicality."

– *Vice President, Pharmaceutical Industry*

"When I think of Warkulwiz Design, I think of problem solvers, always creative, with a keen sense of detail and professionalism. ... And for me personally it's been the back rubs."

– *Creative Director, Pharmaceutical Industry*

alvanon
the global size and fit expert

a

b

a. Logo development and application
b. Icon development for subsidiaries
c. Capabilities materials
d. Sales promotion
e. Exhibit design

Website design :: alvanon.com

c, d

e

"When we expanded our business beyond mannequins to a complete suite of apparel supply-chain services and consulting, we knew we needed to re-launch our brand to the industry. We were already an industry leader in one area, but had to convince clients, globally, that we were much more. Warkulwiz designed the most compelling possible logo, which not only blew us away, but truly elevated the way the industry viewed us. Marketing materials, trade show exhibitions and a re-launch of our website followed, all in perfect harmony with our core message. The way they positioned the overall brand, comprised of a perfectly integrated array of services, was brilliant. We expected a great designer, but what we got was a great communicator."

– Director of Global Strategic Services, Global Apparel Services Provider

DAK Associates

a

b

c

d

e

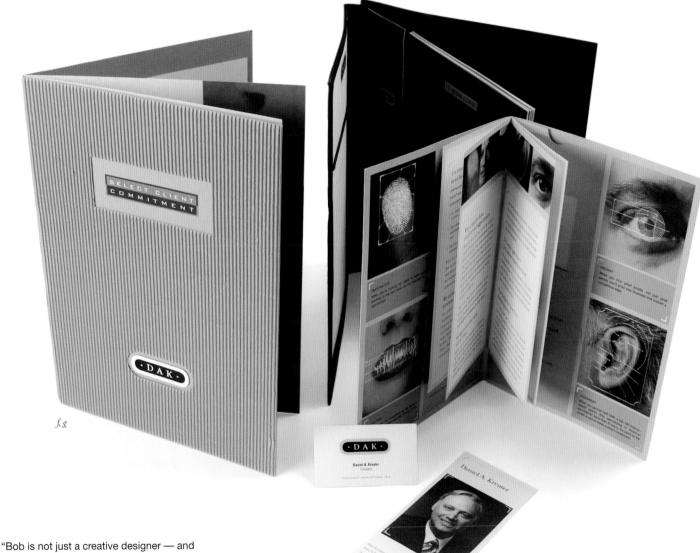

f, g

"Bob is not just a creative designer — and he certainly is that. The critical difference is his feel for communicating the essence of your business in a sharp, high-end fashion to the corporate world. It's always fresh, cutting edge, and thought provoking. Bottom line: Partnering with WDA will set you apart and provide the type of image that generates new business."

– President,
Executive Search Organization/Financial Services

a. *Logo development and application*
b. *Subsidiary logo design and application*
c. *Conference signage*
d. *Incentive gift program*
e. *Premium program*
f. *Capabilities materials*
g. *Sales marketing materials*

Website design :: dakassociates.com

Intellifit

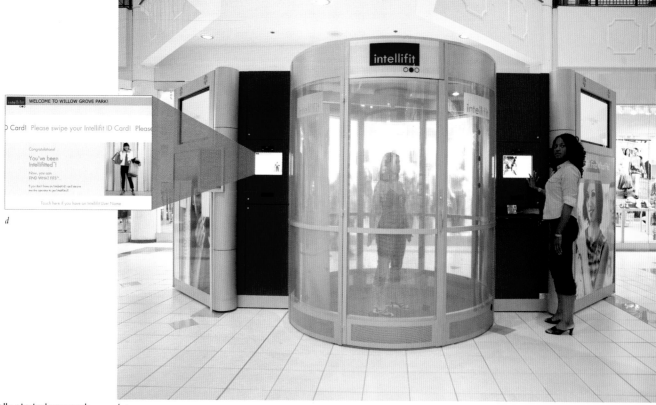

d

"What originally started as a web-only business model evolved into one with a huge mall-based, interactive consumer element. This presented numerous communications challenges, and Warkulwiz understood this immediately. Our brand image needed to be updated, and we had to communicate our value proposition consistently both to consumers and fashion retailers. Warkulwiz came up with creative ways to seamlessly integrate all of our channels, from website to touch-screen interface to smartcards, even to mall signage. Every consumer touch-point had a consistent theme and message, which made our value proposition obvious, even to a first-time user."

– President, Technology Start-up

b, c

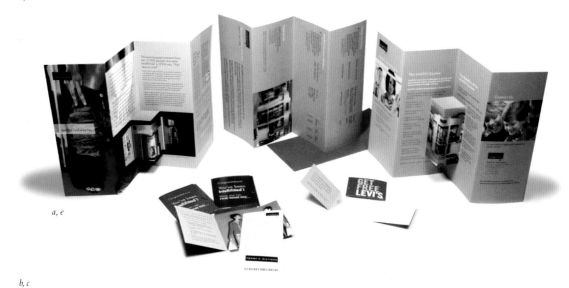

a, e

b, c

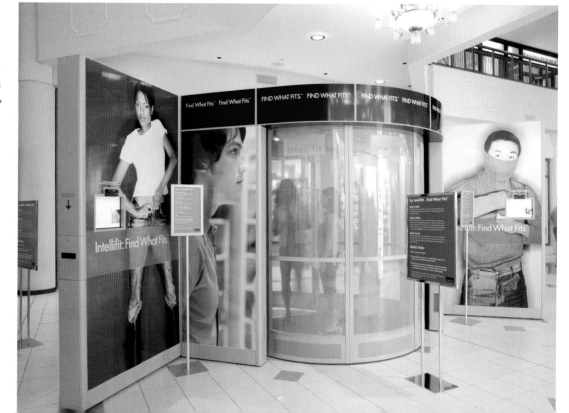

a. Sales promotion materials
b. Kiosk design
c. Signage
d. Touch screen technology
e. Marketing materials
f. Video production

Website design :: corp.intellifit.com

"Working with Warkulwiz Design was like designing and
building a house with a trusted team of advisors. Each
decision was considered. Each option was pushed to
its limit. We started with a broad vision, and, as our
relationship expanded, the process took over, and the
design permeated our entire brand."

– President/Owner, Premier Caterer and Event Planner

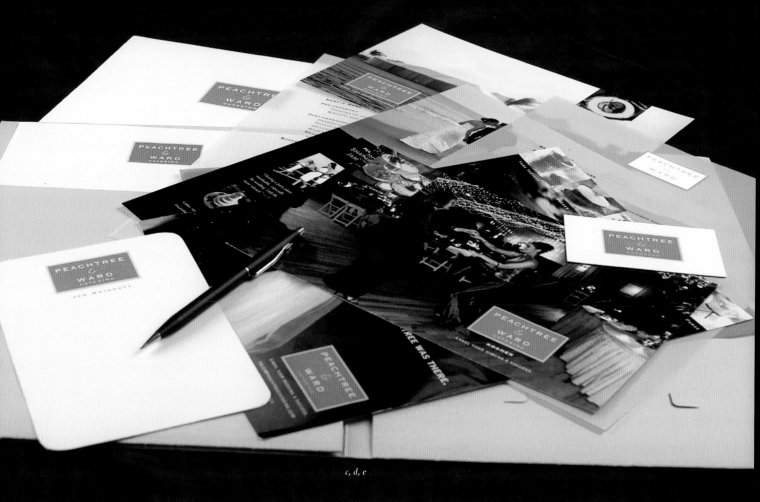

c, d, e

PEACHTREE
&
WARD
CATERING

a

PEACHTREE נשר
KOSHER
CATERING

b

f

g

a. Logo development and application
b. Subsidiary logo design and application
c. Sales/Event materials
d. Direct mail
e. Advertising
f. Sales promotion
g. Apparel

Website design :: peachtreecatering.com

WHAT I DID ON MY SUMMER VACATION

BY LARRY TEITELBAUM

If the Peace Corps had a law division, it might look like our new Human Rights Fellowship Program. Last summer, a group of intrepid students left behind the comforts of home to travel to the far reaches of Africa, the Latin American tropics, and the conflicted lands of Asia. They explored unfamiliar legal systems and the consequences of AIDS, domestic violence and environmental degradation, and the haunting legacy of genocide. What they discovered in the first year of this program can't be learned in books.

Manifest Destiny
in the Middle East

BY SALLY FRIEDMAN

It's a long way from the University of Pennsylvania Law School to Dubai, once a sleepy fishing village in the United Arab Emirates, to what a *New York Times* Magazine supplement recently called "...The fastest growing city on earth...a mix of Singapore and Las Vegas."

Wharton Alumni Magazine

The View from the Summit

The 2007 Wharton Economic Summit marked the close of the anniversary celebration by addressing global economic issues for the next 125 years.

Global Capitalism, Critical Questions

Corporate Responsibility and Sustainable Business

Cornell Enterprise :: The Johnson School at Cornell University

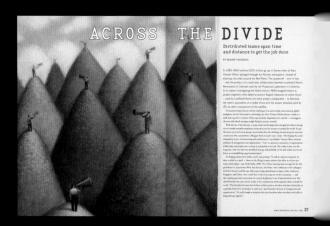

ACROSS THE DIVIDE
Distributed teams span time and distance to get the job done

BY SHARON THOMPSON

became editor of my publication I faced a slew of challenges. I had to invigorate the contant and, foremost, fix the design. The unpredictable fon

he ghosted images and inconsistent use of photos made the publication a chore to read. It looked slapped together. Fortunately, I hired Warkulwi

ates, and they restored order. Bigger photos. Striking graphics. More readable type. Overall, a cleaner design. And readers noticed, as the compli

to roll in. But the best part is, all of the changes occurred with a minimun of fuss. Bob Warkulwiz and his staff are team players — cooperative an

s. They don't get flustered when you make last minute changes. Nor do they mind if you kill the cover story, as happens now and then, and start c

flexible, too. I'm happy I found Warkulwiz Design. Without them, my job and, more important, the reader's job, would be more difficult."

r, Law Journal

Warkulwiz :: Websites

alvanon.com

dakassociates.com

corp.intelllifit.com

peachtreecatering.com

granaryassoc.com

Webster Design Associates
5060 Dodge Street, Suite 2000
Omaha, NE 68132
402.551.0503
www.websterdesign.com

Webster Design Associates is a communications design firm. For 25 years, we have thrived on projects with the most challenging criteria, never losing our focus on developing great solutions to achieve exceptional results for our clients. We believe in the power of good design and strive for excellence in a variety of specialties including: visual identity, naming and theme development, environmental design, 3D direct response, corporate communications including annual reports, event graphics and web/interactive media. Our goal is to engage and delight our clients and their customers with memorable, highly creative work. Webster Design is headquartered in Omaha, Nebraska, with offices in Denver, Colorado, and Portland, Oregon.

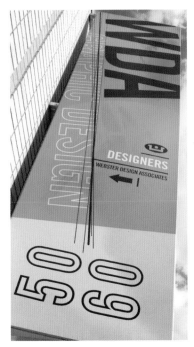

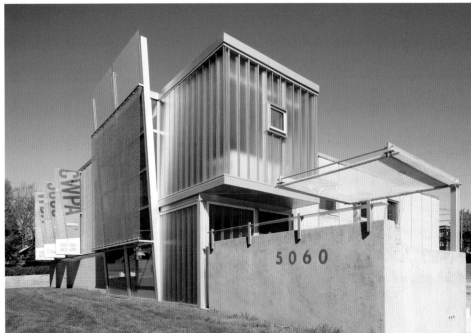

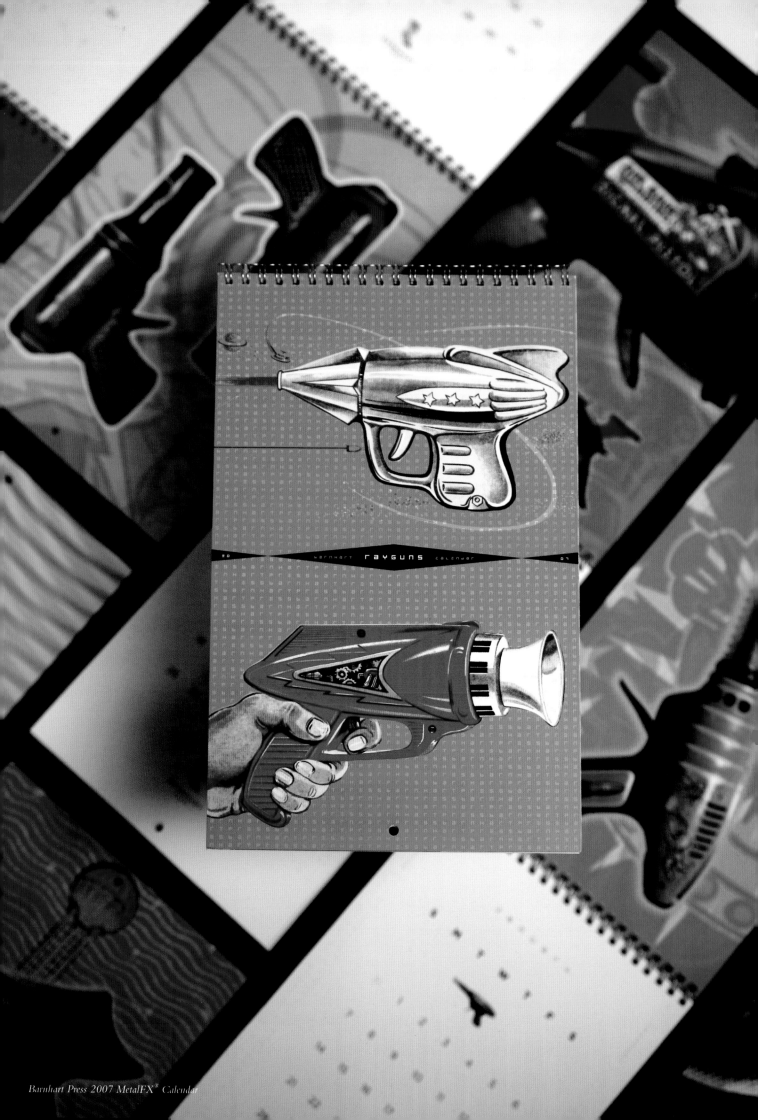

Arcosanti Homes, Inc.
Barnhart Press
AIA Nebraska
Looking Glass Networks
Ozone

(This Spread) Holland Performing Arts Center Pop-up Book

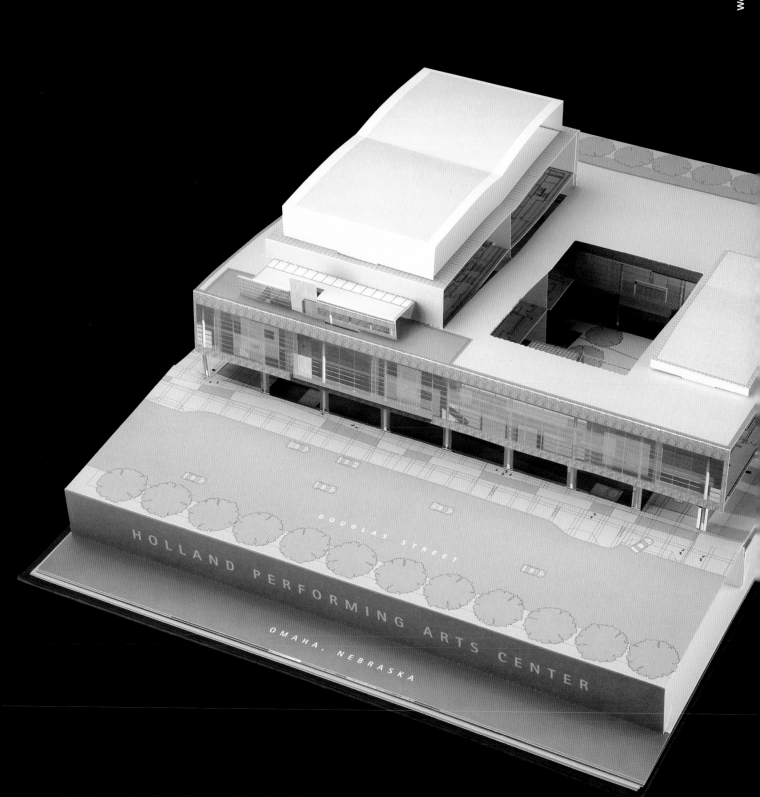

HOLLAND PERFORMING ARTS CENTER

OMAHA, NEBRASKA

DOUGLAS STREET

(This Spread) Branding and Environmental Graphics

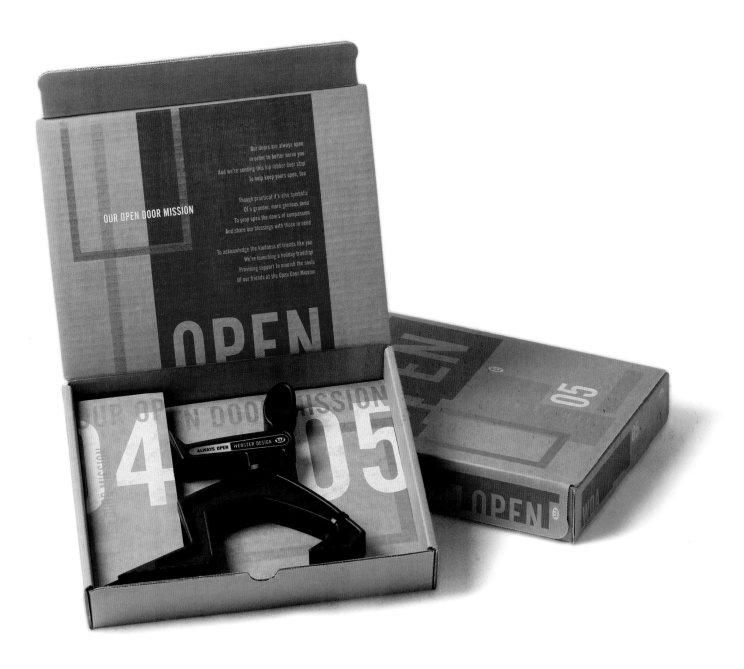

OUR OPEN DOOR MISSION

Our doors are always open
in order to better serve you
And we're sending this big rubber door stop
To help keep yours open, too

Though practical it's also symbolic
Of a grander, more glorious deed
To prop open the doors of compassion
And share our blessings with those in need

To acknowledge the kindness of friends like you
We're launching a holiday tradition
Providing support to nourish the souls
Of our friends at the Open Door Mission

"Open Door Mission" Holiday Mailing

Problem Solvers · Visual Communicators · Print · Web · Interactive

We are a small group of highly-motivated individuals who provide marketing communications and graphic design services to various regional and national blue-chip clients.

HSM Electronic Protection Services

Our client had just purchased Honeywell Security Monitoring. We repositioned HSM and delivered an award-winning campaign—"Protecting What's Important to You™."
From print advertising, corporate collateral and innovative trade show booths; to web and interactive media, we've created solid brand recognition for HSM.

GMAC Home Services

GMAC Home Services calls on us to produce their local and national print advertising, broker and agent sales materials and complete high-end luxury marketing programs...
the final deliverables really hit home.

Navistar Financial

We developed a new positioning statement "Taking the Curves Out of Financing^SM," complete graphic standards, an entire collateral program, and their website—navistarfinancialonline.com—all of which set the pace for the industry.

SIMPLE, STRAIGHTFORWARD FINANCING
FOR OVER 50 YEARS

NAVISTAR®
FINANCIAL

TAKING THE CURVES OUT OF FINANCING℠

PRINTED
CULTURE

love is blind

Flight

BARB'S
STUDIO
104

Z

design solutions that communicate